A HISTORY OF

DUPONT CIRCLE

Center of High Society in the Capital

S T E P H E N A . H A N S E N

Foreword by John DeFerrari

Charleston London

THE
History
PRESS

Published by The History Press
Charleston, SC 29403
www.historypress.net

Copyright © 2014 by Stephen A. Hansen
All rights reserved

Cover images courtesy of the Library of Congress.

First published 2014

Manufactured in the United States

ISBN 978.1.62619.564.6

Library of Congress CIP data applied for.

For Mom, who thought I should write another book.

CONTENTS

FOREWORD

Much has been written about Washington's diverse neighborhoods. Georgetown had a long history rooted in commercial trade on the Potomac. In the nineteenth century, downtown neighborhoods hosted immigrants from Germany, Italy and Greece, many living over narrow storefronts that earned them a living. Later, "streetcar suburbs" sprang up in the outer reaches of the District, places like Anacostia, Takoma Park, Chevy Chase and elsewhere. Among all of these, the Dupont Circle neighborhood holds a special place as the epicenter of the elegance, refinement, architectural distinction and, yes, cultural excesses of the Gilded Age. The development and flowering of Dupont Circle in the late nineteenth and early twentieth centuries were truly remarkable phenomena.

Though we now think of Dupont Circle as essentially part of downtown Washington, it was too far to the northwest of the city center to see any significant development in the early part of the nineteenth century. As Stephen Hansen explains, there was little in the early days other than a tavern, a cottage or two and a large cemetery. All that was to change after the Civil War, when the city began to modernize and expand. As fashionable Washingtonians abandoned their traditional roosts on Lafayette Square and moved west to Connecticut Avenue, Dupont Circle's rise was set. Soon, the wealthy were vying with one another to build the most impressive entertainment houses the city has ever known.

Stephen Hansen has done us a favor in penning this book, a rich and rewarding compendium of Dupont Circle's extraordinary residents and their

marvelous mansions. In addition to the stories of the better-known Dupont Circle denizens, such as Larz Anderson, Cissy Patterson, Alice Longworth and the Du Pont family, there are many more stories here—William A. Clark, the Copper King whom Mark Twain couldn't stand; the Patten sisters, who lived in their "Irish Embassy" on Massachusetts Avenue; or the opinionated writer Thomas Nelson Page, who gleefully alienated all his socialite neighbors.

The stories of these colorful Dupont Circle residents speak volumes about our collective heritage, however rarified and privileged their lives may have been. They left extraordinary houses behind, many of which have found new purposes and are still standing today. Washington is fortunate to retain as many of the great houses of Dupont Circle as it still has, and with this book, they come alive again to tell us their delightful tales.

JOHN DEFERRARI
June 2014

PREFACE

The concept for this book developed from a column I write for the local monthly newspaper *In Towner*. The articles I wrote for the paper covering some of Dupont Circle's more noted personalities were some of the most fun and rewarding to research and write and, as best I can tell, some of the more enjoyable ones to read as well. Many of my colleagues urged me to write a history of Dupont Circle, a task I initially found very intimidating. But as I started to delve further into the history of the neighborhood, I realized there were many stories to be told, and the task of telling just one suddenly seemed more doable. The one theme that stood out in my mind most was the fact that during the heyday of the neighborhood, its residents were not just neighbors. Beyond their proximity to one another, their strongest unifying characteristic was a sense of class and status—not only of those who already had it, but also of those who so strongly desired it.

While there are some excellent biographies and even a few autobiographies of Dupont Circle personalities that helped in the research of this book, I found myself returning again and again to such sources as the *Washington Post*, the *Evening Star* and the *New York Times*. Their unrelenting coverage of people and events, playing out over a period of days, weeks and sometimes even years on front pages and society pages, provided a uniquely human perspective on their daily lives that could not be found elsewhere.

This is by no means a complete history of the Dupont Circle neighborhood, nor is it intended to be so. This story focuses on a select cast of notable or exemplary characters to plot just one course through the

neighborhood's rich and complex history. Also, it does not attempt to cover the entire neighborhood as defined by the boundaries of the present-day Dupont Circle Historic District. With a limited number of pages, that would have undoubtedly resulted in a thin and unfocused story.

In telling this story of Dupont Circle, I attempted not to simply compile and restate generally known facts. The stories of the individuals are not full biographies, but they focus on the events in their lives that brought them to Dupont Circle, as well as on some of the experiences they had while they were living there. What follows is just one path through the rich history of Dupont Circle. An entirely different story could be told by simply following another set of individuals. These are the stories of some of Dupont Circle's palaces, the people who built them and the prominent architects who designed them. Hopefully, much of the information found in the following pages will be new to both the casual reader and the historian.

ACKNOWLEDGEMENTS

This book would not have been possible without the help of multiple individuals and institutions. I would particularly like to express my great gratitude to fellow author and historian John DeFerrari for providing the foreword; Laura Barry, Research Services librarian at the Historical Society of Washington's Kiplinger Library, whose help was unparalleled in providing many of the images for the book; Committee of 100 on the Federal City colleagues and longtime Dupont Circle residents Charles Robertson III, Anne Sellin and Rick Busch, who reviewed the book's contents for accuracy; Matthew B. Gilmore for reviewing the draft of the book and creating yet another helpful map; Kay Hansen, who helped in proofing the draft; and Eric Crabtree, whose unfaltering support throughout helped make this book a reality.

WEALTH, POWER AND STATUS IN DUPONT CIRCLE

The center of the Dupont Circle neighborhood in the northwest quadrant of Washington is the intersection of three of the city's grand avenues: Massachusetts, Connecticut and New Hampshire. What began as one of the many squares drawn on Pierre Charles L'Enfant's 1791 plan for the city of Washington—intended as a public park where three of the city's at the time nonexistent major avenues were to intersect—became a concentration of wealth, status and power that was not equaled in any other nineteenth-century American city.

The Dupont Circle neighborhood was born from the post–Civil War economic boom, the corruption of the early 1870s territorial government of Alexander "Boss" Shepherd, a few slightly corrupt politicians and silver miners and many relatively honest wealthy people. To understand the history of Dupont Circle is to understand the socioeconomic class structures in the city during the second half of the nineteenth century that influenced the neighborhood's rapid growth.

Washington, D.C.'s oldest social set was composed of its permanent residents, nicknamed the "Antiques" by Mark Twain, and was later known as the "Cave Dwellers" on account of its exclusiveness. Mainly from landed, slave-owning southern Democrat families, the early Cave Dwellers could trace their heritage in Washington back to the first political administrations in the capital, namely those ranging from John Adams to Andrew Jackson. Its members never strayed far from their geographic home base—the area immediately around Lafayette Square in front of the

White House or just north of the square in the blocks between H and K Streets Northwest. The area still has architectural artifacts from the early days of the Cave Dwellers, such as the homes of Stephen Decatur, Dolley Madison and Benjamin Ogle Tayloe.

In contrast to the permanency of the Cave Dwellers, official society's time in Washington was seasonal, and its presence in the city mostly followed the congressional season. A position in official society was automatic with a presidential appointment, congressional election or diplomatic posting to Washington. It was composed of the president and his family, members of the Supreme Court, members of the president's cabinet, elected officials and the foreign diplomatic corps. Becoming a recognized social phenomenon during the administration of Ulysses S. Grant, official society was hierarchical, with the highest status given to those who, due to their particular positions in the government, spent the most amount of time in the city during the year; thus, presidential cabinet appointees and Supreme Court members, who spent the better part the year in town, ranked high in the hierarchy, and Representatives, who spent the least amount of time in the capital, were among the lowest ranked. While living in Washington, members of official society tried to live as close to the Cave Dwellers as possible, and those who remained in Washington after their terms and appointments expired often became recognized as Cave Dwellers themselves.

After the Civil War, when Washington, as well as the nation, had turned Republican, members of residential society whose Southern plantations had been devastated by the war, either left town or disappeared from public life. Those who remained were seldom seen and were mostly known only to one another, truly earning the appellation of Cave Dweller. But they would still resurface occasionally to show disapproval of the newcomers and their social mores or when a daughter or granddaughter needed a cotillion to be introduced to society. Their acceptance of outsiders, usually in the form of an invitation, while rarely given, became the ultimate social prize.

A new social set began to appear in Washington immediately after the Civil War that was composed of high-ranking military officers. They followed the great Union generals like Ulysses S. Grant and Philip Sheridan to Washington to fill the many new, high-paying bureaucratic positions in the War and Navy Departments that were being created in the rapidly growing federal government. With solid government incomes or family fortunes of their own, they could stay the course in the neighborhood through the financially troubled 1870s and mixed easily with both the Cave Dwellers and official society.

The Gilded Age, which started after the Civil War and lasted about three decades, was a period of rapid economic growth in the United States, especially in the North, with industrialization and railroads, and in the West, with silver and gold mining. With the dawn of this era also came a new government in Washington, D.C., and an opportunity for fortunes to be enriched in real estate in a city with an exploding population and with the significant improvements under Alexander Shepherd's controversial board of public works programs in the early 1870s.

With Shepherd's city improvements in place, the nouveau riche of the Gilded Age began to view Washington as an acceptable social destination and started to slowly invade the city, seeking to take advantage of its more temperate winter climate and its open-door social policy. The seasonal transience of official society allowed these newcomers to slide in with the start of the next congressional season and reinvent and establish themselves as members of high society—a privilege they were not afforded in their home cities due to their self-made, rather than inherited, fortunes.

Mark Twain took a particularly strong dislike of the post–Civil War nouveau riche, nicknaming them the parvenus, a corruption of the French *parvenire*, "to arrive." In Mark Twain's 1873 novel *The Gilded Age: A Tale of Today*, the "Aristocracy of the Parvenus" was embodied in Patrick O'Riley and his family. O'Riley had made his fortune selling enormously overpriced shingle nails to a corrupt city government official, modeled after Boss Tweed. After touring Europe and learning to speak English with a foreign accent, O'Riley and his wife arrived in Washington, now as the Honorable Patrique and Lady Oreillé, and ready, in their minds, to take their new place in society.

The parvenus continued to grow in number and wealth for the next thirty years, building palatial homes in Dupont Circle until there was simply no more land to be had. With their strength in number, they finally became their own recognized social class, known as the "smart set," defined not by birthright or the origins of their money, but as those whose reasons to be in Washington were purely social. Now able to mix with official society, though never with the Cave Dwellers, their money finally bought them what they were seeking. Still, Washington's smart set took its cues from New York's smart society, of which many thought that Washington's was a mere subset.

One social tradition that developed at the beginning of the Gilded Age was the social "season." This season stretched from mid-November until the end of Lent and marked the time that official society and the smart set returned to Washington. Over the roughly twelve weeks of the winter season, social life for the smart set consisted of a grueling marathon of balls,

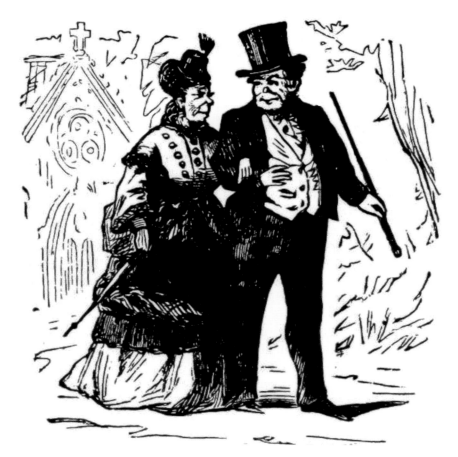

Mark Twain's the Honorable Patrique and the Lady Oreillé. *From Twain*, The Gilded Age.

receptions, parties, dinners, musicales and other activities. Following New York's social calendar, the month of December was the month for coming-out receptions and balls for daughters to be introduced to society. Activities during Lent tended to be less publicly ostentatious and offered a means to quietly close the season.

Summers would be spent in any number of acceptable locations—namely, Bar Harbor, Newport and the European capitals—and almost never back in the city from which one originally came, unless it was to settle family business. By the 1890s, the smart set had broken into cliques based on where

they chose, or were invited, to spend their summers. Newport remained the prime destination for many, as it allowed them to mingle with New York society. The Cave Dwellers rarely left town during the summer season, quietly suffering through the city's heat while scornfully watching the rest come and go.

Most of the grand mansions built by official society and the smart set in Dupont Circle were concentrated directly around the circle and along Connecticut, Massachusetts and New Hampshire Avenues. Today, only two of the grand winter palaces of Dupont Circle's elite still stand directly on the circle itself: the Patterson mansion at 15 Dupont Circle and the pie-shaped Wadsworth mansion at 1801 Massachusetts Avenue. Not far off the circle along Massachusetts Avenue to the west, a few more still survive, including the mansions of James Blaine, Thomas Walsh and Mary Townsend. Many are now homes to organizations, office buildings and embassies. These buildings, along with many of the less grand houses that have remained as private residences, as well as the middle-class homes that were filling in the quiet, tree-lined streets around Dupont Circle at the same time that the palaces were being built, still hold some of the flavor and lure of the neighborhood's golden era.

THE EARLY DAYS

The Dupont Circle neighborhood is located on part of a seventeenth-century Maryland land grant that was known as "Widow's Mite." Widow's Mite was surveyed in 1664 for John Langworth and patented in 1686 for William Langworth, his young son, who was killed in an Indian attack. The land was subdivided and sold many times, eventually ending up in the hands of Anthony Holmead and James Lingan, among others, when it was purchased by city commissioners for use as the capital city in 1791. Holmead built his first house north of Dupont Circle in 1750, and it was later bought by Joel Barlow, who renamed it "Kalorama." Lingan owned about 157 acres of Widow's Mite, which fell mostly below Florida Avenue within the boundaries of the federal city and is where the Dupont Circle neighborhood is located.

SLASH RUN

Slash Run, sometimes called "Shad Run," was a stream that ran a zigzag course down from the north, coming within a block to the east of the circle itself, and then wound its way down to Connecticut Avenue and Desales Street (now the location of the Mayflower Hotel), where it then turned west and ran into Rock Creek. There was mostly marshy ground through much of its course, with such dense growth of bushes and vines that the only way

through was by cutting or slashing, hence the name. At the top of Slash Run, butcher John Little had placed his slaughterhouse in the 1850s and would dump animal entrails and blood into the stream. The insanitary odors arising downstream were very unpleasant in warm weather, especially as the area started to get more populated. Yet, where the brook made a bend about where the Mayflower Hotel is located today, it created a swamp that became a very popular swimming hole. In spite of the marshy ground and slashes, there was still some solid ground that attracted the area's earliest settlers—either dead or alive.

HOLMEAD'S CEMETERY

In 1807, the city government established the Western Burial Ground Cemetery on a plot of about one-third of an acre at the edge of the city at Twentieth Street and Florida Avenue. The land had been a gift from Anthony Holmead and is where he placed his own family cemetery. It became known popularly as "Holmead's Cemetery." The cemetery was intended to serve for general burials for people of all denominations, with a separate section set aside for the African Americans.

The creation of the cemetery mandated the opening of the first street through the neighborhood, Twentieth Street, so that it could be accessed from downtown. But all that was probably ever done was the clearing of a crude wagon path through the brush. For a long time, the cemetery was not enclosed, and mail coaches going between Washington and Baltimore would roll through its grounds.

A number of Native Americans, soldiers of the War of 1812 and other prominent people were buried in Holmead's Cemetery, including the eccentric Methodist minister Lorenzo Dow and early Washington surveyor Nicholas King. Dow, who died in 1834, was an itinerant revivalist preacher and an important figure in the Second Great Awakening. He is said to have preached to more people than any other preacher of his era. For a time, his autobiography was the second-bestselling book in the United States, exceeded only by the Bible.

Holmead's Cemetery held some notorious figures as well. One was the first man executed in the city, Patrick McGurk, who had badly beaten his wife and caused their twins to be stillborn. Relatives of others buried in the cemetery were so incensed that such a man was buried with their

own that they exhumed his body and reburied it outside the cemetery. Upon learning of his relocation, McGurk's friends one night reburied him in his intended cemetery lot. Again, relatives of the deceased rallied and exhumed the body, this time burying it in the thicket on the banks of Slash Run, never to be found again. Another of the more notorious burials was that of Lewis Payne, one of the Lincoln assassination conspirators who was hanged in 1865.

For half a century, second only to Congressional Cemetery, Holmead's Cemetery was the city's leading burial site, with thousands of bodies placed there for what was assumed to be their final resting place. Its straight walks, well-grown cedars and peaceful setting attracted throngs of visitors, friends and relatives of the departed.

About a year after the cemetery was established, a Scotsman by the name of Guy Graham settled in the Dupont Circle area and, around 1808, built a wood-frame house in what is now the west side of the 1700 block of Connecticut Avenue. Graham was a laborer and was involved in the creation of the new city, helping to clear the path for Pennsylvania Avenue from the Capitol to the Treasury building. Years later, some of his descendants remembered his describing how the trees were cut so as to fall across the road and then filled in with stone and gravel to make the roadbed. For some time, he also served as the caretaker of Holmead's Cemetery.

One block to the south of Holmead's Cemetery, proprietor Eden Ridgway had a tavern. Ridgway's Tavern was well placed at the intersection of Twentieth Street and Florida Avenue, then called Boundary Street, on the section used as a shortcut along the north edge of the city from the old Bladensburg Road to Georgetown. It was in the right location to take advantage of the considerable traffic to the graveyard, Joel Barlow's Kalorama estate and the port of Georgetown.

WILLIAM O'NEALE

In 1794, William O'Neale moved from Chester County, Pennsylvania, to open a stone quarry at Mount Vernon and one along the western boundary of the city to provide freestone for Washington's new public buildings. It was grueling work, not only for the hired men and slaves, but also for O'Neale himself. "Keep the yearly hirelings at work from sunrise to sunset—particularly the Negroes," the city's commissioners told him. But

the use of slave labor so frustrated O'Neale that he abandoned the quarries to stake his own claim in the new capital.

O'Neale was originally from Ulster, Ireland—the birthplace of Andrew Jackson's father as well. His wife, Rhoda Howell O'Neale, told everyone in Washington that she was the sister of Richard Howell, the governor of New Jersey at that time, but there is no evidence of this relationship. She may have made this claim to gain entrance to Washington's newly burgeoning social society.

In 1794, O'Neale built a wood-frame house at the corner of Twentieth and I Streets, just four blocks west of the White House, and set himself up in the business of cutting and selling cordwood, coopering barrels and building stoves, as well as selling coal and feed. When he had made enough money, he built a large brick house to the west of his house at Twenty-first and I Streets and put both his houses up for sale. But investors were not flocking to the new capital city as was hoped in the 1790s, and he was unable to sell them. In 1800, he turned the brick house into O'Neale's Tavern, a boardinghouse and general store, which later became better known as Franklin House.

In 1819, O'Neale bought some land just north of Dupont Circle on the eastern part of Connecticut Avenue, where he built a large two-story brick house with a full-width porch facing south to the downtown area that he referred to as his farm. He surrounded the house with an orchard and a garden. The farm became so well known that the area of Dupont Circle was simply referred to as "by Billy O'Neale's." Here, O'Neale would quietly spend his summer months without the concerns of feeding and entertaining lodgers and surrounded by his family.

William O'Neale was well known and liked by official society, although he and his family were never be able to join their ranks. Virginia congressman John Randolph was one of the many boarders at Franklin House and had gotten along famously with O'Neale. Upon his return from his posting in Russia, a reception was held for Randolph that O'Neale attended. But Randolph feigned to not recognize O'Neale. When he was reminded that he had lived at the boardinghouse, Randolph replied, "Oh yes, Billy O'Neale, [the] victualler. Well, what do you want?"

THE INNKEEPER'S DAUGHTER

O'Neale's young daughter Margaret, known as "Peggy," was a celebrity at Franklin House. She was beautiful, well-educated, spoke French and could play the piano exceedingly well, and she quickly ingratiated herself with those who stayed at the boardinghouse.

At the age of fifteen, Peggy eloped with thirty-nine-year-old John Timberlake, who was a purser in the U.S. Navy. She had tried to elope once before with another gentleman, but her father caught her sneaking out a window and ordered her back inside the house.

The Timberlakes had become good friends with a twenty-eight-year-old widower, newly elected U.S. senator from Tennessee and close friend of Andrew Jackson, John Henry Eaton. When Timberlake was away on a four-year sea voyage on the USS *Constitution*, Margaret and John Eaton were often seen parading arm in arm, and talk began that the two were having an affair. Timberlake died of pulmonary disease in 1828 while away on the voyage. There were rumors that he had actually committed suicide because of despair over Peggy's infidelity.

With the encouragement of President Andrew Jackson and throwing the customary period of one year of mourning aside, Peggy and John Eaton were married only months after Timberlake's death, scandalizing official society, especially the women. Among one of the most scandalized was Vice President John C. Calhoun's wife, Floride, who led other cabinet wives in an orchestrated attempt to snub and ostracize Peggy Eaton. Andrew Jackson's niece, Emily Donelson, who had become the surrogate First Lady after the death of Rachel Jackson, also sided with the Calhoun faction. Martin Van Buren, a widower and the only unmarried member of the cabinet, sided with Jackson and John Eaton.

Hoping to quell the rumors, a sympathetic Jackson appointed Eaton as his secretary of war, which only exacerbated the situation, further enraging his opponents, especially the Calhouns. When he was advised against making the appointment because of Peggy's reputation, Jackson barked, "Do you suppose that I have been sent here by the people to consult the ladies of Washington as to the proper persons to compose my cabinet?!"

The controversy finally resulted in the resignation of all but one member of Jackson's cabinet over a period of a few weeks in the spring of 1831. They were replaced with Jackson's trusted friends and advisors, which became known as the "Kitchen Cabinet" as they apparently did sometimes met in the White House kitchen. The situation became widely known as the

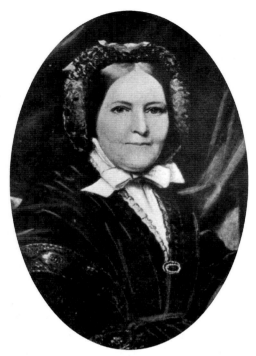

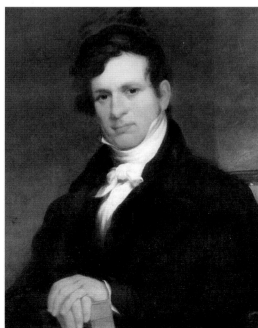

Top: Margaret "Peggy" O'Neale Eaton. *Courtesy State Archives of Florida, Florida Memory.*

Left: John Henry Eaton. *Library of Congress.*

Peggy Eaton affair or the Petticoat Scandal. Jackson later appointed Eaton governor of Florida and then, in 1836, as minster to the Spanish court, where Peggy quickly became a favorite of Queen Christina.

William O'Neale died at his Dupont Circle farm in 1837 at the age of eighty-six while Peggy was still in Spain and was laid to rest in Holmead's Cemetery. When Rhoda O'Neale died in 1860 at the age of ninety, Peggy inherited, along with other properties the O'Neales owned around town, the farm in the Dupont Circle neighborhood.

Peggy Eaton's scandalous life did not end with her effects on President Jackson's cabinet. By the time John Eaton had died in 1856, Peggy had finally gained the respect of her socially elite associates in Washington, but her acceptance was to be short-lived. Only three years after Eaton's death, the then fifty-nine-year-old Peggy married her granddaughter's nineteen-year-old Italian dancing instructor, Antonio Gabriele Buchignani, who was working at Marini's Dancing Academy. She was once again shunned by society.

It was uncertain exactly what Peggy was thinking, but it was clear that Buchignani was nothing more than a two-bit gigolo out for a wealthy American widow's money. Buchignani was never satisfied with the amount of money Peggy provided for him, and what she did give him was spent immediately. He was also caught stealing the family silver, and Peggy was forced to cover for him with the authorities. The couple moved to New York City so Antonio could set up his own import business of Italian wines and other products.

In 1866, Buchignani demanded that Peggy sign everything she owned over to him or he would leave her. In order to get him to stay, she signed over all her real estate, which consisted of nineteen houses and six square blocks that included the farm in Dupont Circle. Fortunately, she did not sign over the family home at Twentieth and I Streets. Buchignani then promptly sold the farm to the Hopkins brothers from Georgetown. The farmhouse stood at 1617 Connecticut Avenue until about 1895, when it was razed for a house for the widow of a gold miner, Ellen Mason White Colton, which still stands on the site today and has been converted to a storefront.

After seven years of marriage, Buchignani ran off to Italy with his wife's fortunes as well as her seventeen-year-old granddaughter, Emily Randolph, whom he would marry after he and Margaret divorced in 1869. The couple lived lavishly on Peggy's money, but it quickly ran out. After scamming an Italian nobleman in Paris, Antonio set out for Montreal. Reports at the time also placed him in Texas and Memphis, Tennessee, where he was supposedly

posing as a doctor. Antonio ultimately ended up back in New York, where Peggy was still residing. Learning that he was back in town and had just secured a loan for $15,000, Peggy had him arrested, but a wealthy New York lawyer put up the bond for his release. He was then arrested for the abduction of a minor, but he was acquitted and fled back to Montreal. In spite of all this, Margaret wrote in her memoirs: "The fact is, I never had a lover who was not a gentleman and was not in a good position in society." Buchignani and Mary Randolph did have a family together, with his children also his former wife's great-grandchildren.

Peggy died in poverty in 1879 at the age of eighty-one at Lochiel House, a boardinghouse on Ninth Street. Antonio died in New York City in 1891 at the age of fifty-seven. The 1936 movie *The Gorgeous Hussy* was based on the life of Peggy O'Neale and starred Lionel Barrymore as Andrew Jackson and Joan Crawford as Peggy.

Douglass's Flower Gardens

In 1826, John Douglass established a flower garden and greenhouse at Florida Avenue and Twentieth Street. In its early days, the garden was mostly devoted to the raising of market produce, but it later became one of the finest flower establishments in the city. In the 1840s, Douglass built greenhouses at the northeast corner of Fifteenth and G Streets in connection with the garden. The *Evening Critic* reported that "the gardens are the most complete in the United States, and there is no necessity for going to any other place for floral decorations."

In 1881, as a gesture of her deep sorrow for Lucretia Garfield and the people of the United States after President Garfield's assassination, Queen Victoria sent a large wreath of white tuberoses to the funeral that she ordered from Douglass florists. The wreath was placed on the president's casket as his body lay in state in Washington, D.C., and during his funeral in Cleveland. Lucretia Garfield was so touched by the queen's gesture that she preserved the wreath after the funeral, sending it to Chicago to be preserved with a wax treatment. Today, visitors to James A. Garfield National Historic Site can see the wreath from Douglass florists still displayed in the Memorial Library's vault.

HOPKINS BRICKYARD

Due to the high clay content of the local soil, the brick-making business flourished in the Dupont Circle area from the 1840s to 1870s. Thomas Corcoran, a brother of Washington banker, philanthropist and art collector William Corcoran, established a brickyard around 1840 northwest of Dupont Circle and tried to make a go of the business for several years.

In 1856, Georgetown brothers John and George Hopkins bought Corcoran's brickyard and, four years later, also bought the O'Neale farm. George Hopkins took up residence in the O'Neale house while his brother, John, continued living in Georgetown. In 1858, John died, leaving nine orphaned children who then moved in with their uncle George. The Hopkins family continued in the business, and with the explosive need for more housing after the Civil War, the brickyard's business took off. With its tempering sheds, kilns, offices and outbuildings scattered around the area, it blocked the course of Massachusetts Avenue west of the circle.

Due to the smoke that the Hopkins brickyard produced, by 1870, it was considered a nuisance, and a bill was introduced in Congress for its removal. But the Hopkins family continued the business in its location until 1875, when the value of the land exceeded the profitability of making bricks. Hopkins's brickyard was so well known that newspapers in the 1920s were still making references to the "days of Hopkins's brickyard," perhaps as a nostalgic memory of how rural Dupont Circle had been not long before. The old road into the brickyard, the one-block Hopkins Street, just off P Street between Twentieth and Twenty-first Streets, is all that remains of the brickyard today.

Into the 1850s, the Dupont Circle area remained an isolated village, accessible by only one road—Twentieth Street, then simply known as "the Road," which led to Holmead's Cemetery and the Kalorama estate. Twentieth Street had only been graded and graveled in 1856, and then only to fulfill a campaign pledge. William Linkins, a butcher, had his house and slaughter yard on Twentieth Street. German immigrant August Mueller, whose daughter, Amelia, would later marry brewer and Dupont Circle resident Christian Heurich, farmed the land between Massachusetts Avenue and Twentieth Street, with his cornfields stopping just across the street from where the circle is today.

Into the 1860s, the three grand avenues that merge at the circle—Connecticut, Massachusetts and New Hampshire—still existed only as lines on Pierre L'Enfant's 1791 plan for the city of Washington. Connecticut Avenue had

only been graded as far north as O Street in 1858, and Massachusetts and New Hampshire Avenues remained almost completely uninhabited. In *North America 1863*, Anthony Trollope, an English writer who visited Washington in 1862, went about exploring the city and trying to travel its grand avenues. Of Massachusetts Avenue, he wrote:

> [It] *runs the whole length of the city and is inserted on the maps as a full-grown street about four miles in length. Go there and you will find yourself not only out of town,* [but] *among the fields in an uncultivated, undrained wilderness. Tucking in your trousers up to your knees, you will wade through bogs; you will lose yourself through snipe grounds, looking for civilization where none exists.*

By the time of the Civil War, the Dupont Circle area began attracting some criminal activity. With the rising occurrence of vandalism, county police began patrolling the area around Holmead's Cemetery. Residents also complained that passing teamsters were robbing Mueller's and Douglass's gardens, stripping cornfields and carrying away cabbage and potatoes by the bagful.

Holmead's cemetery became a magnet for problems, both for the living and the dead. Over the years, it had become completely full. By the early 1870s, cemetery record books accounted for over nine thousand burials within its small area, not including a large number of unofficial burials as well. Bodies were often buried three- or four-deep in a single grave, and walkways were encroached upon for grave sites. After Florida Avenue was graded, the grounds were some eight to ten feet above the street grade, with the banks in danger of caving down into the street, hitting passing carriages and carts and leaving the coffins of old graves exposed. Other areas of the cemetery were so low that bodies had to be interred only two and a half feet deep for fear of reaching water.

About 1870, the cemetery was condemned as a health menace, and directions were given that no more bodies were to be buried there, although unofficial burials continued, mostly of black people. The remains of many bodies were then removed to other cemeteries by relatives and friends. Lorenzo Dow was moved to Oak Hill Cemetery, and unclaimed bodies were placed in a lot at Rock Creek Cemetery, that of Lewis Payne among them. Peggy Eaton enlisted the help of William Corcoran to have her father, mother and two younger brothers reinterred in Oak Hill Cemetery. After selecting the new lots in Oak Hill, she said, "It will make a nice place for us all to stay in."

Relocating all the bodies in the cemetery was a daunting task, and by 1882, the city had run out of money for the undertaking, leaving many graves open or half exposed. Now within playing distance of the cemetery were hundreds of children. Boys were spotted parading about the area armed with human bones as swords and with a skull on a pole doing duty as a standard. It was not until 1884, when all the bodies had been moved out, that the land was sold to John Roll McLean, owner of the *Washington Post* and father-in-law to Evalyn Walsh McLean, who turned it into Holmead Park. The President Madison apartment building, constructed in 1905 and originally named the Cordova Apartments, now stands on the site.

A NEW GOVERNMENT AND A NEW NEIGHBORHOOD

B y 1870, Washington's population had grown to nearly 132,000 residents. Still, the city was little more than a collection of hamlets with dirt roads, wooden sidewalks, open sewers and farmland within the city and large country estates around the periphery of the city. Conditions were so bad around the city that Congress began discussing relocating the seat of the federal government westward to St. Louis. The constant talk of moving the capital was hurting local businesses and real estate development.

With the support of President Ulysses S. Grant, local businessmen pushed an agenda to reorganize the city government by consolidating the still-independent governments of Georgetown and Washington County under a locally ruled territorial form of government. Grant and his supporters prevailed over their opponents in Congress with the passage of the Organic Act of 1871, which created a territorial and locally ruled government for the District of Columbia. The act provided for a presidentially appointed governor, a legislative assembly and a twenty-two-member house of delegates elected by residents of the District. It also established a five-person board of public works that would plan and oversee citywide improvements.

Grant appointed his friend from Ohio, Henry D. Cooke, as the governor of the new government. Cooke's mandate in this capacity was to oversee the integration of Washington, Georgetown and Washington County into a single government. Among Grant's appointments to the board of public works was a former plumber and real estate developer, Alexander Robey Shepherd, better

known as "Boss" Shepherd. Shepherd served as vice-chair while Henry Cooke served as an ex-officio board member. Cooke did not take an active interest in the board, rarely appearing at meetings, and was little more than a hand and mouthpiece for Shepherd's wishes. The other members of the board of public works also yielded almost full control to Shepherd.

Shepherd was a native son of Washington, D.C. Born in 1835, he dropped out of school at age thirteen and took a job as a plumber's assistant, working his way up to eventually own the firm. Shepherd then invested the profits from the business in real estate development, which made him a very wealthy and influential citizen of the city.

German-born architect Adolf Cluss replaced Alfred Mullet as the city architect on the board of public works in 1872. Cluss was nicknamed the "Red Architect," not only because his favorite building material was red brick, but also because he was a card-carrying Communist. He was a close associate of Friedrich Engels and had been an intimate member of Karl Marx's circle before leaving Germany.

A REAL ESTATE SYNDICATE'S LAND GRAB

In 1871, Shepherd submitted a citywide, $6.25 million Comprehensive Plan of Improvements to pave streets, lay water and sewer lines, lay out parks and build public buildings. At the same time, three Nevada silver mining magnates saw the potential for very lucrative real estate investments in the yet untamed northwest section of the city—namely, the Dupont and Logan Circle neighborhoods of today. Many of Shepherd's better improvements, which included poured-concrete streets instead of using ground stone or wooden boards, were reserved for these areas. While the investors were all friends of Shepherd and very supportive of his improvements, they claimed no special or advance knowledge of his plans for the area.

Senator William Stewart, Judge Curtis Justin Hillyer and Thomas Sunderland, all three midwesterners who knew one another from their mining days in Virginia City, Nevada, formed what was known as the "Pacific Pool" or "Pacific Syndicate," which was managed through a local real estate firm operated by Hallet Kilbourn and Matthew Latta. The pool was also sometimes referred to as the "California Syndicate" or the "Honest Miners Camp," although honesty may not have been the prevailing virtue of the syndicate.

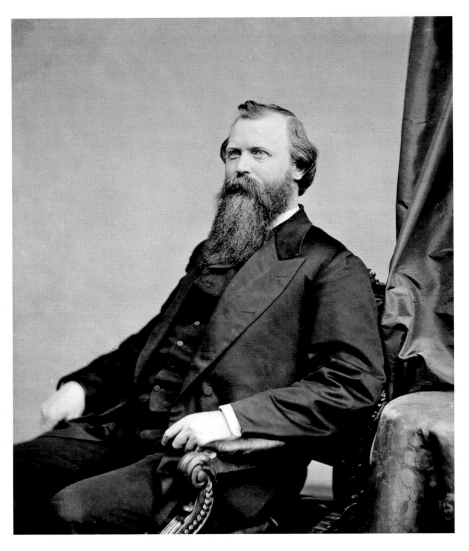

Senator William Morris Stewart. *Library of Congress.*

Opposite: Curtis Justin Hillyer. *Author's collection.*

William Morris Stewart, often referred to as the "Silver Senator," was born in 1827 in Wayne County, New York. When he was still a small child, he moved with his parents to Trumbull County, Ohio. Stewart made his first fortune in silver mining in Nevada but abandoned mining in 1860

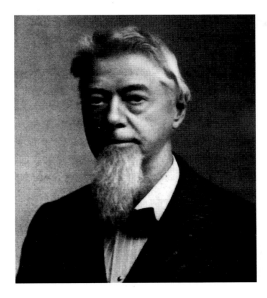

to become a mining attorney in Virginia City, participating in litigation for the Comstock Lode. When Nevada became a state in 1864, Stewart assisted in developing its constitution and became the first U.S. senator from that state in 1864.

Curtis Justin Hillyer was born in Granville, Ohio, in 1828. After graduation from Yale University, he studied law and taught in a high school in Cincinnati. Due to his health, he left the Midwest for California, where he ended up buying a mining claim. After working the claim for only four months, he set up a law office in the mining district in Placer County, California. While there, he was appointed clerk of the Supreme Court of California, but he resigned the position when the Comstock Lode was struck in 1859 and moved to Virginia City, Nevada, where he worked at a law firm under its senior partner, William Stewart. There, he served as legal counsel to the Silver Kings' Consolidated Virginia Mining Company and, as a result, amassed a considerable fortune. Hillyer first visited Washington in 1871 on business and was so impressed by its developmental prospects that he moved to the city and set up a law firm.

Thomas Sunderland, born in 1820, was a native of Indiana. Sunderland studied law in Iowa and then practiced in Hannibal, Missouri, before going to California in 1849. After some success as a miner, he established a lucrative law practice in Virginia City and, in the early 1860s, went into partnership with a good friend of Mark Twain, Alexander W. Baldwin. Sunderland continued to practice law in Virginia City through most of the 1870s, and he made a large fortune from his various mining interests. Unlike Stewart and Hillyer, Sunderland never became a long-term resident of Washington or built a home for himself in Dupont Circle. So convinced that this real estate was the investment opportunity of a lifetime, Sunderland also bought a sizable amount of land outside the pool as well.

With the capital the pool members put up, lot purchases were made in cash for one-quarter of the sale price. Promissory notes were given for the

remaining balances that were secured by deeds of trust underwritten by the prominent banking firm of Jay Cooke & Co., whose founder, Jay Cooke, was Governor Henry Cooke's brother. The pool would then rely on profits from sales of lots to meet the notes as they came due. By 1873, along with Sunderland's purchases outside the pool, the syndicate's holdings accounted for most of the unimproved land in the Dupont and Logan Circle areas.

In 1871, improvements around other parts of the city got off to a modest start following what was outlined in the Board of Public Work's plan with paving some of the major streets with ground stone or wood. But in August 1872, the board of public works awarded a contract for the first concrete pavement to be laid on Connecticut and Massachusetts Avenues. Connecticut Avenue suddenly, and without any apparent reason, became a twenty-four-foot-wide concrete roadway, flanked by aspen trees and running from Lafayette Square though Dupont Circle to the city boundary at Florida Avenue.

In 1873, a wooden fence that had been erected around the area meant to be a public circle was removed and was improved with paths, trees and shrubs, drinking fountains, post-and-chain fences and gas lamps. It was then named "Pacific Circle" in recognition of the origin of the investors in the area. By the late 1870s, Pacific Circle had started to be referred to as Dupont Circle, even before its official designation as such in 1882.

A Reversal of Fortune

With the stage now set for rapid real estate development in Dupont Circle, multiple events in 1873 dashed the general upswing in mood about the city's prospects. In February of that year, Congress enacted the Mint Act, which took up the gold standard, demonetizing silver. Western miners labeled this measure the "Crime of '73." The move started a long, slow contraction of the nation's money supply and the so-called Long Depression, which began that year and lasted until 1879.

Gone were the days of huge fortunes being made through silver mining and selling it to a guaranteed purchaser, the federal government. Fortunes made from gold and copper would soon replace those from silver in Washington. William Stewart would spend the rest of his days trying to reestablish the use of silver in backing U.S. currency, ultimately leaving the Republican Party for the Silver Republican party in the 1890s. Curtis Hillyer became an outspoken advocate of bimetallism and "Free Silver" as well.

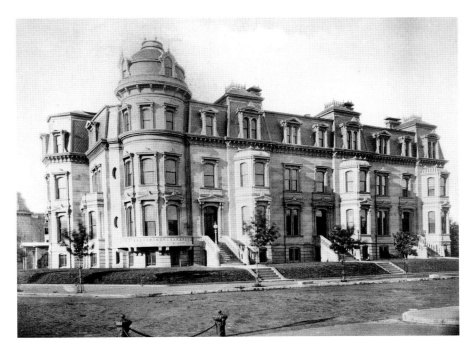

Shepherd's Row once stood at 1701–1705 K Street, across from Farragut Square.
Alexander Shepherd lived at number 1705 (left-most house). *Historical Society of Washington, D.C.*

Yet Alexander Shepherd remained optimistic about the financial future for both himself and the city. As a measure of his faith in the future, he commissioned board of public works architect Adolf Cluss to design three magnificent Second Empire–style homes that would border the north side of Farragut Square at 1701 to 1705 K Street and became known as "Shepherd's Row." With Shepherd's Row, Cluss introduced the concept of terraced row houses with full-height, front-projecting bays, a design element he would use again for the more modest Phillips Row on Connecticut Avenue five years later, thus establishing the dominant architectural vernacular for Washington's middle-class row houses for decades to come.

Shepherd purchased the end house on the corner of K Street and Connecticut Avenue at 1705 K Street. It was the largest of the three and included a great salon that ran the length of the house, a spacious ballroom and a grand staircase. It was ideal for Shepherd's large parties. Real estate pool manager Hallett Kilbourn took the house on the other corner, and Adolf Cluss took the center house for himself.

In September 1873, President Grant appointed Shepherd to succeed Henry Cooke as governor of the territorial government, a move that Shepherd construed as a mandate to continue his citywide improvements. But the halcyon days of the early 1870s were numbered, and Shepherd would only stay in office for another ten months.

Only five days after Shepherd became governor, Jay Cooke & Co. declared bankruptcy, causing a worldwide financial panic. The firm, which had been a principal financier of the government during the Civil War, had invested heavily in the Northern Pacific Railway. But just as Jay Cooke was about to swing a $300 million government loan to launch the railroad in September 1873, reports circulated that the firm's credit had become nearly worthless. When Jay Cooke & Company found itself overextended and unable to sell several million dollars in railway bonds, it was forced to declare bankruptcy.

The failure of Jay Cooke & Co. set off a chain of bank failures. The New York stock market closed for ten days, factories began to lay off workers and the United States began slipping into the Long Depression. Building construction was halted, and real estate values plummeted. Kilbourn and Latta's real estate pool lost its financial underwriter and suddenly found itself with a large amount of land on its hands with no one interested in buying it and no way to finance it. Its holdings decreased in value to the point that they were no longer worth the amount for which they were mortgaged. Thomas Sunderland sold the properties that he held outside the real estate pool to Senator John Alley, who later sold them to Nevada senator and William Stewart's political rival, William Sharon, for a huge profit.

In 1874, the territorial government was abolished and replaced with a presidentially appointed three-member board of commissioners. That year, Alexander Shepherd was investigated by a congressional committee for financial mismanagement during his time as chief of the board of public works. He was not found guilty of any level of corruption but was accused of cronyism and jobbery. In spite of the means by which he may have accomplished it, Shepherd created a new city infrastructure, which ultimately paved the way for the development of the Dupont Circle neighborhood.

Hallett Kilbourn continued to engage in real estate and banking and expanded into the newspaper business, purchasing the *Washington Critic* and the *Republican*, as well as railroads. But by 1898, Kilbourn started to go insane. His family said he had been very depressed for six months by financial troubles, which he had imagined to be worse than they actually were. He made several attempts at suicide. The first attempt was by taking a

mixture of chloroform and morphine. In his second attempt, in full dress suit, he turned on the gas, took about half an ounce of morphine, saturated his clothes with chloroform and wound them tightly about his head and then lay down on the lounge and waited to die. On the third try, he simply attempted to jump from a window of his K Street home. On the advice of close friend Senator William Stewart, his wife and daughter had him committed to St. Elizabeth's Hospital, the District's public psychiatric institution, where he died in 1903 at the age of seventy-two.

3
DEVELOPMENT SLOWLY BEGINS

In spite of the economic setbacks of 1873, development did begin slowly on and around Dupont Circle, led largely by the efforts of William Stewart and Curtis Hillyer. Although Stewart was financially strapped and had to sell out of the real estate syndicate, Hillyer and Sunderland were pressuring him to build in Dupont Circle to encourage property sales and development, and the larger the house Stewart could build, the better.

Stewart contracted board of public works architect Adolf Cluss to design a huge, five-story, Second Empire–style mansion. Where a financially strapped silver miner and modestly paid senator found the money to build such a large and costly home is a mystery. One possibility was Stewart's lucrative involvement in a mining scam. In 1871, Stewart, along with a Wisconsin businessman and with the help of the minister to the United Kingdom, had sold shares in a depleted silver mine in Utah to unsuspecting British investors who poured $5 million into the sham company. In January 1872, Stewart and the other American investors who were in the scam sold their shares for a hefty profit. After a congressional investigation in 1876, no one was ever charged with any crime.

For many years, Stewart's grand house—or Stewart's Castle, as it was known—was the most magnificent private home in the city. But it was often jokingly referred to as "Stewart's Folly" as it was so far away from everything, standing in an open commons in the midst of the former Hopkins brickyard. Yet after the building was completed, land that had been selling for ten cents a square foot was now demanding three to four dollars a square foot. Sadly,

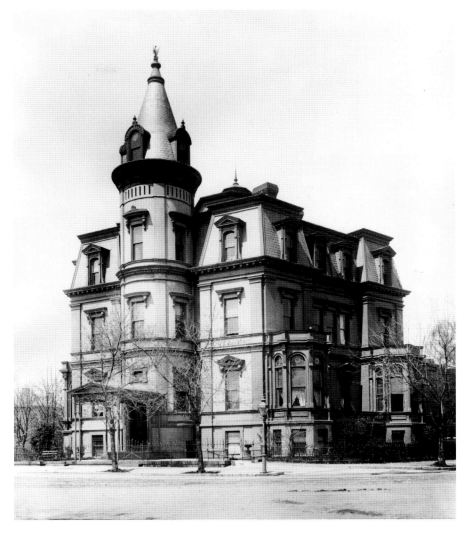

Stewart's Castle. *Library of Congress.*

Stewart was no longer a member of the real estate pool and did not reap the benefits of the soaring real estate prices that the construction of his house had spawned.

Still, the Stewarts reveled in their new castle, which became a center of social activity, and Annie Stewart's large dinner parties were legendary. But their time in their new house was to be short-lived. The costs of lavish

entertaining and the upkeep of the house and large staff proved too costly for a financially ailing senator.

Adding to Stewart's problems was William Sharon. Another miner from Ohio, who at one time was the richest man in California, Sharon wanted Stewart's Senate seat, for which he could and would spare no expense to get.

In 1874, Stewart decided not to stand for reelection. He had only occupied his castle for less than two years before deciding to return to the West Coast to practice law again. The castle would remain closed for four years, occupied only by a couple servants and a watchman. With Stewart out of the political picture, Sharon easily won his Senate seat and served only one term, from 1875 to 1881.

In the summer of 1879, Annie Stewart had had enough of the West Coast and returned to Washington without her husband in hopes of recapturing her former place in society. On New Year's Eve of that year, she headed out to spend the evening with family friends, but she was soon notified that her house was on fire and rushed home to find the upper story in flames. There had been an unseasonably warm winter that year, and the boiler had only recently been turned on to warm the large house. No one had thought to check to see if the system had enough water in it.

The British minister himself, Sir Edward Norton, and other members of the British Legation from down the street were soon on the scene. Sir Edward took Annie Stewart and a companion back to the British Legation building and then returned to the burning house to help rescue valuables and personal belongings. Most of the silver was saved, and the carpets were all safely removed from the first and second floors, as were the gold-finished furniture, oil paintings, large mirrors and lace curtains. But most of the clothing could not be saved.

When it was over, the fire had completely destroyed the upper story of Stewart's Castle and most of the plaster and woodwork in the interior. Stewart hired local architect and builder Robert Isaac Fleming to restore and fireproof the mansion, with many claiming that the rebuilt mansion was handsomer than it had ever been. Fleming would become a prominent architect in the Dupont Circle neighborhood in the 1880s, as well as wealthy and well positioned socially.

In 1886, a year before Stewart returned to Washington as a senator from Nevada, he rented the castle, now referred to as that "grim old building," completely furnished to the Chinese Legation in Washington. The Stewarts found temporary accommodations in a rented house on H Street when they returned.

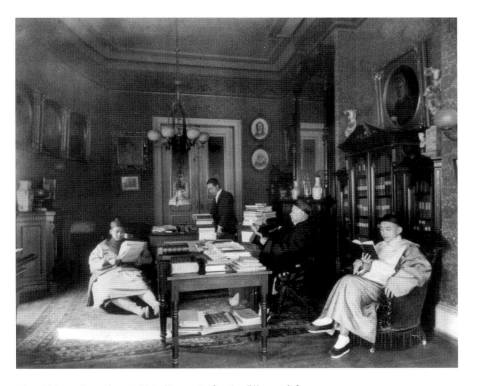

The Chinese Legation staff in Stewart's Castle. *Library of Congress.*

The Chinese Legation had been in Washington since 1878, but it still remained a curiosity to the local population. The domestic staff of the legation would take the laundry to Dupont Circle and lay it out in the grass to dry. Legation staff would be spotted romping around the flower pots in the circle and playing hide and seek in the moonlight. Neighbors had no idea how to react. When the Chinese went out on the balconies of the house for air, crowds would travel from miles around to gather and stare, and the police would have to move them along the sidewalk away from the house.

The Chinese ambassador did entertain occasionally in the house, but more modestly than the Stewarts ever did. In 1885, he gave only two dinners—one for U.S. government officials and the diplomatic corps in Washington and the other for his personal friends at the Chinese New Year. Unlike when the Stewarts occupied the house, there was no dancing; the large ballroom was used for opium smoking and conversation.

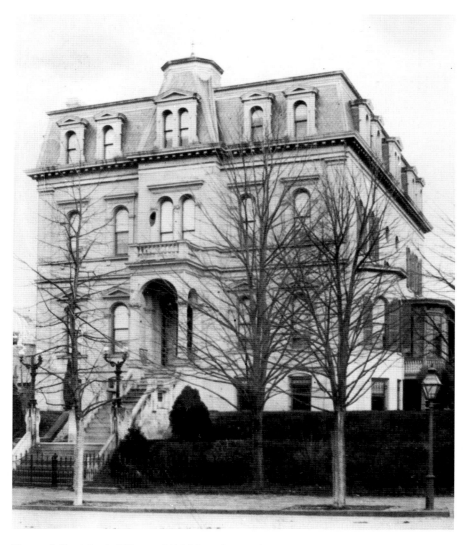

Home of Curtis Justin Hillyer at 2121 Massachusetts Avenue Northwest. *Library of Congress.*

The Chinese Legation stayed in the castle until 1893, and by the time it left, it had done significant damage. Kitchen staff had been cooking fish on the tiled bathroom floors as they were unaccustomed to stoves and ovens. Opium smokers had burned holes in the expensive European furniture. When the ambassador tired of his guests in the evening and wanted them to

leave, he would burn red peppers in the room, which while burning the eyes of the guests, also left heavy smoke stains everywhere.

William Stewart was again reelected to the Senate in 1893 and finally moved back into his castle and lived there quietly for another six years. In 1899, he sold the house to Senator William Clark of Montana at a reported one thousand times the profit of the original cost to construct the house. Stewart finally realized a profit as a result of his early involvement in the real estate pool and his investment in his grand house.

In February 1873, months before the disastrous financial events of that year would unfold, Curtis Hillyer withdrew some land from the real estate pool for himself and obtained a permit for the construction of a new house on the western end of Massachusetts Avenue, where it then terminated at the edge of the city at Florida Avenue.

Hillyer was shielded from much of the financial effects of the Panic of 1873, as he still maintained his successful legal practice on the West Coast. He was able to hold on to all his property in Washington and meet the payments as they became due. He paired with architect Robert Fleming in the early 1880s to develop two neighborhoods on his properties, one of which is Hillyer Place in the Dupont Circle neighborhood, where Hillyer would later retire.

By 1881, Hillyer began suffering from significant hearing loss. He was forced to give up his law practice on the West Coast and decided to reside permanently in Washington. He continued to argue cases before the Supreme Court until his increasing deafness compelled him to stop, and he retired completely from practicing law in 1891.

Hillyer remained in his house at 2121 Massachusetts Avenue until 1898, when he sold it to Mary Scott Townsend, the daughter of a Pennsylvania congressman and railroad and coal magnate. Hillyer then moved to a modest town house next to the Phillips mansion at 1618 Twenty-first Street that he had built in 1884 and that was also designed by Robert Fleming. The house still stands today but has been significantly modified and has been incorporated as part of the Phillips Gallery complex. Hillyer's original house is now part of the Cosmos Club.

The British Are Coming

Although William Stewart and Curtis Hillyer had built their mansions as a statement of the future respectability of the west end, it was not until the

arrival of the British Legation in the southern part of the neighborhood that the area north of Shepherd's Row would begin to be viewed as desirable.

With the increase in the importance of the city, both as the center of the federal government and as a town beginning to reflect an expanding global political and cultural influence, Britain's minister to the United States since 1867, Sir Edward Norton, believed that it was now imperative to have an impressive and permanent legation building in Washington. Up until this time, the British Legation had been leasing a house at 1525 H Street Northwest just to the east of St. John's Episcopal Church on Lafayette Square. The Prussian government had already purchased its own legation building on Fifteenth Street, but a new legation building for the British would be the first foreign investment in new construction in the city.

In May 1873, Matthew Latta sold Sir Edward a large parcel of land on the corner of N Street and Connecticut Avenue that was held by the Pacific Syndicate. The British government paid the astonishingly high price of fifty-five cents a square foot in a still remote and unpopulated area of the city that many considered an unacceptable location for such an important building as the British Legation.

Scottish-born American architect John Fraser from Philadelphia was contracted to build the large Second Empire–style legation building. On Christmas Day 1873, New York's *Illustrated Newspaper* wrote, "Sir Edward Thornton is now building a magnificent mansion in the English style. It…will be, when completed, the most substantial building in Washington." Construction began in late 1873, and the stately building was ready for occupancy early the following summer; however, Sir Edward would not take up residence himself in the new building until 1876. The new legation was often referred to as the "second most famous residence in Washington" and, jokingly, as "1600 Connecticut Avenue."

Topped by a gray slate mansard roof, the entrance to the legation was reached from under an imposing porte-cochère on Connecticut Avenue that was dominated by the British coat of arms. Past the outer vestibule, a second interior vestibule had heavy mahogany doors, the inner ones decorated with heavy bas-relief and brass knobs. When the doors were opened, visitors were greeted by an impressive and imposing staircase with a portrait of Queen Victoria in her coronation robes at the head of the landing.

Yet when it was first built, the new British Legation building did not attract much development along Connecticut Avenue. The city was still under the shadow of the Long Depression, and property values remained depressed. There was little new construction in the city.

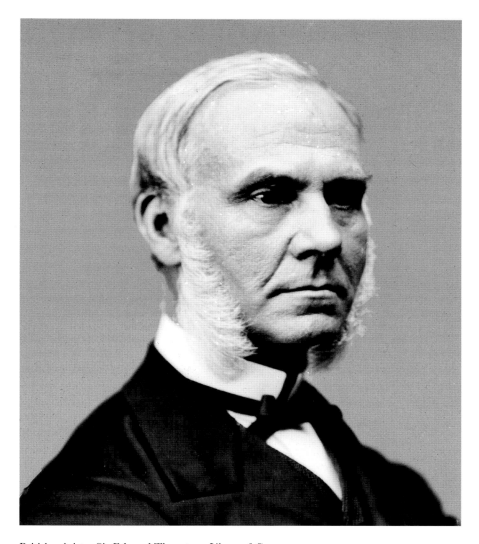

British minister Sir Edward Thornton. *Library of Congress.*

When Sir Edward was appointed as ambassador to St. Petersburg in 1881, many of the household goods that he left behind were sold at a public auction. Crowds poured in early on the day of the auction, not so much to inspect the items before the sale as to see the interior of the mansion. They ended up being very disappointed as all items to be sold were grouped in the ballroom with the entrance only by a side door and

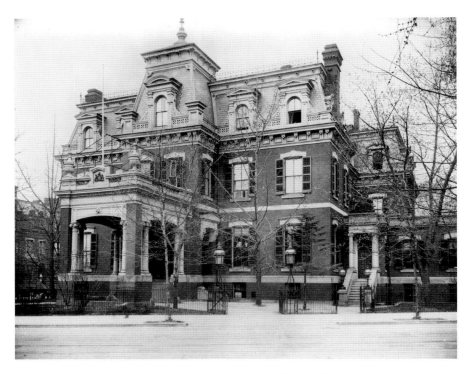

British Legation at 1300 Connecticut Avenue Northwest. *Historical Society of Washington, D.C.*

hall, thus cutting off other ingresses or the potential to wander off to see other parts of the house.

For many years, the British Legation, which would become the first official embassy in Washington, was the epicenter of social life in the neighborhood. Many evenings, the streets near the building were filled with curious crowds who assembled to watch the long line of carriages rolling up to the door and discharging eminent men and women invited to attend one function or another. In 1893, the Infanta Eulalia of Spain and her husband were entertained at the legation. The Prince of Wales was a guest at a formal dinner in 1919. The embassy became a society objective of almost unparalleled rank. To have been a guest there was to have finally been accepted and "approved" as entitled to the highest social consideration. It was even a higher honor to have the British minister or high-ranking legation staff attend one's own social functions.

By 1928, the old British Legation building, along with the other buildings along the southern stretch of Connecticut Avenue, began to yield to the

Lawn party at the British Legation. *Library of Congress.*

pressures of commercial expansion. In 1892, the restaurant Maison Rauscher, sometimes called the "Delmonico's of Washington," opened on the southwest corner of Connecticut Avenue and L Street, and from there began the slow and steady crawl of commercial development up the avenue.

In 1928, British ambassador Sir Esme Howard laid the cornerstone for the new embassy and chancery farther out Massachusetts Avenue. In 1931, when the staff had relocated to the new complex, the wrecking ball took down the old legation building. In a course of less than sixty years, what was once considered the most prime piece of real estate in the city, as well as its social center, became a parking lot.

The Galt Family and a Future First Lady

Even with the depressed real estate market during the 1870s, William Galt, a wealthy local flour merchant, decided that Dupont Circle would still be a good investment and the perfect area to build his own palatial house.

William Galt was born on his father's farm in Carroll County, Maryland, in 1834. He moved to Washington at the age of seventeen and worked in a dry goods house before going into the coal trade with a cousin. In 1861, he married Harriet "Hattie" Turner, and the following year, he established his own flour business in an old government warehouse.

By 1876, William was wealthy enough to purchase a triangular lot on the south side of the circle between Connecticut Avenue and Nineteenth Street and construct a large, three-story French Gothic–style house. In many ways, it rivaled Stewart's Castle across the circle. When Galt's new house at 1328 Connecticut Avenue was complete, the *Evening Star* described it as "not only one of the finest residences in the city, but one of the pleasantest homes." When William and Hattie, along with their seven children, had finally settled into their magnificent new residence, they began to entertain on a large scale. But the Galts only stayed in the house until 1880, when William sold it to Alexander Graham Bell's father-in-law, Gardiner Greene Hubbard. The Galts moved to a house just south of Thomas Circle, where William died in 1889.

William's cousin, Matthew William Galt, married William's sister. Matthew and his brother, also a William, were heirs to Washington's oldest and best-known jewelry store, Galt & Bro. Jewelers.

Matthew's grandfather James Galt was a native of Maryland as well and had moved to Alexandria, Virginia, in 1802 to open a jewelry store. In

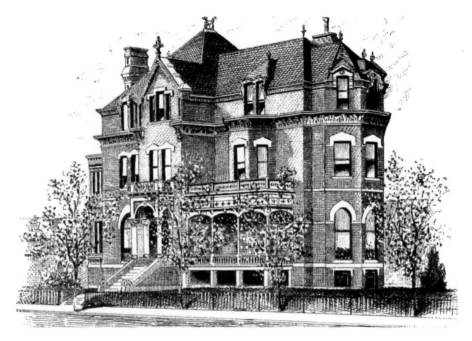

William Galt's house on Dupont Circle at 1328 Connecticut Avenue, circa 1876. *In Hutchins, The National Capital, Past and Present.*

1826, James opened his first store in Washington on Pennsylvania Avenue between Ninth and Tenth Streets. The business became known as Galt & Bro. Jewelers and survived until 2001, when it finally closed its doors after 199 years.

Matthew's thirty-two-year-old son, Norman, met twenty-three-year-old Edmonia "Edith" Bolling while she was in Washington visiting her older sister Gertrude and Gertrude's husband, Alexander Hunter Galt, who was Norman's cousin. Edith was anxious to leave Wytheville, Virginia, where she grew up living in crowded rooms above a storefront. Norman and Edith were married in 1896 and settled into a modest brick town house in the Dupont Circle neighborhood at 1404 Twenty-first Street. A few years later, they moved to a larger house at 1308 Twentieth Street (now demolished). They had one child, who died in infancy in 1903.

Norman Galt died in 1908, and Edith took over the management of the family jewelry business. Seven years later, she met the recently widowed Woodrow Wilson, and after only three months of a secret courtship, they

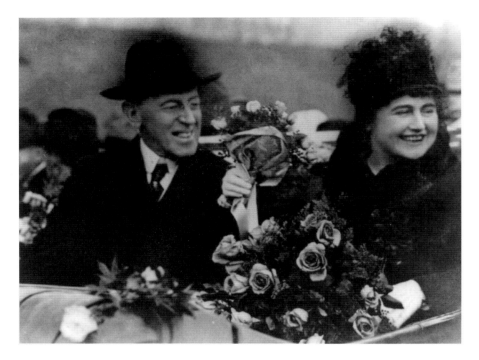

Edith Galt Wilson and President Wilson. *Library of Congress*.

were married in a simple ceremony in her Twentieth Street home. Edith was First Lady until 1921 and died in 1961 at the age of eighty-nine at the Wilson home on S Street.

Phillips Row

By 1878, real estate, the price of building materials and labor costs were at record lows due to economic deflation and were feared to go even lower. But a Washington lawyer, railroad manager and entrepreneur, Samuel Louis Phillips, had faith that the economy was bound for a recovery. Phillips purchased 170 feet of frontage on Connecticut between the British Legation and William Galt's house from Thomas Sunderland.

Hoping to attract investors, Phillips hired architect Adolf Cluss to design a speculative row of town houses on the lots. Cluss designed seven fine four-story brick residences between 1302 and 1314 Connecticut Avenue, with

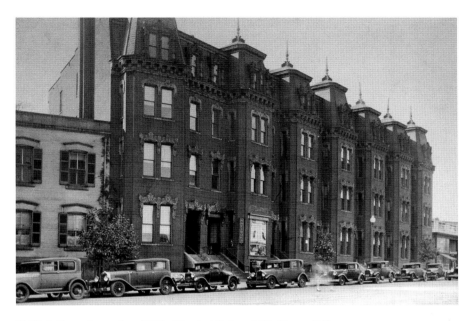

Phillip's Row, photo circa 1920. *Historical Society of Washington, D.C.*

basements, full-height bays with mansard roofs and which included all the latest improvements. When completed, Phillips Row was regarded as one of the finest improvements in Washington at the time. But the real estate market was still depressed, and Phillips could not sell them. So he kept them as rental properties for high-end tenants until the housing market recovered.

Phillips Row always remained as rental properties. In 1914, Phillips began making plans to raze the houses and replace them with seven storefronts with apartments above. He went so far as to rewrite all the leases so they would all expire at the same time so he could secure possession of the properties all at once. But Phillips never realized his new plans for new retail space as he died in 1920. The buildings remained rentals until 1948, when they were demolished.

SAMUEL PERRY "POWHATAN" CARTER

As construction progressed on Phillip's Row, architect Adolf Cluss was also putting the finishing touches on a grand home for Samuel Perry "Powhatan"

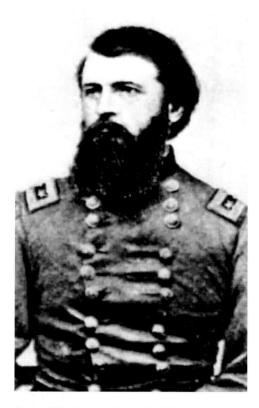

Samuel "Powhatan" Carter. *In Miller and Lanier,*
The Photographic History of the Civil War.

Carter and his wife on the lot immediately to the north of Phillips Row at 1316 Connecticut Avenue. Carter was the first of Washington's military social set to build in the Dupont Circle neighborhood. A distinguished military leader, he was the only person to have served as both an admiral in the U.S. Navy and a general in the U.S. Army.

Carter was born in upper East Tennessee in the Appalachian Mountains in 1819. The Carters were one of the wealthiest families in that part of the state during the early 1800s, having accumulated large land holdings and operating several iron forges.

Samuel attended Washington College in Limestone, Tennessee, and then Princeton University. He graduated from the U.S. Naval Academy in Annapolis, Maryland, in 1846. His brilliant military career included tours of duty with the Pacific and Brazil Squadrons, serving aboard the USS *San Jacinto* of the Asiatic Squadron, which participated in the bombardment of the Barrier Forts in the Pearl River in Canton, China, during the Second Opium War. He also commanded the side-wheel gunboat the USS *Monocacy* in the Asiatic Squadron. Between postings, Carter would teach mathematics at the Naval Academy.

At the outbreak of the Civil War, Carter was assigned to the War Department to organize a regiment of Union sympathizers in East Tennessee. It was then that he adopted the code name "Powhatan" that he used when communicating secretly with Union sympathizers behind enemy lines.

At the age of fifty-eight, Carter married Martha "Markie" Custis Williams. Markie was a great-granddaughter of Martha Custis Washington, the granddaughter of Thomas and Martha Custis Peter (the builders of

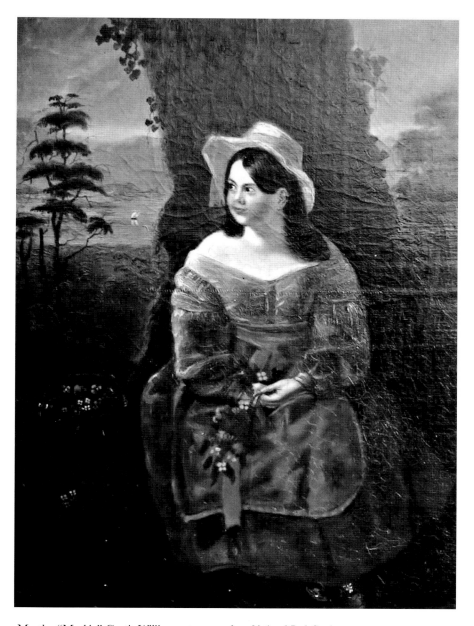

Martha "Markie" Custis Williams at age twelve. *National Park Service.*

Tudor Place in Georgetown) and a distant cousin, friend and confidante to General Robert E. Lee.

Markie was born at the Peters' home, Tudor Place, in Georgetown in 1827. The Peter family had strong Southern sympathies and was very supportive of their cousins the Lees just across the Potomac River at Arlington House, now the site of Arlington National Cemetery.

Markie was a favorite cousin of the Lee family and moved to the Lees' Arlington House to help care for the elderly George Washington Parke Custis, Robert E. Lee's father-in-law, after the death of his wife in 1853. Although an ardent Unionist herself, Markie remained very close to the Lees throughout the Civil War and to the end of her life, corresponding with Robert E. Lee for twenty-six years from 1844 to just before his death in 1870. On the eve of the Civil War, Lee, while still a colonel in the U.S. Army, wrote to Markie: "God alone can save us from our folly, selfishness & short sightedness...I only see that a fearful calamity is upon us, & fear that the country will pass through for its sins a fiery ordeal."

One of Markie's brothers, William Orton Williams, along with a cousin, was hanged as a spy by the Union army in 1863, outraging the Custis family as well as the president of the Confederacy, Jefferson Davis. Their bodies were later reinterred in the Oak Hill Cemetery in Georgetown.

After retiring from the military in 1882, Carter spent his remaining days in his Connecticut Avenue house, where he died in 1891. Markie died in 1899 at her modest town house on Q Street, just a few blocks from the Connecticut Avenue house, and was buried in Oak Hill Cemetery along with her husband and her brother.

The Rescuer of the Greely Expedition

The year 1879 saw the arrival of another new significant military resident on Connecticut Avenue, William Hemsley Emory Jr. Unlike the members of the military set who followed their Republican generals to Washington after the Civil War, Emory was young and had not served in the war, having only graduated from the Naval Academy in 1866 at the age of twenty. He also represented the old Washington social order of the Cave Dwellers, coming from one of the old, wealthy southern Democrat military families as well as the next wave of Washington socialites who would transform Dupont Circle in the 1880s—he came with money and a lot of it.

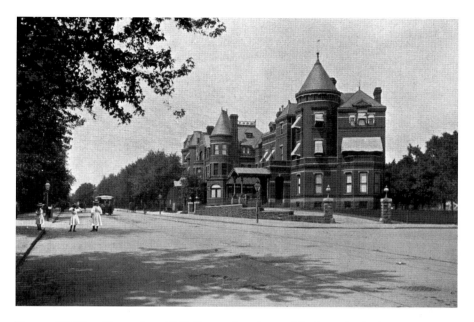

Home of William Emory Jr. at 1301 Connecticut Avenue Northwest in the foreground. The home of David Levy Yulee at 1305 Connecticut Avenue Northwest stands behind to the left. *Historical Society of Washington, D.C.*

Emory was from one of the wealthiest families on Maryland's Eastern Shore. The Emorys owned a vast tobacco and wheat plantation, Poplar Grove, which has been held continuously by the family for over three hundred years.

In 1879, the thirty-three-year-old Emory, then a navy lieutenant, contracted the architectural firm of Smithmeyer and Pelz (which later would design the Library of Congress's Jefferson Building) to design a house for him, his wife and their daughters across the street from the British Legation at the intersection of Connecticut Avenue and Nineteenth Street at 1301 Connecticut Avenue. But due to the demands of his naval career, he and his family lived there for only short periods of time between assignments until Emory finally retired as a rear admiral in 1909.

One of Emory's more noteworthy assignments during his naval career was commanding the USS *Bear*, one of three rescue ships sent in search of the survivors of the Greely Expedition. The Greely Expedition had set out to the Arctic in 1881 to collect scientific information in the Lady

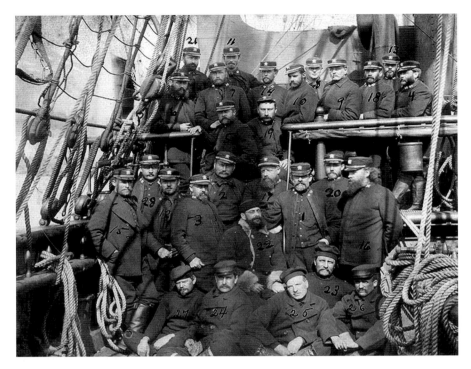

The six survivors of the U.S. Army's Greely Arctic expedition (seated) with their U.S. Navy rescuers in Upernavik, Greenland, in July 1884. William Emory is labeled #2 in the photo. *U.S. Navy.*

Franklin Bay region and became stranded, cut off from food and supplies. On June 22, 1884, less than two months after his departure, Emory sighted the survivors of the expedition, who for months had been existing on moss, leather sledding equipment and whatever small game they could find. By the time they were discovered, most had died or gone mad from deprivation. The six that survived resembled skeletons. The surgeon accompanying the expedition had committed suicide.

During most of his active career, Emory was stationed away from Washington and leased out the house on Connecticut Avenue. At one point, he rented it to Representative John Glover of Missouri, who would later marry Augusta Patten, one of the Patten sisters who dominated society from their home on Massachusetts Avenue. He then rented the house to naval colleague and friend Lieutenant Richardson Clover, who would later build his own house on New Hampshire Avenue.

In 1908, after several years of absence, Mrs. Emory returned to Washington while her husband was in command of the USS *California*. The following year, William Emory retired with the rank of rear admiral and joined his family on Connecticut Avenue. They spent the summer seasons at their home in Roslyn on Long Island that adjoined the Whitney estate.

One of Emory's daughters, Blanche, did not look too far or too long for a husband. Within a year of the family's return to Washington, she met and married Esmond Ovey, a third secretary at the British Legation just across the street. Ovey himself had only arrived in Washington from Paris the year before.

The ceremony was held in the house and attended by only a small company of family relatives, the British ambassador and his wife and members of the British Embassy staff and their families. The reception and breakfast that followed included Washington's diplomatic core, as well as many Dupont Circle neighbors. The month they were married, Ovey was promoted to second secretary and later went on to become one of Britain's outstanding diplomats, serving as ambassador to Mexico, Brazil, the Soviet Union, Belgium and Argentina.

After the marriage of Blanche to Esmond Ovey, the Emorys left the Connecticut Avenue house, leasing it to Mrs. John Jackson, who was also hosting the Swedish Legation there. Proximity again proved key in a marriage to the diplomatic core in Washington. Mrs. Jackson's daughter, Laura Wolcott Jackson, married August Ekengren, the Swedish secretary and counsellor who would later become the Swedish minister, who was living in the house at the time.

The southern part of Connecticut Avenue at this time was quickly becoming known as the "foreign quarter," with the Swedish Legation taking possession of the Emory house, the British Embassy just across the street and the Austro-Hungarian Legation at 1305 Connecticut Avenue in the former home of Senator David Levy Yulee.

Hoping to capitalize on the commercial expansion making its way slowly north along Connecticut Avenue, Emory attempted to sell his house in 1912 to a developer who planned to remodel it into stores and offices, but the deal fell through. Mrs. Jackson remained in the house until 1916, when it was demolished in order to erect the seven-story flatiron building that stands on the site today. Part of the new building became home to the D.C. Chapter of the American Red Cross where many Dupont Circle women volunteered for the war effort.

Esmond Ovey skating in Washington. *Library of Congress.*

4

THE FASHIONABLE WEST END

The election of President James Garfield in 1880 produced a local boom in real estate and more new construction occurred in Dupont Circle during this decade than in any other. Dupont Circle started to attract a number of wealthy politicians, more members of the military, as well as the idle and nouveau riche of the post–Civil War era.

By early 1880, Washington was growing in preeminence as a social center and was often referred to as the "Winter Saratoga." Dupont Circle became recognized as the center of the best houses in the city, and as a result, real estate prices began rising quickly as house lots in the vicinity started to become scarce. Those who were well off enough and desired to live in or near the new social center began constructing row houses along the quiet streets around Dupont Circle. By 1889, almost every architect in the city was busy trying to meet the demand for higher-end middle-class housing in the neighborhood.

While the Dupont Circle neighborhood was not an option for most in Washington as a place to live in the 1880s, it was still a place to see and be seen regardless of social rank or income. The *Washington Post* said of Connecticut Avenue at the time that it "is to the Capital what Fifth Avenue is to New York City for promenade purposes." Sunday afternoons saw a tide of humanity casually strolling from H Street up to Stewart's Castle—and they were not just the wealthy, but people from all walks of life and all parts of the city. A lucky stroller might catch a coveted glimpse of the Chinese outside Stewart's Castle or the British ambassador reading his daily paper seated on a bench in Dupont Circle.

Still, at this time, there was barely any commerce in the neighborhood to meet the needs of its residents. Tibbett's grocery store was located two blocks away at the intersection of Massachusetts Avenue and Seventeenth Street and offered cut meats and vegetables. Directly on the circle and opposite Stewart Castle was Thompson's Drug Store. It advertised itself as "the place for west end people to buy drugs, fine perfumes, sponges, toilet requisites, etc. as the prices are as low as downtown." One of its most popular products was "Wine of Coca," a "nervine," tonic and appetizer.

ARCHITECTS OF THE WEST END

Starting with Adolf Cluss and John Fraser in the 1870s, certain architects began playing an increasingly important role in the development of the neighborhood. The services of these architects would be sought after for not only their skill but also their reputations as builders for the wealthy.

Two architectural teams were prominent in designing homes in Dupont Circle beginning in the 1880s. The first was the firm of Gray & Page. W. Bruce Gray joined Harvey Page as a junior partner in 1879, and together they designed many of the finer Victorian-era residences in the Dupont Circle area. Harvey Page was noted for his unique and handsome homes, each with their own individual architectural twists. The team designed the first and only set of row houses immediately on Dupont Circle at numbers 1 through 4 in 1881.

Gray broke off his partnership with Page in 1885 and continued to practice on his own. While much of Gray's work has been demolished, some examples of his row house designs remain, along with perhaps the most notable survivor, the 1885 Richardsonian Revival–style home of Samuel Bryan at 2025 Massachusetts Avenue. Gray quickly took to the Beaux Arts style when it arrived in Washington in force at the beginning of the next decade, submitting a Beaux Arts–style design in the competition for the new Corcoran Gallery of Art in 1892.

Unlike his former partner, Harvey Page did not make the transition to the Beaux Arts style in the following decades, essentially closing him out of high-paying commissions. When George Hearst wanted to retrofit John Field's Colonial Revival–style house in the older Richardsonian Romanesque Revival style, he chose Harvey Page. For one of his last commissions in Washington, Page finally embraced a newer style with the 1892 Arts and

Crafts–style home for Sarah Whittemore on New Hampshire Avenue. In 1897, Page left Washington for Chicago, the home of the Chicago Arts and Crafts Society and the Chicago School, and eventually ended up in San Antonio, Texas, designing homes in the newly popular Spanish Mission style.

The architectural firm of Hornblower and Marshall also began designing residences for wealthy Washingtonians in the 1880s and became one of the city's most accomplished and leading architectural firms over the span of twenty years. Joseph Hornblower studied in an atelier of the *École des Beaux-Arts* in Paris, and in 1883, he joined with partner James Rush Marshall. Their early work was related to the English Arts and Crafts movement, but after 1893 and with the impetus of the World's Columbian Exposition, their work (like that of many other architects) turned to the Beaux Arts style's more classical motifs that were beginning to overtake Washington's tastes. The firm's more notable buildings in the Beaux Arts style include the U.S. Custom House in Baltimore, Maryland, and the National Museum Building for the Smithsonian Institution in Washington (now the National Museum of Natural History), as well as the home for Woodward and Lothrop department store founder Alvin Lothrop on Connecticut Avenue. After Joseph Hornblower's death in 1908, the firm was unable to compete with architect Jules Henri de Sibour, who by now was easily snatching up the commissions for most of the large residential projects in Dupont Circle.

THE HUBBARD AND BELL FAMILY EMPIRE

Gardiner Greene Hubbard was one of the most ambitious and driven businessmen and residents whom the Dupont Circle has ever seen. A lawyer by training, he was the patriarch of both the Hubbard and Bell families, the father of the Bell Telephone Company, the founder of the National Geographic Society and a real estate speculator.

Hubbard moved to Washington from Cambridge, Massachusetts, in 1873 to lobby for the nationalization of the telegraph system and for the legislation that was named for him, the Hubbard bill. In order to break Western Union's monopoly on telegraphic communications, Hubbard needed patents on breakthrough communication technologies that he then planned on offering to the government, such as the capability of sending multiple messages simultaneously on a single telegraph wire.

Gardiner Greene Hubbard. *Library of Congress*.

While Hubbard was busy lobbying in Washington, an unknown Canadian inventor and speech therapist, Alexander Graham Bell, was working at the Massachusetts Institute of Technology conducting experiments in acoustics on a device that could translate sound vibrations into visible written marks. At this time, Bell also had two private students, six-year-old George, the son of Hubbard's business partner, Thomas Sanders, and Hubbard's fifteen-year-old daughter, Mabel, with whom Bell fell in love. Hubbard and Sanders provided financial backing for Bell's development of the acoustic telegraph, the technology that ultimately led to the invention of the telephone.

Early in 1876, Hubbard filed a patent application for Alexander Graham Bell for the telephone, which was granted three weeks later. Three days after that, Bell uttered the famous words to his assistant, "Mr. Watson, come here. I want you."

Hubbard abandoned his idea of giving new technologies to the government to defeat Western Union's stronghold on telegraphic communications—he now had in his possession a revolutionary new device that would make the telegraph obsolete and him a very wealthy man.

In 1877, Hubbard, Bell, Thomas Sanders and Bell's assistant, Thomas Watson, together formed the Bell Telephone Company, taking its name from its inventor. Hubbard became its president and Sanders the treasurer. Because Bell did not have much of a feel for business, he took the position of chief electrician, an advisory role that left his time free for research into the causes of deafness. In the summer of that year, Alexander and Hubbard's daughter Mabel were married.

As its president, Hubbard was the public face of the new Bell Telephone Company. Mark Twain once wrote to Hubbard at his Connecticut Avenue home complaining about the telephone service in Hartford, Connecticut, blaming Alexander Bell for his troubles. Twain claimed that it was the worst service on the face of the earth and that they even charged for night service "in their cold calm way, just the same as if they [actually] furnished it." He continued, "And if you try to curse through the telephone, they shut you off. It is this ostentatious holiness that gravels me...as you see yourself, the inventor is responsible for all this."

In 1880, Hubbard realized that he needed his chief electrician close by, and his daughter even closer. That year, he bought the Galt house on Dupont Circle for himself and architect John Fraser's newly completed home for John Brodhead only a few blocks away at 1500 Rhode Island Avenue for Bell and his family. Bell set up his first Washington laboratory in a rented house on L Street near Thomas Circle and, a year later, moved

it to 1221 Connecticut Avenue, just a block to the south of his father-in-law's house.

Once in his new house on Rhode Island Avenue, Bell built the city's first electric burglar system with an elaborate system of wires and bells that connected every door and window in the house to a room he referred to as the "central office." Indicators in the central office would show instantly whenever a door was opened or shut or only partially opened. If anyone tried to enter the house at night, bells would sound. This caused Marguerite Cassini no end of grief when her father rented the house for the Russian Legation a few years later, allowing him to know when she was sneaking in and out of the house, often forcing her to crawl out a second-story window to go unnoticed by the alarm system. The house stands today and is the headquarters of the American Coatings Association.

Alexander's cousin, Charles "Charlie" Bell, made the move to Washington in 1880 as well, not only for business purposes, but also to follow his heart. Charles first saw a portrait of his future wife, Roberta Hubbard, Mabel's spirited and mischievous younger sister, when Alexander was passing around photos of the Hubbard family at a family dinner in Canada, and Charles was immediately smitten. Charles announced that he might ask for a vacation from his bank job to visit his cousin in Washington. Five years later, Charlie moved to Washington to become secretary of the new Bell Telephone Company. The move also put him in proximity to Roberta, as he undoubtedly had planned. But while Roberta took an instant shine to Charles as well, her father did not. Hubbard reacted to the news that the two young people had fallen in love by ordering Charles out of the house. However, after Charles had set up branches of the Bell Telephone Company for Hubbard in Europe, Hubbard recognized that Charlie was a man after his own heart who possessed the business acumen Alexander did not, and he finally gave his permission for the two to marry. Unfortunately, Roberta died in childbirth in 1885, and two years later, Charles married another Hubbard daughter, Grace.

In 1891, Alexander and Charles Bell, not only cousins but also now both sons-in-law of Hubbard, both built houses next to each other and just across the street from Hubbard. Alexander built at 1331 and Charles at 1325 Connecticut Avenue.

In 1903, Alexander hired architects George Oakley Totten and Laussat R. Rogers to design an addition to his Connecticut Avenue home. This new wing contained an art gallery that housed Bell's large collection of etchings, a theater that sometimes was also used as a projection room for movies and a fifteen- by thirty-five foot and seven-foot-deep indoor swimming pool.

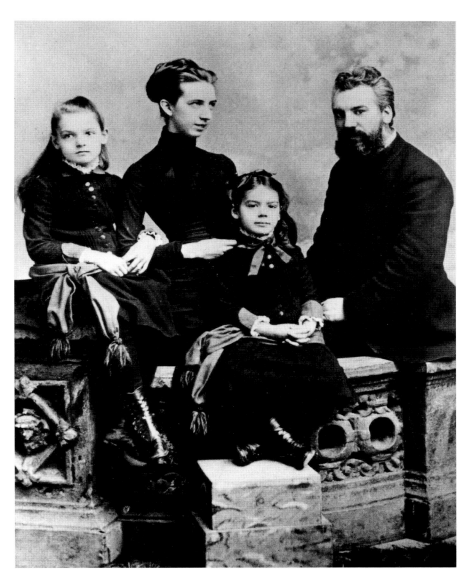

Alexander Graham Bell with his wife, Mabel, and their daughters, Elsie (left) and Marian (center). *Library of Congress.*

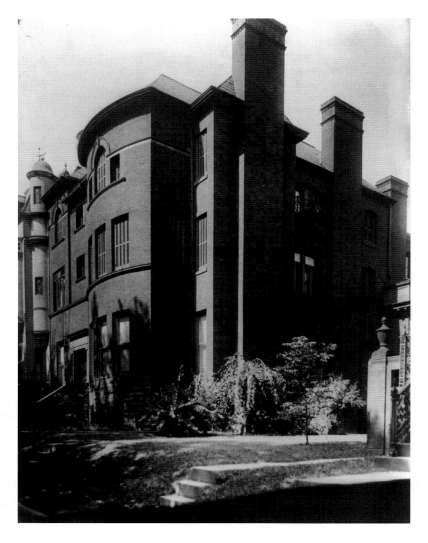

Alexander Graham Bell's house at 1331 Connecticut Avenue Northwest. *Library of Congress.*

Bell once developed a theory that a sealed floor was essential to keeping a room cool in the summer. To test this theory, he drained his swimming pool and set up the bottom of the pool as a study with an easy chair, a couch, a table and books. He then built a large icebox in another room with pipes leading from it to the ceiling of the next room, through which the chilled air from the icebox was blown. The cooled air

would gradually settle down into the body of the swimming pool where it remained cool. Bell had no interest in patenting his discovery and said anyone was free to try it for himself. The experiment was undoubtedly never duplicated as it required an empty indoor swimming pool and two hundred pounds of ice a day.

Bell was the epitome of the absentminded professor, often absorbed in thought about his latest experiments. In her biography *Never a Dull Moment*, Marguerite Cassini fondly recalled the white-haired man with a noble face who once let her use the telephone in his house. She noted that to the amusement of his neighbors, Bell's telephone always seemed to be out of order.

Along with his father-in-law, Charles Bell co-founded the National Geographic Society and served as its first treasurer. While Hubbard had conceived of the society, Charles did all the legwork to make sure the association was formed. He secured the society's current property on Sixteenth Street and contracted the architectural firm of Hornblower and Marshall to design its new headquarters building, which was named Hubbard Hall after its founder and is where the National Geographic Society remains to this day. Hubbard became its first president, and Charles remained a member of the society's board until his own death in 1929.

Hubbard died at the family summer home Twin Oaks in Washington's Cleveland Park neighborhood in 1897, and his funeral was held at the Church of the Covenant in Dupont Circle. Former secretary of state and Dupont Circle neighbor, John Watson Foster, served as an honorary pallbearer for Hubbard's funeral. The actual pallbearers were the sixteen officers of the board of the National Geographic Society.

In 1907, Hubbard's widow sold the house on Dupont Circle to a Kentucky whiskey distiller, Edson Bradley, and moved to Twin Oaks. Twin Oaks would remain the Bell family summer compound until 1947, when it was sold to the Republic of China. It is now owned by the government of Taiwan and is used for official receptions.

After Hubbard's death, Alexander Graham Bell became the second president of the National Geographic Society, but he resigned to spend more time on his "kite flying machine" or box kites that were flown both unmanned and manned. This led to the formation of Bell's company, the Aerial Experiment Association, which created several early aircraft designs.

Both of Alexander Graham Bell's two daughters, Elsie and Marian "Daisy," stayed very close to home after they married. In 1901, Elsie married Gilbert Hovey Grosvenor, a third cousin of President Taft, and moved just

Charles Bell, Alexander Graham Bell's cousin as well as his brother-in-law. *Courtesy of Library of Congress*.

across the backyard from her father to 1328 Eighteenth Street. Bell had hired Grosvenor as the first full-time employee of the National Geographic Society in 1899. In his fifty-five years at the society, Grosvenor grew the organization from just a concept to a full-fledged association. He launched and served as the first full-time editor of *National Geographic* magazine and is considered the father of modern photojournalism.

Alexander Graham Bell's other daughter, Daisy, married David Grandison Fairchild in 1905 and moved across the street from her sister to 1331 Eighteenth Street. David Fairchild was a botanist with the U.S. Department of Agriculture in Washington, D.C., and also served as a member of the board of trustees of the National Geographic Society. The house still stands today and is now a condominium building.

In 1910, one of Charles Bell's two daughters, Grace, married U.S. Army major Granville Fortescue, who was a cousin of Theodore Roosevelt and served under him as a Rough Rider in Cuba. But Grace is probably best remembered for her involvement in what came to be known as the Massie affair and trials. In 1932, Grace, along with her son-in-law, Thomas Massie, and two navy enlisted men, was charged and convicted of manslaughter in Hawaii for the murder of one of the suspects in the alleged rape of her daughter. When her daughter's rape trial ended in a mistrial, Grace decided to take justice into her own hands. She arranged for the kidnapping and beating of one of the defendants and then talked her son-in-law into kidnapping another one of the defendants, who was eventually shot to death. Clarence Darrow accepted a fee of $40,000 to serve as their defense attorney even though he knew that they were guilty. Darrow obtained a commuted sentence from ten years to just one hour based on his argument that the murder could be considered an "honor killing."

Mary Gage Confronts a Dark Force

Charles Bell's peaceful life in Dupont Circle was ruffled some years later when Mary Gage, a widow from New Jersey, moved to Washington with her daughter in 1906 and purchased the house at 4 Dupont Circle.

For Mary Gage—who believed that in order to achieve social acceptance, it was necessary to have a wide circle of acquaintances—standing into Washington society was everything. She claimed she could trace her lineage to several royal families of Europe and published her genealogy in a pamphlet

entitled "The Colonial Ancestors and Royal Descent of Mrs. Harlan Calvin Gage," which she then sent around to Washington's society women hoping for invitations, but none ever came. Upon her arrival in Washington, she also founded the National Society of Colonial Daughters of America and declared herself its president for life.

Mary had overextended herself financially in purchasing the Dupont Circle house. Much of the annual fees of members of her society went to help pay her mortgage. Her daughter claimed that they were led to buy the house by a realtor who assured them that owning a house in the neighborhood would ensure their entry into high society. After a while, when they felt they had not entered society, they complained to the police about the realtor's empty promise, to no result.

Mary's mental state continued to decline, and she began to believe that someone or something had been working against her for seven or eight years to thwart her social aspirations. She once called the police claiming that there was a mysterious person at the door. She then claimed that a "dark force" had entered her home and had interfered with her telephone service. By 1912, that dark force became personified in a neighbor, Charles Bell. Mary then started telling people that she was going to "horsewhip" him. Bell claimed that he was not really acquainted with Mrs. Gage, having only met her once at a function two years prior.

Almost every day, friends of Charlie Bell would stop him in the street to inform him that Mrs. Gage had told them that she was going to horsewhip him. He had initially ignored these reports, but when he told his wife about them, she convinced him to go the police and file a complaint. When taken into police headquarters, Mary Gage threatened to also horsewhip the questioning inspector if he did not desist. Her daughter confirmed that the pair had indeed been excluded from social functions in the capital and that her mother was a victim of "a social Black Hand, a mafia that is as vicious as an Italian one." Mary Gage told police that Mr. Bell had gone to many of her friends and persuaded them to exclude the Gages from their invitation lists, therefore keeping them from many social functions to which they would have otherwise been invited. She claimed that she was told this by a friend, Mrs. Archibald Gracie, who also said to her about her daughter, "It's a shame to keep that girl in Washington, as she can never get into society." This supposedly led to Mrs. Gage's paranoia. A search went out for Mrs. Gracie, who, when located, denied having said anything of the kind. Mary was then committed to St. Elizabeth's Hospital, the government hospital for the insane.

A jury was paneled to determine Mary's mental health and the trial became a high-profile social event, held before curious throngs of men and women, many of whom were members of Washington's most exclusive social circles. Mary was ultimately judged to be sane, but as soon as the jury's verdict was read, she was charged with making dangerous threats to Charles Bell. She quickly entered a plea of guilty and was fined $300.

COLONEL BELDON NOBLE

Unlike Gardiner Greene Hubbard, who had moved to Washington for business pursuits, Colonel Beldon Noble made the move from Essex, New York, to Washington in order to become part of Washington's burgeoning social society. In 1880, he built what was undoubtedly the largest private home in the city at the time at 1785 Massachusetts Avenue. For Noble, architects W. Bruce Gray and Harvey Page designed one of the city's best examples of High Victorian Gothic architecture. *Harper's* magazine described it as "perhaps the best illustration in the city of what may be accomplished in massiveness and the ornament in brick, without superficial adornment. It is thirteenth-century Gothic in its general effect."

Belden Noble was born in 1810, a son of the War of 1812 veteran General Ransom Noble. Ransom Noble had started a tannery and lumber and iron business in Essex, New York, in 1800 and later went into banking, becoming a very wealthy man. Belden and a brother followed him into the businesses and eventually took them over.

As a boy, Beldon was interested in military affairs and acquired the nickname "colonel." Not much is known of Beldon's life in Washington, having moved to the city at the advanced age of seventy. And only seven years after his house was completed, he drowned in New York State, survived by his wife, Adeline; son William; and daughter Mary Maud.

The Nobles' son, William, enrolled in a private school in Nice, France, after which he attended the University of Florida, the University of California and Princeton University, before finally graduating from Harvard magna cum laude in 1885.

In 1887, William married a young woman from the neighborhood, Nannie Yulee, who was the daughter of Senator Yulee of Florida. The next year, the couple left Washington so that William could attend the Episcopal Theological School in Cambridge, Massachusetts, in preparation for the

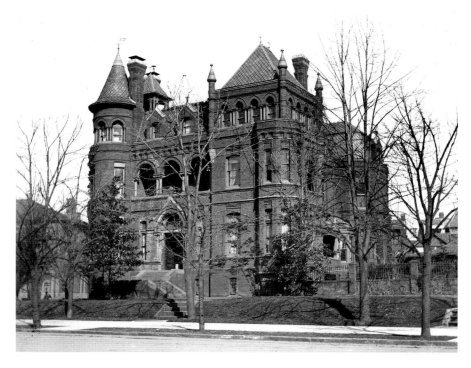

Beldon Noble house at 1785 Massachusetts Avenue Northwest. *Library of Congress.*

ministry, but he was forced to leave after two years due to ill health. He and Nannie lived in the house on Massachusetts Avenue off and on thereafter. William died in 1896, and in his memory Nannie created and endowed the William Belden Noble Lecture Series at the Harvard Divinity School that still continues today. Notable lecturers over the years have included theologian Henry Churchill King, Theodore Roosevelt, Eugene McCarthy and the Archbishop of Canterbury.

In 1897, the Noble house was leased to the Spanish Legation, which later moved to 1521 New Hampshire Avenue. In 1906, the Beldons' daughter, Mary Maud, and William's widow, Nannie, sold the house to Stanley McCormick of Chicago, whose wife, Katharine, would replace it with the McCormick Apartment Building in 1915.

The Wise Sisters

A unique set of twin houses was built by the husbands of two sisters, Charlotte and Katherine Wise, on Dupont Circle in 1880. One house fronted on Connecticut Avenue at number 1347 and the other on Massachusetts Avenue at number 1826. Each of the houses' three levels shared balconies facing Dupont Circle, with a large iron door separating the two houses, allowing them to be joined as one when desired. These houses may have been built with the intention that the two sisters could remain close to each other, but they ultimately only lived in the adjoining houses together for two years.

The architect of the twin houses was New York–based architect J. Cleaveland Cady, who is probably best known for designing the original Metropolitan Opera House in New York City, as well as the rusticated Richardsonian Romanesque Revival–style entrance to the American Museum of Natural History. He would also design the structurally flawed Church of the Covenant just south of the circle on Connecticut Avenue a few years later.

Charlotte and Katherine were the daughters of the U.S.-Mexican and Civil War veteran Commodore Henry Augustus Wise and granddaughters of Massachusetts governor, congressman, senator and ambassador to the United Kingdom, Edward Everett. Charlotte was born in 1852 and Katherine only a year later, in 1853. Both sisters would marry military men.

Katherine Wise was the first to marry in 1874 to naval officer Jacob William Miller. Miller, the son of Senator Jacob W. Miller from New Jersey, was born in Middletown, New Jersey, in 1847 and graduated from the U.S. Naval Academy in 1867.

In 1882, only two years after the houses were completed, Miller returned to sea on the USS *Jamestown*, the last sail-powered man-of-war ever to sail from San Francisco to New York around Cape Horn. Miller then resigned his commission and left for Kansas, where he served as vice-president and general manager of various railroad and steamship companies. The Millers ultimately ended up in New York, where William reentered the navy during the Spanish-American War.

In 1887, Owen Aldis from Chicago bought the Millers' house and moved his father, Judge Asa Owen Aldis; his mother; and his unmarried sister into the house. Owen Aldis had been managing properties in Chicago for the Boston developer Peter Brooks. Aldis was very successful in convincing his clients to take advantage of the newly invented hydraulic elevator to build taller

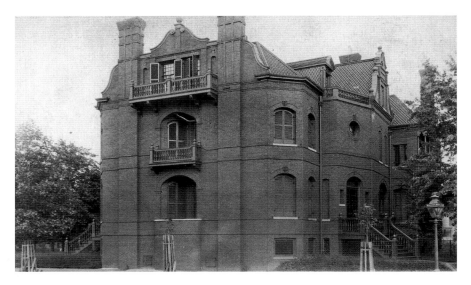

Hopkins and Miller houses on Dupont Circle. *Historical Society of Washington, D.C.*

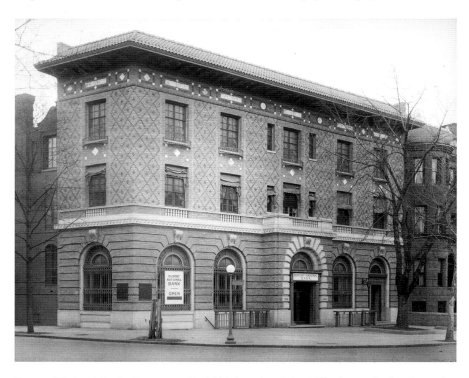

Dupont National Bank. Constructed in 1912, it replaced the Miller house. In the photo, the Hopkins house is still standing to the left. *Library of Congress.*

buildings and then in recommending the architects for the job. His partnership with Brooks resulted in some of Chicago's notable buildings, including the Montauk, Monadnock, Rookery and Pontiac Buildings, designed by Daniel Burnham and John Root. Louis Sullivan named Aldis, along with Chicago architect John Root, as the one responsible for the modern office building. By 1902, more than one-fifth of Chicago's office space was produced and managed by Aldis & Company.

In 1907, Owen Aldis hired the architectural firm of Hornblower and Marshall to build a three-story addition onto the rear of his home for his extensive library of 6,600 first editions of American authors, the largest and most comprehensive collection of its kind. Only four years later, Aldis began making plans to leave Washington and donated his entire library to Yale University, where it became the Yale Collection of American Literature.

In 1912, Aldis married Mademoiselle Madeleine du Mas, the daughter of the Countess du Mas. After the wedding, he sold the Dupont Circle house to the U.S. Trust Company and spent the rest of his life in Europe. The U.S. Trust Company had the house surgically severed from its mate, the Hopkins house, and torn down to construct the Dupont National Bank building that was one of architect Jules Henry de Sibour's industrial buildings. The bank building still stands on the site today, but its fine brick detailing has been painted over.

In 1878, the other Wise sister, Charlotte, married a friend of Ulysses S. Grant, Colonel Archibald Hopkins. Hopkins was the son of Dr. Mark Hopkins, once the president of Williams College and a distinguished American educator. Archibald attended Williams College himself. During the Civil War, he served as a full colonel of the Thirty-seventh Massachusetts volunteers. He never dropped the title of "colonel."

After the war, and having served as a government officer under the Reconstruction Acts, Hopkins went on to Columbia Law School. Upon returning to Washington, he was appointed clerk at the Court of Claims. He was considered one of the best lawyers in the city in his day. He was very active in the affairs of the city and an active opponent of the conversion of residential property for commercial use, as well as urban noise pollution, in Dupont Circle. He was also among those who put up the money for the new parish hall that was the start of St. Thomas' Parish on Eighteenth Street after it had to vacate the old Holy Cross Episcopal Church on Dupont Circle.

Charlotte Hopkins took to her causes with unparalleled dedication. She served as president of the Washington Home for Incurables for thirty-four years, the first facility in the city to admit people with cancer, which was believed at that time to be highly contagious. Charlotte, along with Dupont

Circle neighbors Mabel Boardman and Isabel Anderson, was also very active in the early days of the American Red Cross and volunteered at the Red Cross office at 1301 Connecticut Avenue on the site of the former Emory mansion. She fought tirelessly to eliminate alley slums in Washington, and in 1933, the eighty-two-year-old Charlotte took the new First Lady, Eleanor Roosevelt, on an exploration through Washington's back alleys and worst slums, driving her own blue roadster.

While charitable by nature, Charlotte exhibited a certain level of naiveté prevalent in her social class. She once gave a lecture with the message that women could solve high cost-of-living problems themselves simply by practicing more economy and conservatism in their dress.

The Force School and the "White House Gang"

Every neighborhood needed a public school, and the Dupont Circle area was no exception. In 1880, the twelve-room Force Elementary School was erected on the south side of Massachusetts Avenue between Seventeenth and Eighteenth Streets and was named for renowned soldier, journalist, politician and book collector Peter Force. Its distinguished alumni included the sons of Presidents Theodore Roosevelt and William Howard Taft and aviator Charles Lindbergh.

A descendant of French Huguenots, Force was born near the Passaic Falls in New Jersey in 1790 and grew up in New Paltz in Ulster County, New York. He afterward moved to New York City and learned the printing trade. During the War of 1812, Force served in the army as a lieutenant. Three years after the war, Force moved to Washington, D.C., and served as editor of the *National Journal* until 1841. A member of the Whig Party, he served as a city councilman and alderman and was elected mayor of Washington twice.

Force assembled what was probably the largest private collection of printed and manuscript sources on American history in the United States. The year before he died, in 1867, his library was purchased by an act of Congress for $100,000 and is still called the Peter Force Library.

The Force School's district covered a wide swath from I Street and Pennsylvania Avenue to Corcoran Street and from Fourteenth Street to Rock Creek. By 1896, the school had six hundred students enrolled. Perhaps

Force School at 1740 Massachusetts Avenue Northwest. *Historical Society of Washington, D.C.*

due to the large number of children enrolled, the school was never very popular with its neighbors on Massachusetts Avenue. School buildings were generally considered a detriment to adjoining properties, especially in the finer residential sections of the city. Neighbors complained it was impossible to keep the children from running over lawns, leaving the area in shabby condition. A playground was later added to the rear of the school, which helped to appease some of the neighbors. Other schools in the neighborhood would follow, including the Fairmont Junior College and Preparatory School for Girls that moved into the old Beriah Wilkins home at 1711 Massachusetts Avenue.

One neighbor who was not so easily appeased by the playground was Senator Henry Cabot Lodge. In 1896, Lodge, who lived across the street from the school at 1765 Massachusetts Avenue, introduced an amendment to the District appropriation bill to transfer the school to another section of the city and sell the land for fashionable residences. The action was pushed vigorously by supportive neighbors. But the bill was strongly opposed by the District commissioners and was defeated.

Lodge must have eventually come to terms with the school in his neighborhood, as it was later attended by Archie and Quentin, the sons of

his closest friend, Theodore Roosevelt. Archie attended the Force School in 1902 for a year but was withdrawn to study with a private tutor and later attended Sidwell Friends School. Quentin was enrolled in the Force School the next year and remained there until 1908 when he started attending Episcopal High School in Alexandria. Theodore wanted the boys to experience public school for a period of time, as he said it was the true school of democracy.

William Howard Taft's son, Charles Phelps Taft II, or "Charlie," was the same age as Quentin and was a close friend and classmate at the Force School when his father was serving as the secretary of war under Theodore Roosevelt. He was then sent to private school when the Tafts moved to the White House.

Led by Quentin, Charlie and a number of other boys from the Force School formed a group that Theodore Roosevelt dubbed the "White House Gang." The gang would hold its meetings in the attic of the White House every day after school let out. President Roosevelt, an honorary gang member, often would cut meetings short to join the boys for hide and seek, historical reenactments and other games. The gang basically had free reign over the entire White House, until the day when the president discovered that the boys had been shooting spitballs at the presidential portraits. The president gave them a serious talking to and banished the gang from the White House for a week.

Archie, Quentin and Charlie Taft all served in World War I. Quentin was shot down behind German lines in France and was the only student of the school to die during the war. On Armistice Day in 1919, the graduating class planted a tree in the schoolyard in his honor.

Charles Lindbergh attended Force School as well as the Sidwell Friends School while he was living in Washington with his father, Minnesota congressman Charles Lindbergh Sr. In 1911, eight-year-old Count Guy de Buisseret, the son of former Belgian minister to Washington and at the time minister to the imperial court in St. Petersburg, Russia, was sent back to D.C. to attend Force School.

The building was abandoned as a school in 1939, and after that, it became home to a series of organizations. Force School was razed in 1962 to make way for the Johns Hopkins University School of Advanced Studies. The Quentin Roosevelt memorial tree was razed along with the building.

JAMES GILLESPIE BLAINE

In 1881, ground was broken for James Gillespie Blaine's new mansion on Massachusetts Avenue one block to the west of Dupont Circle and on the site of the former Hopkins Brickyard.

Blaine had first come to Washington as a freshman congressman from Maine in 1862 and quickly emerged as a rising star in the Republican Party. Blaine was an enthusiastic debater and outspoken politician and became known by various epithets, including "the Continental Liar from the State of Maine," "Slippery Jim" and "the Magnetic Man." Blaine became Speaker of the House for three terms between 1869 and 1874.

Blaine was elected to the Senate in 1876 and, that same year, also sought his party's nomination for president. But the "Mulligan Letters" scandal, which implicated Blaine in accepting bribes from the Union Pacific Railroad, cost him the nomination.

During the 1880 presidential election, Blaine again sought the Republican nomination, which ultimately went to James Garfield. After Garfield won the general election, he offered Blaine the position of secretary of state, and Blaine resigned his Senate seat in 1881 to take it.

Probably feeling quite secure in his new position as secretary of state, Blaine commissioned Philadelphia architect John Fraser to design what he described as "a square, old-fashioned house." The massive red brick, Queen Anne/Second Empire–style house at 2000 Massachusetts Avenue still stands today. When completed, it had more rooms than Fraser's earlier British Legation building.

But the Blaines did not live in their new house very long. Blaine's fortunes changed suddenly in September 1881, when while strolling through the Sixth Street B&O Railroad station with President Garfield, Garfield was struck by an assassin's bullet and later died. Blaine lasted only three months as secretary of state in the Chester Arthur administration. The grand house was never used for lavish entertaining as Blaine had planned. After less than two years in the house, the Blaines moved to the newly purchased and renovated Seward house on Lafayette Square and, in 1883, rented the mansion to a relatively unknown family from Chicago, the Leiters, who were soon to change the face of Washington society.

After losing his presidential nomination bid in 1884 to Grover Cleveland, Blaine was absent from Washington political life, traveling and lecturing, but he returned in 1889 to serve again as secretary of state under Benjamin Harrison and to live once more in the Seward house on Lafayette

James Gillespie Blaine. *Library of Congress*.

Opposite: Blaine mansion at 2000 Massachusetts Avenue Northwest. *Library of Congress*.

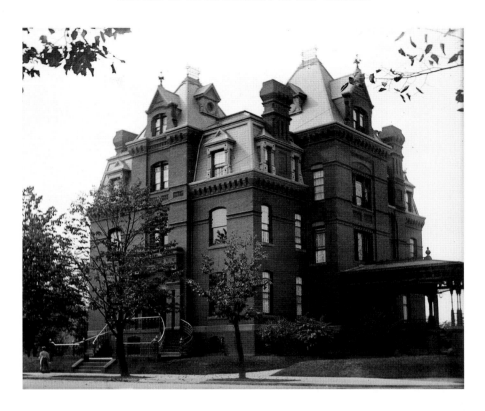

Square. Blaine's health had been continuously deteriorating since his return to Washington, and he died in January 1893. His funeral was held in the neighborhood Church of the Covenant. In 1901, Blaine's widow, Harriet, sold the Massachusetts Avenue house to George Westinghouse, the inventor of the railway air brake.

CHARLES VAN WYCK

The year 1881 was a busy one for architect John Fraser. In addition to James Blaine's house, he was also building a large house for Senator Charles Van Wyck of Nebraska on the other side of Dupont Circle at 1800 Massachusetts Avenue. Little is known about Charles Van Wyck's personal life or his ancestry, except that he had inherited a sizeable amount of money and was quite eccentric. Never very concerned about his personal appearance, Van

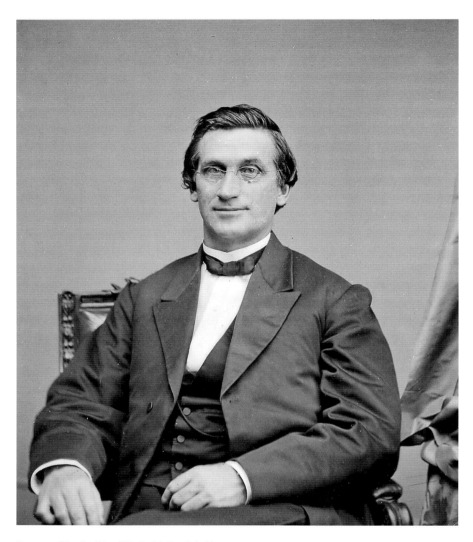

Senator Charles Van Wyck. *National Archives*.

Opposite: Senator Van Wyck's house at 1800 Massachusetts Avenue Northwest. *Historical Society of Washington, D.C.*

Wyck would not have been mistaken as someone with wealth. His clothes were baggy, his collar was often awry and his black string neckties were often caught around his ears. His enemies called him "Crazy Horse" on account of his jerky speech and gestures.

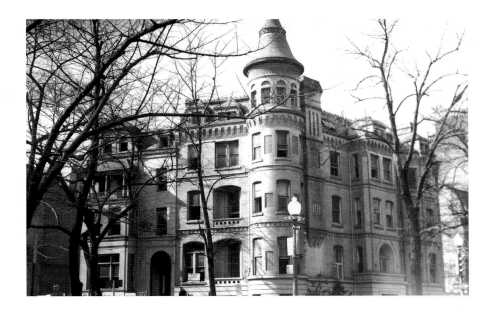

Van Wyck first came to Washington when he was elected to Congress as a Republican from New York, serving two terms from 1859 to 1863. During his first term in Congress, Van Wyck delivered a harsh and widely reported antislavery speech on the House floor in which he denounced the Southern states for slavery. A year later, and on the same night as an attempt was made to assassinate president-elect Lincoln in Baltimore, Maryland, Van Wyck was attacked near the U.S. Capitol building by three men in an assassination attempt, reportedly in response to the speech. Van Wyck fought off the attack, surviving only because a copy of congressional records that he kept in the breast pocket of his coat had blocked the blade of a Bowie knife from going into his heart. The three men fled and were never identified.

After his second term in Congress ended, Van Wyck entered the Union army as colonel of the Fifty-sixth Regiment, New York. He was the idol of his men. His purse was always open to his soldiers, and he would write letters home for those in his regiment who could not write themselves, as well as pay for the postage. Van Wyck went on to serve in the Army of the Potomac during the Peninsula Campaign and was wounded at the Battle of Fair Oaks in Virginia. He left the army as a brevetted brigadier general. After the war, Van Wyck returned to Congress and served two more terms until 1871.

Van Wyck then moved to Nebraska and took up farming, but he could not stay away from politics for very long. After serving as a delegate to the Nebraska

Holy Cross Episcopal Church on Dupont Circle. *Library of Congress.*

constitutional convention in 1875, he was elected to the state senate. In 1881, Van Wyck returned to Washington as a Republican senator from Nebraska. In the Senate, Van Wyck specialized in attacks on local businesses and corporations and the wrongs suffered by the population at the hands of public franchises. He fought hard against street railways and gas companies, attempting to cap gas prices. After an unsuccessful run as a Populist candidate for governor of Nebraska in 1892, Van Wyck retired from politics and returned to Washington.

The Holy Cross Episcopal Church that once sat on a triangular lot on Dupont Circle across from Van Wyck's house had been in financial trouble for a long time. The wealthy around Dupont Circle at that time tended to be Presbyterian, and the Church of the Covenant was just one block south of the circle. No longer able to stay afloat, the parish put the church up for auction; Van Wyck bought it and presented it to his wife, Kate, as a "little after-dinner favor."

One day, Van Wyck astonished the fashionable Dupont Circle neighborhood by suddenly moving his family into the deserted church while repairs were being done on his Massachusetts Avenue house. Due to increasing illness, Van Wyck had developed a fear of climbing stairs and thought

The Van Wycks relaxing on the steps of Holy Cross Episcopal Church. *From the* Evening Star, *1895.*

it would be better to live on a single floor. He initially divided the sanctuary by imaginary lines into parlor, bedrooms, dining room and a picture gallery that later became real walls and rooms. Van Wyck would often be seen sitting on the lawn in front of the church in his shirt sleeves, smoking a cob pipe and nodding to those passing by.

Charles Van Wyck died of a stroke in 1895, and a year later, Kate Van Wyck sold the church and its lot on Dupont Circle to Herbert Wadsworth from New York City. Fortunately for the neighborhood's Episcopalian population, Calvary Parish had formed and built its own parish hall on Church Street just three years before and would complete the construction of its new St. Thomas' Parish on Eighteenth Street in 1899.

A CONFEDERATE CONGRESSMAN AND FIRST JEWISH SENATOR

The decades immediately following the Civil War in the northern and midwestern Republican-dominated city were not totally free of former Confederates. One was railroad tycoon and former Florida senator David Levy Yulee retired with his wife to Washington, D.C., in 1880. Three years later, Yulee built a house for himself directly across from the British Legation at 1305 Connecticut Avenue.

David Levy Yulee was born David Levy in 1810 in Charlotte Amalie, U.S. Virgin Islands. Levy later officially changed his name to David Levy Yulee by adding his father's Sephardic surname.

In 1846, Yulee married Nannie Wickliffe, the daughter of Charles Wickliffe, a former governor of Kentucky and postmaster general under President John Tyler. Nannie was Christian, and the Yulees raised their children as Christians as well.

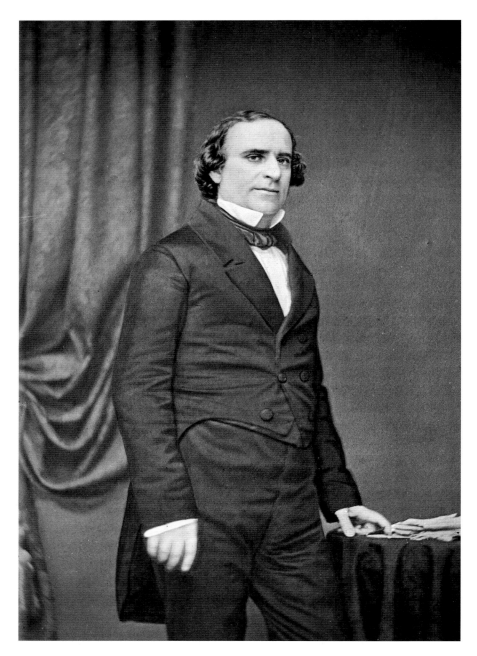

David Levy Yulee. *Library of Congress.*

Yulee began his political career as a territorial delegate to Congress from Florida in 1841. After Florida was admitted as a state in 1845, he was elected as a Democrat to the U.S. Senate, serving as its first Jewish member. Yulee was defeated for reelection in 1850.

Elected to the Senate again in 1855, Yulee served until January 21, 1861. A vigorous supporter of slavery and secession, he resigned his Senate seat after Florida seceded from the Union and served as a member of the Confederate Congress during the Civil War. In 1865, Yulee was imprisoned in Fort Pulaski in Georgia for nine months for participating in the Confederate government.

Returning to Florida after his prison term, Yulee founded the Florida Railroad Company and served as president of several other railroads as well, earning the nickname "Father of Florida Railroads." The Yulees' daughter Nannie married William Noble, the son of Beldon Noble, who had built his house on Massachusetts Avenue in 1880.

Yulee died in 1886, only six years after his house was completed. The house later became the Austro-Hungarian Embassy and was torn down in 1922 for stores that were slowly making their way up Connecticut Avenue. The last Austro-Hungarian ambassador who occupied the house tried everything in his power to keep both the Emory and Yulee mansions from being torn down for the flatiron building that was ultimately built on the site. He even enlisted the aid of Sir Cecil Spring-Rice, the British ambassador, to help get an injunction against tearing the house down.

A TARNISHED SABER:
GENERAL NICKERSON'S TWO WIVES

In 1883, Civil War veteran General Azor Nickerson bought a town house at 7 Dupont Circle. Nickerson, as it turned out, was married three times and once to two women at the same time. The result was one of the most sensational divorce cases that ever occurred in army circles, as well as in the Dupont Circle neighborhood, where divorce was frowned upon.

Azor Nickerson was born in 1837 in Litchfield, Medina County, Ohio, and was studying law when the Civil War broke out. He volunteered with the Eighth Ohio infantry regiment and was promoted to the rank of second lieutenant. He then was promoted to captain, leading his company in the Battles of Antietam and Gettysburg and being wounded in both battles.

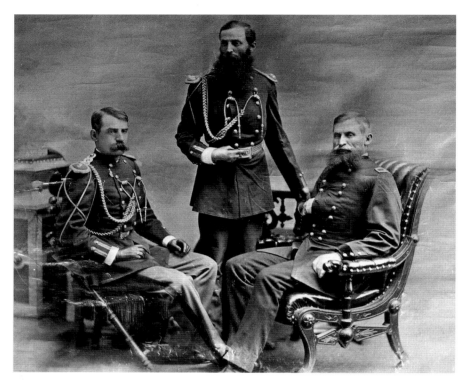

Captain J.C. Bourke, Adjutant General Azor H. Nickerson (center) and General George Crook, circa 1880. *Sharlot Hall Museum.*

After the Battle of Gettysburg, Nickerson was nursed back to health in the house of a Quaker family near the battlefield. When he recovered, he married his first wife, Ella Nora Riegal, the daughter of the family. After the war, Ella went with him to the western frontier, where she died a few months later. Nickerson then married his second wife, Emma Cecilia Derby, in San Francisco in 1870. President Rutherford B. Hayes, an old friend of Nickerson from Ohio, appointed him, now a major, as assistant adjutant general of the army in Washington, D.C. He and Emma moved to Washington and into a rented house near Logan Circle.

After arriving in Washington, Nickerson fell in love with Lena Diller Carter, his wife's twenty-four-year-old dressmaker. He then talked his wife into going to Europe with their daughter to obtain medical treatment for herself and to enroll the daughter in school there, suggesting that it would be cheaper than in Washington and would save them some money. Nickerson

wrote to his wife consistently for two years, kept sending her money and discouraged her from returning home. He also convinced Emma to sign over her rights to the deeds to lots of land they owned in Portland, Oregon, as well as in Washington, under the pretense of using the proceeds from the sale to purchase a house of their own. Nickerson then bought the house at 7 Dupont Circle and moved all of Emma's belongings from the rented house on Rhode Island Avenue to the new one.

Next, Nickerson filed for and was granted a divorce from Emma in Pennsylvania on the grounds of abandonment, claiming that she refused to return from Europe. He insisted that Lena marry him immediately, before her family could find out and whose disapproval of her marrying a divorcé might deter the marriage.

At this point, Nickerson had stopped writing to Emma altogether, and she started to get concerned. One day, she received an urgent telegram from her mother informing her about the divorce and urging her to return to Washington at once. When Nickerson learned that his wife was returning home, he had the title to the Dupont Circle house transferred into Lena's name.

Emma filed to annul the divorce in a Philadelphia court, and the details of Nickerson's philandering were openly aired, tarnishing what was otherwise a bright military record. The divorce was annulled, and papers were issued for the immediate arrest of Major Nickerson in preparation for his court-martial for obtaining a fraudulent divorce and conduct unbecoming an officer and a gentleman.

With the annulment in her hands, Emma then filed for divorce, alleging adultery. At this point, it was suddenly realized that Nickerson was missing. Robert Todd Lincoln, then secretary of war, hired the famous Pinkerton Detective Agency to track Nickerson down. The Dupont Circle house was put under surveillance, and Lena's comings and goings were watched closely. All mail sent to the house was intercepted and read. The Pinkerton Agency finally tracked Nickerson down in a small mill town in Ontario, Canada, and Lincoln signed a warrant for his arrest, assuming that Nickerson could easily be lured back over the border. This proved not to be the case.

Divorce proceedings dragged on, and in 1887, Emma Nickerson was finally granted a divorce on the grounds of adultery and cruelty. The next year, Nickerson once again married Lena Carter in Niagara Falls, and the couple remained in Canada until the end of 1890, when they returned to Washington and took up residence with Lena's mother.

For the remainder of his days, Nickerson fought to have his name restored to the rolls of retired army officers. That finally occurred the week of his

death in 1910, when Congress passed a bill restoring his commission. When he died, he was the last surviving person who had sat on the platform when President Lincoln delivered the Gettysburg Address. He is buried in Arlington National Cemetery.

Admiral Du Pont: Not Such a Great Statue

In 1881, James Blaine had started complaining about the poor condition of Pacific Circle and was pushing to have it cleaned up. The park had fallen into generally bad condition, with concrete walks needing to be replaced and the lawn to be re-sodded. The fence around the park needed replacing, and the open area was in need of trees and flowers. Also, Blaine thought that the circle could benefit from a fountain or statue of some sort. He actually suggested moving the Bartholdi fountain from the Capitol grounds to the circle, claiming it had attracted a lot of attention at the Centennial Exposition in Philadelphia but hardly any since its arrival in Washington. But the assassination of President Garfield distracted Blaine from his improvement project for the circle.

In 1883, Congress appropriated $13,700 for a bronze statue of Admiral Samuel Francis Du Pont to be designed by Irish-born sculptor Lount Thompson of Philadelphia. Many residents in the city were opposed to yet another statue of a Civil War hero. There were already statues of Generals George Henry Thomas and Winfield Scott, Major General James McPherson, Admiral David Farragut and General John Rawlins occupying public parks and traffic circles. These military statues were becoming monotonous, but Congress wanted to continue reminding the citizens of a once southern-dominated city that the North had won the war.

No one was certain why, if there had to be another military statue, it should of Admiral Du Pont—few actually knew who he was. And Du Pont did not have what one might consider a particularly stellar military career. In 1863, his attack on Charleston failed dramatically. He was relieved of command and died dejected in 1865. One outraged citizen wrote to the *Washington Post* suggesting that there should be a picture posted around the area so people would know if the statue actually looked like its subject and then suggested that a fountain, even if it had no water, would be better option than a statue of Du Pont.

The unveiling of Du Pont's statue, which finally had been erected on a raised mound in the center of the circle, occurred on a cold, wintery

Admiral Samuel Francis Du Pont statue in Dupont Circle. *Library of Congress.*

afternoon on December 20, 1884. Sophie Du Pont, who was both the widow and a first cousin of the admiral, was not able to attend the unveiling.

The crowd was not as large as expected but still numbered around 2,500. Attended by President Chester Arthur, the ceremony consisted of the marine band and an opening prayer by the rector of St. John's

Episcopal Church, the unveiling of the statue by Secretary Chandler and a speech by Senator Bayard elaborating Du Pont's brilliant military exploits. The ceremony was capped off with a rear admiral's thirteen-gun salute. The circle was then officially rechristened as Du Pont Circle (the name soon to be contracted to Dupont).

In addition to being another unwanted military statue, it was considered ugly, even by the Du Pont family. Mississippi congressman John Williams, who was orphaned as a result of the Civil War and not a fan of Union generals, tried to pass a joint resolution in Congress authorizing the removal of the statue from the circle and the erection a more suitable memorial to be paid for by the Du Pont family. But the statue would remain until 1922, when it was finally replaced by the Du Pont family with the present fountain.

MARGUERITE LAMMOT DU PONT

The same year that the statue of Admiral Du Pont arrived in his namesake circle, so did the first member of the Du Pont family, twenty-two-year-old Marguerite Lammot Du Pont Lee. Marguerite's father had been the resident manager of the Du Pont family powder mill near Wilmington, Delaware. Both of Marguerite's parents died in 1877—her mother while she was in an insane asylum and her father from consumption, aggravated by exposure from working in the powder mills.

The sudden death of both parents left five orphans alone in their big house. After the second funeral, their uncle Alfred Du Pont went to the house to tell the children that the family council had decided to split them up among their relatives. When he arrived, he found them well armed and ready to defend their home: seventeen-year-old Anna brandished an axe; Marguerite, then fifteen, a rolling pin; Alfred, age thirteen, a shotgun; Maurice, age eleven, a pistol; and nine-year-old Louis, a bow and arrow. Uncle Alfred was impressed, and the children remained in the house.

After a grand tour of Europe, Marguerite married a cousin (now a Du Pont tradition), Cazenove Gardner Lee, in 1881. Three years later, the couple decided to move to Dupont Circle. Although from the wealthy Du Pont family, they hired architects Gray & Page to build a relatively modest (by Dupont Circle standards), three-story row house below Dupont Circle at 1321 New Hampshire. Once in Washington, Marguerite devoted herself

Marguerite Lammont Du Pont Lee. *Hagley Museum.*

to various charities for the poor and to endless correspondence with editors, clergymen and public authorities on women's rights.

When Cazenove Lee died in 1912, Marguerite, age fifty, sold their residence on New Hampshire Avenue and built a settlement house in the

slums of old Georgetown. The settlement house was home to a kindergarten, a boys' club that later became the Washington Boys Club and various classes for the mothers of the neighborhood. Marguerite became an aggressive campaigner for women's rights, as did many other Washington society women, and marched in the great Washington parade for women's suffrage in 1913.

After ten years in Georgetown, Marguerite turned her settlement house over to the Salvation Army and retired to a suite in the Powhatan Hotel located near the White House. From there, she continued her private charities and her correspondence, but she also found time to indulge her interest in psychic phenomena, becoming a spiritualist and pursuing the science of spirit photography. She believed not only that she could obtain likenesses and written messages from departed friends on a camera plate but also, by strapping the plates around her head, that she could secure what she believed to be pictures of her brain as well. Marguerite's book, *Virginia Ghosts*, has been reprinted many times since it was originally written.

The Ubiquitous Miss Pattens

In 1885, Anastasia Patten, the Irish-born widow of Edmund Patten, one of the successful pioneer miners of "Gold Hill," Nevada, decided to make the move to Washington. After Edmund Patten died in 1872 of typhoid, Anastasia took her five daughters Augusta, Mary, Josephine, Edythe and Helen "Nellie" to Europe for eight years. Upon their return from abroad, she came to Washington to introduce her now sophisticated and Continental daughters to society.

Anastasia bought several house lots from William Sharon a block west of the circle and across the street from family friend from Nevada, Curtis Hillyer, and contracted architect Robert Fleming to build a house. When it was completed, the house at 2122 Massachusetts Avenue had cost Anastasia Patten more than $70,000 to build. Even though she was quite rich, Anastasia was also known to be very frugal and sued Fleming for overcharging her $30,000 on the construction of the house.

The Patten sisters knew everybody in society and went everywhere, no two of them ever attending the same event to ensure that one Patten would be at every social gathering. The sisters seemed to be interchangeable socially,

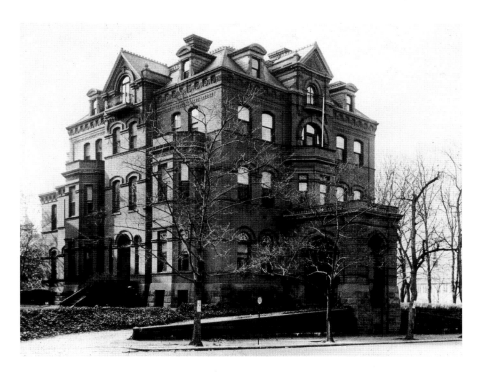

The Patten home at 2122 Massachusetts Avenue Northwest. *Historical Society of Washington, D.C.*

with society pages daily listing the events attended by "Miss Patten," but rarely, if ever, knowing or feeling compelled to say which one.

Only two of the daughters, Augusta and Edythe, would ever marry. Augusta was the first to wed in 1887 to Missouri representative John Glover, and the newlyweds moved into the Massachusetts Avenue house with the rest of the sisters. But the death of the Pattens' mother, Anastasia, in 1888 caused a serious breach between Augusta and her sisters that was never mended. John Glover and Augusta sued the other sisters for Augusta's share of her mother's inheritance. But the sisters claimed that Augusta already received her share when Anastasia gave Glover $100,000. Glover argued that it was simply a marriage gift and should not represent his wife's share of the estate. The Glovers were then asked to move out of the house. The legal battles went on for years and ended only when the sisters agreed to pay Augusta $25,000 each for her to relinquish any further claims on their mother's estate, but this by no means was equivalent to the amount she was due to originally inherit.

Edythe Patten Corbin. *Library of Congress.*

The Glovers eventually found themselves in New York, where John then retired from official life.

The Patten house came to be known as the "Irish Embassy" or the "Irish Castle" because of the sisters' devout Irish nature and devotion to Catholicism. They had a private chapel in the house built where priests would come to celebrate Mass for the sisters.

Sunday afternoon teas at the Patten home were the talk of the town, especially with the diplomatic set to whom the sisters catered. Jules Cambon, the French ambassador, referred to the remaining sisters in the house as "Quatre Pattes"—the four legs.

In 1901, Edythe Patten, a wealthy woman in her own right with a pending $700,000 inheritance, married Civil War veteran Major General Henry Clarke Corbin. He was a fifty-nine-year-old widower with three children, and Edythe was only twenty-eight. According to the mother's will, she could not get possession of her inheritance without the consent of her three sisters, which they gave. Five years prior to this engagement, Edythe had been engaged to another gentleman; however, even with the wedding date already announced, her sisters did not give their consent, and the engagement was broken off.

Widely covered by the press across the country, Edythe's Catholic wedding ceremony was officiated by Cardinal Gibbons in the elaborately decorated drawing room in the Pattens' home. The three other sisters were Edythe's only family present. The wedding guests included President Roosevelt, his daughter Alice, representatives of the official and diplomatic corps and resident society. After Corbin retired from military service, the couple moved to their newly built house at 1701 Twenty-second Street Northwest and spent the weekends at Highwood, Corbin's country house in Chevy Chase. They had one daughter, Edythe, who became a prominent member of the next generation of young Washington socialites.

Edythe's independence from her sisters was to be short-lived. Henry Corbin died in 1909, and Edythe leased out both the downtown and the Chevy Chase houses and moved back in with her three sisters on Massachusetts Avenue.

THE REVEREND JOHN ABEL ASPINWALL AND ST. THOMAS' PARISH

In 1882, architect W. Bruce Gray designed a house on the south of Dupont Circle between New Hampshire Avenue and Nineteenth Street for A.M. Gibson. The building was a large, oddly shaped, fifteen-room house located at 17 Dupont Circle. Gibson had originally come to Washington in 1872 as correspondent for the *New York Sun*. Both an investigative reporter and a lawyer, Gibson had a particular interest in Republican scandals.

At the time Gibson's house was completed, he was serving as a special assistant attorney for the Star Route investigations, in which U.S. postal officials had received bribes in exchange for awarding postal delivery contracts in southern and western states. Gibson was appointed the prosecutor for the trial of two men charged with defrauding the government. It was later disclosed that Gibson himself had accepted a bribe of $2,500 from a Star Route contractor and was removed from the case.

In 1886, Gibson sold the Dupont Circle house to a wealthy clergyman, Reverend John Abel Aspinwall. Aspinwall was the son of William Aspinwall, who was once president of the Pacific Mail Steamship Company and had built the Panama Railroad across Panama. Due to poor health, Aspinwall resigned as the rector of a church in Bay Ridge, Long Island, where he had been serving as rector for twenty-one years. After a three-year rest, Aspinwall came to Washington to live and became active in the formation of St. Thomas' Parish on Eighteenth Street, as well as served as its first rector.

St. Thomas' Parish had originally started meeting in 1890 with a mere handful of people as Calvary Parish, worshipping in the old Holy Cross Episcopal Church on Dupont Circle. In 1892, the congregation relocated to a parish hall that was designed by architect Thomas Franklin "T.F." Schneider on Church Street (then Monroe Street). By the following year, the congregation had become so large that Philadelphia architect Theophilus P. Chandler, who had just designed Levi Leiter's mansion on Dupont Circle, was contracted to design a large Gothic-style church next to the parish hall on the corner of Eighteenth and Church Streets. The cornerstone was laid in 1894, and that year, the parish changed its name to St. Thomas to match that of its new church. Construction was completed five years later, when the church formally opened.

Reverend Aspinwall resigned as the church's rector in 1902, again due to poor health. He then went on to earn a doctor of divinity from Virginia Theological Seminary in 1912, but he died the following year at the age

St. Thomas' Parish. *Historical Society of Washington, D.C.*

of seventy-four in his home on Dupont Circle. His funeral was held at St. Thomas' Parish.

In 1912, one of Washington's RMS *Titanic* survivors, Colonel Archibald Gracie, captivated fellow St. Thomas' parishioners with his experiences on the sinking ship.

Over the years, the church was home to Franklin D. Roosevelt, Harry S. Truman and Mrs. Woodrow Wilson (formerly Edith Galt of Dupont Circle). Franklin Roosevelt, while serving as assistant secretary of the navy, was an active member of the parish and was elected to the church's vestry in 1918. Later, as president, Roosevelt returned to St. Thomas' Parish on the first Sunday in Lent in 1933, when hundreds of people lined up at the front entrance hoping to get into the 11:00 a.m. service. Roosevelt also served as an honorary senior warden of the church while he was president. President Harry S. Truman attended services there on Thanksgiving Day in 1952.

On the night of August 11, 1970, an arsonist poured twelve gallons of gasoline on the church and set it afire. By the next morning, after the fire was doused, the church that the *Evening Star* once called "one of the most beautiful edifices in the country" had been totally destroyed.

Instead of trying to rebuild, the church's leaders decided to convert the area where the old church building had stood into a public park that could be enjoyed by the whole neighborhood. A second parish hall that had been constructed in 1922 survived the fire and assumed the role of the lost church.

Collapse of the Church of the Covenant's Tower

Across from the British Legation on the southeast corner of N Street and Connecticut Avenue once stood the Presbyterian Romanesque Revival–style Church of the Covenant, designed by New York architect and devout Presbyterian himself, J. Cleaveland Cady. It was one of the handsomest and wealthiest churches in the city, and its congregation drew from the White House to Dupont Circle and beyond.

Months into the church's construction in 1888, stones at the base of its 148-foot-high tower began to crack. But both Cady and a city building inspector determined that the walls were strong enough to support the weight of the tower, so work continued. On August 21, 1888, the day the last stone of the tower was put in place, Robert Fleming, who was serving as supervising architect for Cady on the project, inspected the construction and realized that the integrity of the structure was severely at risk.

At 4:40 a.m. on the morning of August 22, 1888, less than two months before the church was to be dedicated, loud noises were heard coming from the foundation of the building. The tower on the northwest corner of the church began to sway and then crumbled straight down onto itself with a ground-shaking crash, taking with it the front wall of the church and a large part of the roof. What was intended to be a grand architectural statement fell into a mass of loose stones and broken timbers.

The event was observed by only a policeman on his beat and a church watchman who had been appointed by Fleming to keep an eye on the building. The whole neighborhood was aroused, windows were thrown open and neighbors still in their nightclothes ran from their houses thinking that there had been an earthquake. J. Cleaveland Cady showed up that afternoon from New York intending to oversee just the painting of the woodwork and was totally unaware that the tower had collapsed.

The builder blamed the collapse on the weakness of one of the piers. Cady blamed quicksand under the foundation, which he had covered

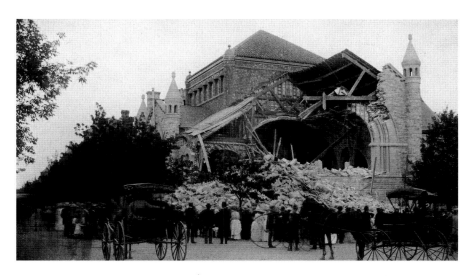

The collapsed tower of the Church of the Covenant. *Historical Society of Washington, D.C.*

with an insufficient amount of concrete before construction began. An investigation revealed the cause of the collapse to be poor materials and a lack of competent supervision over the construction.

The church was rebuilt and opened in February the following year. Scores of horses pulling private carriages tramped over the pavement in front of the church at noon on that day, bringing with them some of the wealthiest in the city for the opening service. In Reverend Teunis Hamlin's inaugural sermon that day, he referred to the many fine homes, undoubtedly including those in the immediate vicinity, in which the owners were abject slaves to their fine houses, clothes and furniture.

President Benjamin Harrison was a regular attendant at the church, often walking unaccompanied from the White House to listen to Reverend Hamlin's spirited sermons. James Blaine, Gardiner Greene Hubbard and John Hay, the personal secretary to Abraham Lincoln, as well as many other Dupont Circle residents had attended the church over the years and had their funerals in the church as well.

In September 1918, Washington officials disclosed that the Spanish influenza had arrived in the city. An emergency city ordinance was quickly passed requiring citizens to stay behind closed doors. It was illegal to walk along the streets and sidewalks, and there were even fines for sitting on front porches. Shops closed, and indoor meetings of any kind were prohibited

as well. Dr. Charles Wood, then pastor of the Church of Covenant, held open-air services on the vacant lot on Dupont Circle that was once the site of Stewart's Castle.

As with most of the great buildings along the southern section of Connecticut Avenue, the church fell victim to the development of the neighborhood. The property was rezoned to allow for the construction of a ten-story building. In July 1966, the church came down and was replaced with an office building.

George and Phoebe Hearst

In 1889, George Hearst, a wealthy American businessman, U.S. senator and the father of newspaper tycoon William Randolph Hearst, purchased a house south of Dupont Circle on New Hampshire Avenue that had been built in 1883 for John Field, a successful Philadelphia banker and businessman.

Home of John Field at 1400 New Hampshire Avenue Northwest (on the left) before it was remodeled by William Hearst. *Historical Society of Washington, D.C.*

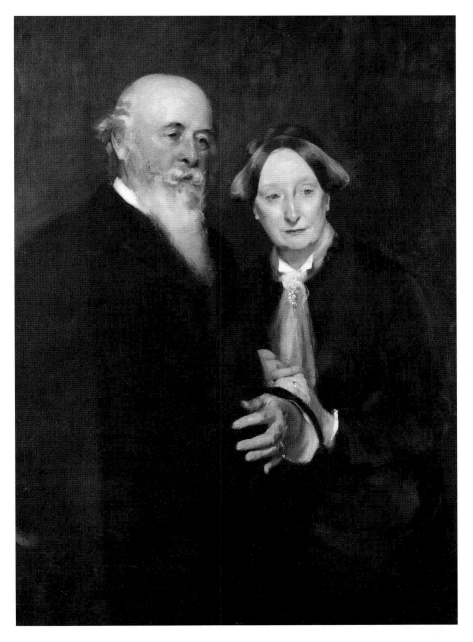

Mr. and Mrs. John Field. Portrait by John Singer Sargent. *Pennsylvania Academy of Fine Arts.*

Home of George and Phoebe Hearst on New Hampshire Avenue. *Library of Congress.*

After retiring and spending ten years in Europe, Field and his wife, Eliza, decided to make Washington their home for their final years. The spacious square house at 1400 New Hampshire Avenue was designed by local architect Robert Fleming, and it is believed to have been the first Colonial Revival–style house in Washington.

The Fields were well established in Philadelphia before their arrival in Washington. They were great patrons of the arts and noted benefactors of the Pennsylvania Academy of Fine Arts; Mrs. Field's father was one of its founders. The couple's portrait was painted by John Singer Sargent in Paris in 1882, and Mrs. Field donated it to the academy after John Field's death. Artist Gilbert Stuart had painted her mother's (Abigail Willing) portrait, and Rembrandt Peale had painted her father's.

John Field had a special gift for friendship and became friends with many noted authors, poets and artists in England and the United States. He maintained an ongoing correspondence with poet Robert Browning and was an intimate friend of James Russell Lowell, who was once a guest at

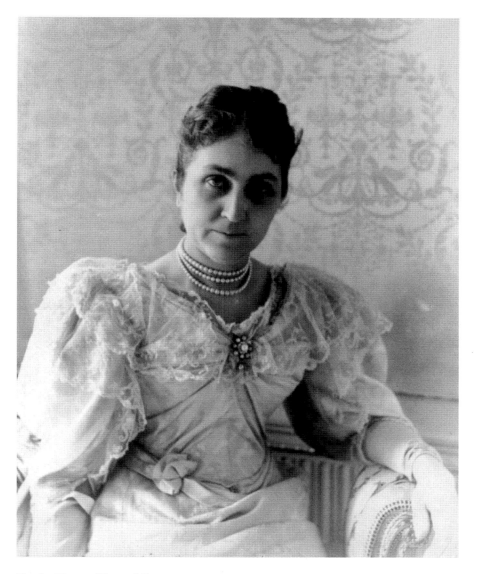

Phoebe Hearst. *Library of Congress.*

the Fields' house in Washington. John Field died in 1887, and according his wishes, Eliza was to remain in Washington. But that same year, she sold the house to Charles Fairchild, who had just been appointed as secretary of the Treasury, and moved to New York.

In 1889, George Hearst purchased the Field house from ex-secretary Fairchild. Hearst had arrived in Washington in 1886 to fill a vacant U.S. Senate seat and, a year later, was elected to the Senate, where he served until his death in 1891.

When the Hearsts bought the Field house, they were not happy with either its size or its architectural style. While Robert Fleming had pioneered the introduction of the Colonial Revival style to Washington with this house, the Hearsts preferred the much heavier and old-fashioned Richardsonian Romanesque Revival style. The house was completely torn apart, inside and out, expanded and refaced. The finished house boasted thirty-two bedrooms and twenty-two baths and was, in the Hearsts' minds, a home worthy of their wealth and stature.

When she first arrived in Washington and began entertaining, Phoebe Hearst preferred to host intimate gatherings in her home, sponsoring talks by various well-known men rather than the larger, traditional social fêtes. These talks were held in the afternoons, each featuring a unique topic. Initially, these gatherings were considered an undesirable and uncomfortable innovation, but they soon became quite the thing for others to host as well, although Mrs. Hearst was recognized as the leader in what became a very fashionable movement.

According to Marguerite Cassini, Phoebe Hearst also set the bar for society musicales; they were simply the best shows in town. The gatherings never consisted of more than fifty guests and featured the biggest opera stars, musicians and theatrical names of the time. Counted among them were contralto Madame Schumann-Heink and violinists Jan Kubelik and Fritz Kreisler. Phoebe was also very devoted to her charities, one of which was a free kindergarten modeled after those she had seen in San Francisco at the time, and also enjoyed helping out neighbors with theirs.

Alice Pike Barney

After Phoebe Hearst, perhaps no other person had as significant an impact on cultural and artistic life in Washington at the beginning of the twentieth century as Alice Pike Barney, who worked to make the city into a center of the arts. Alice was an artist, community activist, theatrical producer and the creator of the National Sylvan Theater on the grounds of the Washington Monument.

Alice Pike was born in 1857 in Cincinnati, Ohio. Her parents, Samuel and Ellen Pike, were well-known philanthropists in Cincinnati. Samuel was a whiskey distiller who had built the city's first opera house. Alice's early years were filled with the musicians, impresarios and actors who were frequent guests in her parents' home. In 1866, the Pikes moved to New York City, where Samuel built Pike's Opera House, later renamed the Grand Opera House

In 1876, Alice married Albert Clifford Barney, the son of a wealthy railway car manufacturer from Dayton, Ohio. The following year, Alice launched her career as an artist, studying painting in Paris.

In the spring of 1889, the Barneys moved to Washington and hired the architectural firm of Barry, Simpson and Andrews to design an Italianate palazzo–style home at 1626 Rhode Island Avenue Northwest, across the street from the home of General Phillip Sheridan. The fine marble and white stone house with a large ballroom and a commodious dining room was heralded as one of the largest and finest in the city. The walls of the hallways were eventually adorned with portraits of some of the famous beauties of the city, all painted by Alice.

The Barneys quickly became influential members of Washington's smart set. Albert followed the norm for new wealthy socialites in D.C. and joined the Metropolitan, Chevy Chase and Alibi Clubs. But Alice was not satisfied playing just wife, mother and hostess, much to her husband's chagrin. Albert did not want their newly acquired social status threatened by his wife's interests in the arts and her bohemian tendencies. Even still, the Barneys would continue to travel to Paris, and Alice continued her painting studies.

While in France in 1900, Alice's daughter, Natalie, asked if Alice would do the illustrations for a book of poetry she had written. Alice did not realize that it was a collection of lesbian poetry and that three of the women who had posed for Alice for the illustrations had been Natalie's lovers. When Albert Barney learned of this from a newspaper review of the book, he rushed to Paris to buy all the printed copies as well as the printer's plates and demanded that the two return with him to the States.

On her return to Washington, Alice was determined to take an active role in Washington's artistic community. She wanted to be recognized as a serious artist, not a dilettante. In pursuit of her goal, she joined the Washington Water Color Club, a group of local artists led by Henry Moser, which exhibited drawings, pastels and watercolors. Her first showing of paintings in Washington was with the club. Alice did become a prominent artist with solo shows at major galleries, including the Corcoran Gallery

Alice Pike Barney. *Library of Congress.*

of Art. Many of her works are now in the collection of the Smithsonian American Art Museum.

Albert died of a heart attack in southern France in 1902 at the age of fifty-two, possibly brought on by worries caused by his wife and daughter's less-than-conventional lifestyles. That same year, Alice began developing plans for her new "Studio House" at 2306 Massachusetts Avenue on Sheridan Circle, which was being designed by prominent Washington architect Waddy Butler Wood. Alice intended for the Studio House to be a place to foster a public awareness of the arts in Washington, where she could both work and entertain and where affluent society and artists could mingle.

When the Studio House was built, Dupont Circle was still Washington's most fashionable neighborhood for the smart set. But the Studio House quickly became one of the centers of Washington social and artistic life, putting Sheridan Circle on the map as the newest of vogue neighborhoods, attracting many of the country's newer multimillionaires to build around the circle.

Alice leased out the Rhode Island Avenue house after she moved to the Studio House. It became an acceptable temporary residence for many who were moving to Washington, either looking to purchase the perfect house or to have one built for themselves.

5

THE NOT-SO-GAY NINETIES

The term "Gay Nineties" became widely used during the Great Depression in the 1930s when Americans became nostalgic for what they remembered, or wanted to remember, as a comfortable and prosperous decade marked by heroic events. Among those pleasant images conjured up were the memory of the World's Columbian Exposition in Chicago in 1893 with the introduction of the popular Ferris wheel, vaudeville shows and Theodore Roosevelt leading his Rough Riders up San Juan Hill in Cuba.

Although the '90s were fondly remembered as a prosperous and carefree time for the American middle class, it was anything but for the poor and the wealthy. A series of events in the first half of the decade would either completely wipe out the great fortunes that were made in the previous two decades or leave those that remained uncertain. The explosive real estate growth of the previous decade in Dupont Circle slowed to a crawl for the next ten years.

The economy officially went into recession in January 1893. Ten days before Grover Cleveland was to take office in March 1893, the Philadelphia and Reading Railroad filed for bankruptcy. The stock market soon collapsed, and there were widespread bank runs. The U.S. Treasury's gold reserve fell to such dangerously low levels that President Grover Cleveland borrowed $65 million in gold from banker J.P. Morgan to bail out the U.S. economy. Banks continued to fail along with more railroads: the Northern Pacific, Union Pacific and the Atchison, Topeka & Santa Fe Railroads. The Panic of 1893 had begun, and the economy would not begin to recover until 1897.

The Panic of 1893 remains one of the most severe financial crises in American history. The fortunes of silver miners and railroad tycoons, as well as those who were invested in these endeavors, were wiped out. The silver kings of the previous decades gave way to the new gold barons. Some fortunes were protected—those of people who had retired completely from their businesses or were not heavily invested in speculation or railroads at the time. Fortunes were constantly at risk, which made their owners cautious about the extravagant expense of building, maintaining and staffing a grand home. Many who made Dupont Circle home after the panic, instead of building their own houses, began buying houses that had been built during the previous two decades.

THE ROOSEVELTS

The year after William Howard Taft had settled into a rented house at 5 Dupont Circle while serving as U.S. solicitor general for the Department of Justice, President Harrison appointed Theodore Roosevelt U.S. civil service commissioner. Roosevelt and his family rented the house at 1215 Nineteenth Street Northwest. Theodore and Edith's family at this point consisted of Alice, the only child of Roosevelt's first marriage to Alice Hathaway Lee; Theodore Jr.; Kermit; and baby daughter, Ethel. Their son Archibald was born while they were living in the Nineteenth Street house. Roosevelt returned to New York in 1895 to replace Frederick Dent Grant as police commissioner, a position he held for two years.

Roosevelt's close friend and Dupont Circle resident Congressman Henry Cabot Lodge urged President William McKinley to appoint Roosevelt as assistant secretary of the navy in 1897. Upon their return to Washington, the Roosevelts moved into a house at 1810 N Street, where their last child, Quentin, was born in 1897.

Roosevelt left Washington once again to serve only part of a term as New York's governor before President McKinley chose him as his vice presidential running mate. When visiting Washington as governor, Theodore would stay at his sister Anna Cowles's house at 1733 N Street Northwest. He and his family also stayed there while awaiting the move to the White House to take over the presidency after William McKinley's assignation in 1901. It was during one of his stays with his sister that Roosevelt hosted a reception for his Rough Riders. The attendees were all decked out in the khaki they had worn when they followed Roosevelt to Cuba.

At the late age of forty, Theodore's elder sister, Anna, had married gunboat commander and naval aide to President McKinley, William Sheffield Cowles. After Edith Roosevelt's untimely death, Theodore entrusted the care of his daughter Alice to his sister. In many ways, Alice became Anna's adopted daughter as well as her niece. To Alice, the Cowleses were always "Auntie Bye" and "Uncle Will."

Theodore relied heavily on his sister Anna's opinion and advice. Another one of her nieces, Eleanor Roosevelt, once said that Theodore made few important significant political decisions and even fewer personal decisions without getting her input. Anna remained a trusted confidante throughout his entire career. While he was president, Roosevelt would often refer to Anna's house as the "other White House."

When Woodrow Wilson appointed Franklin Delano Roosevelt assistant secretary of the navy in 1913, Franklin and Eleanor first rented the Cowleses' house and then later moved to a larger home at 2131 R Street Northwest.

GRACE DENIO LITCHFIELD

The Dupont Circle neighborhood was full of notable and high-profile individuals, yet it was also home to many who lived mostly under the radar of the society pages, though their lives were as full and interesting. One such person was Grace Denio Litchfield. A novelist and poet, Grace was born in 1849 and was the daughter of Edwin Litchfield, a railroad magnate who had pieced together the Great Northern Railroad system. Grace had been an invalid for the first twenty-four years of her life. She started writing in early childhood, and her verses and stories appeared in the *Century*, *Atlantic Monthly* and the *(New York) Independent* among others.

Grace had been educated in Europe and was fluent in four languages. In 1890, she contracted the architectural firm of Hornblower and Marshall to build a house at 2010 Massachusetts Avenue, just to the west of the Blaine mansion. When the house was finished in 1893, she moved in with her brother, Henry, who had been crippled since childhood as the result of a careless nurse. The two shared the thirty-room house with a Scottish maid, butler, footman, cook and scullery maid. Henry lived in a third-floor corner room and was always working on his never-to-be published book, "Lives of the Presidents." Due to a speech impediment, he found it easier to speak German with this sister and remained in his upstairs room when visitors

Grace Denio Litchfield house at 2010 Massachusetts Avenue Northwest. *Library of Congress.*

Grace Litchfield's study. *Library of Congress.*

came. Grace was later joined in the house by Katharine Dumbell, who, after a visit from England in 1921, became Grace's constant companion.

Grace and Katherine would receive guests for afternoon teas and regularly held Monday afternoon salons into the 1930s, well past when they were considered fashionable. The salons attracted persons of note in the arts and letters, as well as local society. Dinner guests included the actor Joseph Jefferson and Polish pianist Ignacy Paderewski, who would play for the guests.

Grace's butler, Middleton, was so impressive that he was sometimes borrowed for a day at the White House, where he later took a permanent position. Kermit Roosevelt would bring his pony across the street from his cousin Robert's house and up the steps of the Litchfield back porch to be fed apples and carrots by the kitchen staff.

Grace remained actively writing throughout her long life. At the age of ninety, a limited edition of her poems that she had written in her eighties was published. She stayed in Washington until 1943, when she suffered a stroke while visiting Katharine in her Goshen, New York home, where she died a year later at the age of ninety-five. It took twenty-two days to tear the house down in 1969.

The Rise of the House of Leiter

Perhaps no family made as lasting an impact on Dupont Circle as the Leiters. They were the quintessential parvenus—ostentatious, social climbers and with airs of questionable sophistication. But in the end, everyone loved them, and Mary Leiter would reign over Washington's smart set for twenty years.

At the age of twenty-one, Levi Ziegler Leiter moved to Chicago from Leitersburg, Maryland, and took a job as a clerk in a dry goods store. In 1865, he went into the dry goods business himself with Marshall Field and Potter Palmer as Field, Palmer, Leiter & Co. In 1867, Palmer sold his share of the business to his partners, Leiter and Field. Levi Leiter later sold his interest in the company to Marshall Field, and it became Marshall Field and Company and survived until 2005, when it was acquired by Macy's, Inc.

In 1866, Levi Leiter married a schoolteacher, Mary Theresa Carver. She was the daughter of Benjamin Carver, a wealthy banker from Utica, New York, and a descendant of John Carver, the first president of the Plymouth

Levi Ziegler Leiter.
From the Bismarck Daily
Tribune, *1904.*

Colony. The couple had four children: Joseph, Nancy, Marguerite "Daisy" and Mary Victoria.

Leiter developed an interest in real estate and invested heavily in Chicago, helping it to recover from the fire of 1871 while building his already immense fortune. Leiter also became involved with the Chicago School of architecture and was the builder of the first true steel skeleton building of 1889—architect William Le Baron Jenney's Leiter Building. He also served as the second president of the Chicago Art Institute, provided a new building for the Chicago Historical Society and donated generously to the Chicago Public Library.

Yet even with the Leiters' great wealth and civic involvement in Chicago, they were still not accepted socially. While they remained in Chicago, Levi

Leiter would always be seen as a self-made man, and the socially ambitious Mary Leiter would always be a former schoolteacher. In 1883, the Leiters joined former business partners Marshall Field and Potter Palmer in Washington for the winter season, renting the Blaine mansion at 2000 Massachusetts Avenue.

The Leiters paid the exorbitant of sum of $11,500 a year in rent for the house. The rental price was highly publicized, as the Leiters probably wanted to impress on their new neighbors that money was no object. But they may have only made the impression that they were gullible and easily taken by Blaine's attempts to take advantage of the out-of-towners.

In 1891, Leiter decided to permanently move to Washington and purchased a lot at 1500 New Hampshire Avenue Northwest. Instead of choosing from the Chicago School of architects, Leiter chose Philadelphia architect Theophilus P. Chandler to design his palatial mansion on Dupont Circle. When the house was finally completed in 1893, it was ninety-six feet across the front; three stories high, plus the basement, at a height of sixty-two feet; seventy-five feet in depth; and hosted fifty-five rooms.

Mary's early attempt to enter Washington society was awkward at best. She quickly developed a reputation for comical malapropisms and social missteps. Upon returning from a trip to Europe, she was reported as saying that she "was relieved to set my feet on American terra cotta." She was particularly proud of one acquisition and proudly showed guests "the bust of my daughter's hand, done by Rodin." At one of their dinners, Marguerite Cassini tried to refuse the terrapin soup. Mrs. Leiter screamed, "You can't refuse my terrapin! It costs a hundred dollars!" But ultimately, Mary prevailed and became the leader of the smart set.

Guests were never certain of the reception they would receive at Mary Leiter's hands. At one cotillion she gave, she had a silk ribbon strung through the center of the ballroom to separate whom she considered the socially elite among her guests from the others.

In 1874, President Grant's daughter, Ellen "Nellie," married Englishman Algernon Sartoris in an elaborate White House ceremony. In the minds of the parvenus, the marriage of a midwesterner to an Englishman of some status would open the door to their acceptance in high society. Similar matches would become the goal of a generation of young, wealthy girls invading England for titles and winning social success, a group that Edith Wharton christened "buccaneers." The practice became so prominent that Andrew Mellon publically spoke out against such intercontinental

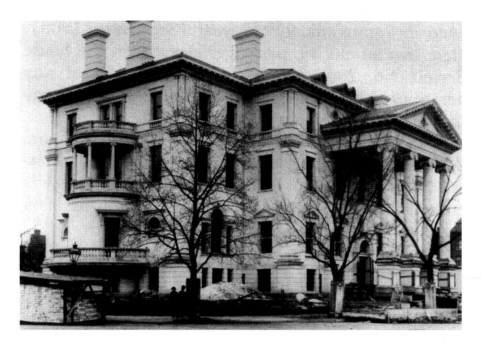

The Leiter mansion at 1500 New Hampshire Avenue Northwest while still under construction. *Commission on Fine Arts.*

marriages. Unfortunately for Nellie and the many others who would follow suit, the dream of being a buccaneer ended in misery, divorce or even worse fates.

The Leiters' eldest daughter, Mary Victoria, married Lord George Curzon in 1895 and became Baroness Curzon of Kedleston. The ceremony was held at St. John's Episcopal Church. Levi Leiter provided Mary with a dowry that was speculated to be between $3 and $5 million. The couple honeymooned at Beauvoir, John McLean's country estate in the Woodley Park neighborhood of Washington before leaving for England. The Curzons then moved to Bombay three years later when Sir George was appointed viceroy of India. Mary Leiter's elevation to vicereine remains the highest position an American woman has ever held in the British Empire and made Mrs. Leiter's position in Washington society almost impregnable. Tragically, India's climate, the demanding social responsibilities of the wife of a viceroy, a miscarriage and fertility surgery took its toll on Mary Victoria's health, and she died during a return visit to London in 1906.

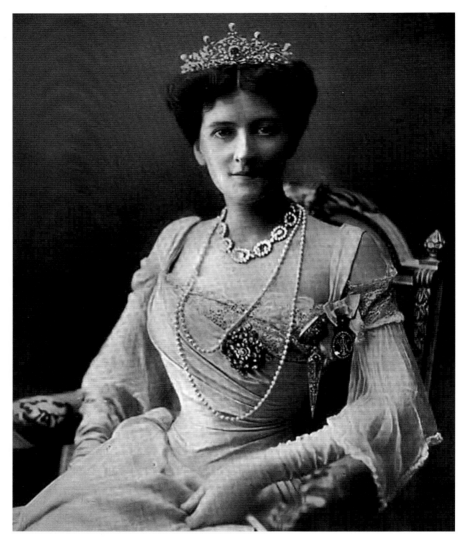

Mary Leiter, Baroness Curzon of Kedleston and Vicereine of India. Photo taken in 1906, the year she died. *From the* Bystander.

When it became time to bring out their daughter Daisy, Mrs. Leiter shocked Washington society by arranging Daisy's reception and cotillion on the same evening as one of the most important events of the season, the annual subscription dance organized by the Cave Dwellers. Enraged

that a newcomer to society would schedule something to compete with their event, they dispatched a note to Mrs. Leiter asking her to postpone her cotillion. Mrs. Leiter sent a firm reply saying it would be too much trouble to recall the invitations at this point and suggested they postpone their dance instead. Neither side backed down, and war was declared between the old Cave Dwellers and the leader of the smart set. Mrs. Leiter also let it be known that if anyone expected at her cotillion attended the Cave Dweller dance instead, they would be taken off her visiting list. Many planned on attending both, but when they went to leave the dance, they were blocked at the door by the old Cave Dwellers. Nellie Grant Saratoris's son, Captain Algernon Sartoris Jr., bribed a waiter to be let out a back door and was one of the many who successfully attended both events that night without a scrape. By eleven o'clock, the only ones left at the dance were its organizers and a few frightened dancers; the rest had made it to Mrs. Leiter's. According to Captain Sartoris, Washington society acknowledged that Mrs. Leiter was the victor, and the Cave Dwellers went back to their caves.

In the same buccaneering spirit as their sister Mary, the other Leiter daughters married foreigners of stature as well. Daisy married the Earl of Suffolk and became Countess of Suffolk and Berkshire. Nancy married Colin Campbell, a colonel in the British army whom she had met and fallen in love with in India while visiting her sister. But Mrs. Leiter did not stop helping to bring young ladies out to society after she had successfully married off her three daughters. She had a reputation for being quite the matchmaker.

Upon his son Joseph's graduation from Harvard, Levi offered him $1 million to see what he could do with it. He soon had $30 million worth of properties, but he did make one large financial miscalculation. In 1897, he tried to corner the wheat market by buying up twenty-two million bushels in futures to drive up the price, but the wheat market collapsed. Joseph lost at least $10 million, and his father had to bail him out of debt. But Joseph bounced back, and by the time of his death, he was reportedly earning about $1 million annually.

In 1904, Levi Leiter died of heart disease while vacationing at the Vanderbilt cottage in Bar Harbor, Maine, which the Leiters had taken for the summer season. At his death, Leiter's fortune was equivalent to $1.4 billion in today's dollars. Mary Leiter continued to live in the house and entertain there on a large scale until her death in 1913.

When Mary Leiter died, society lost its recognized leader of the smart set, and a new leader was needed to step forward by the beginning of the winter

Joseph Leiter attempted to corner the wheat market in 1897. Library of Congress.

season. Who would replace Mrs. Leiter was not only the talk of Washington but also New York, Boston, Philadelphia and Chicago. The *New York Tribune* noted that the "the list of prerequisites that are taken as a matter of course is long and terrifying and may well daunt the bravest and most ambitious climber." First on the list to succeed Mary Leiter was Mabel Boardman, but people thought she had no interest in the social affairs of the smart set. Other candidates who were thought to be in the running for the position included Kate McCormick, her sister Elinor Patterson of 15 Dupont Circle, Elinor's daughter Cissy, Carrie Walsh and her daughter Evalyn, though the latter two were not considered leadership material. In the end, the title was passed on to Mary "Minnie" Townsend.

After Mary Leiter died, the grand house passed to Joseph and his wife, who occupied it until Joseph's death in 1932. The house was then left to Joseph's son Thomas, with the provision that his mother be allowed to live there until her death. After she died in 1942, the house was leased to the federal government for offices. Later it was sold to Dupont Plaza, Inc., for $190,000, only $65,000 more than it cost to build more than fifty years before. It was razed in 1947 to construct the current building on the lot, then an apartment building and now a hotel.

With the Leiter mansion as the anchor house on New Hampshire Avenue north of the circle and no vacant lots left directly on the circle itself, development began to move north on New Hampshire Avenue, where empty sites became some of the most coveted real estate in town.

THOMAS FRANKLIN SCHNEIDER: ARCHITECT OF WASHINGTON'S FIRST SKYSCRAPER

Architect Thomas Franklin "T.F." Schneider was one of the first to build along the northern part of New Hampshire Avenue above Dupont Circle. In 1890, he built a massive sandstone, Romanesque Revival–style house for himself at the intersection of New Hampshire Avenue, Eighteenth and Q Streets at 1539 Eighteenth Street. The following year, he designed a similar house just across the street to the south for naval intelligence officer Rear Admiral Richardson Clover, who had been renting the Emory house on Connecticut Avenue.

Schneider was a native of Washington and was one of the city's premier builders of the time with two thousand residences and twenty-six

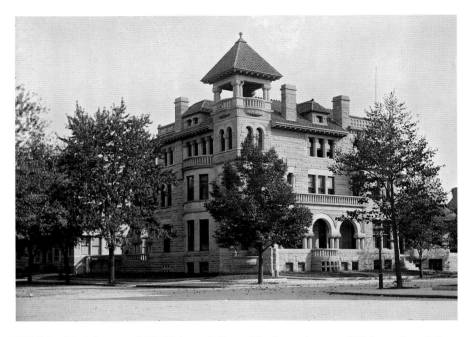

T.F. Schneider's home at 1539 Eighteenth Street Northwest (corner of Eighteenth and Q Streets) became another temporary home of the Chinese Legation. *Library of Congress.*

apartments and hotels to his credit. He is perhaps best known for the 1894 Cairo Hotel at 1615 Q Street Northwest, Washington's first steel-frame skyscraper. At 164 feet high, it was the first of its kind in Washington, and it caused an uproar. At the request of the district commissioners, who were concerned about the city's skyline, Congress passed the first Heights of Buildings Act that same year that limited building heights within the District of Columbia.

After only about ten years in his new house, Schneider retired and began to rent the house out. One of the first tenants was a friend of Schneider's, the Chinese minister Wu Ting-fang, who rented it as yet another temporary home for the Chinese Legation. The interior was bedecked with Chinese embroideries, bric-a-brac, vases and pictures to give a characteristic Chinese air. In 1902, the *Omaha Daily Bee* reported that a young woman who once attended a reception in the house wrote to a friend, "The house is very much like an American home and the Wus are becoming more like us every year. Formerly, the minister received and his wife was poked back in a corner. Now, she receives and he wanders

about looking lonesome." The Chinese government would soon move to its own, newly constructed building on Nineteenth Street and Vernon, where it would remain until 1944.

SARAH ADAMS WHITTEMORE

Until 1898, the only other house on the Leiters' side of the block of New Hampshire was an eclectic English Arts and Crafts-style house at 1526 New Hampshire that was designed by architect Harvey Page for William and Sarah Whittemore in 1892. Only five years earlier, they had built a large house at 1300 Seventeenth Street for themselves that became the Cambridge Boarding House the year they moved into their new house on New Hampshire Avenue.

Sarah Adams Whittemore was a native of Massachusetts and a descendant of both John and Henry Adams as well as Miles Standish. After an early career as an opera singer, she married her first husband, Sextus Wilcox, a prominent lumber merchant from Chicago. Wilcox had made his fortune making shingles and selling them to buyers in Michigan and Wisconsin. Sextus drowned in Lake Superior in 1881 while fishing, leaving Sarah with two children and a very large fortune. She later married prominent local businessman William Whittemore and lived in Washington entertaining and working with her favorite charities.

In 1902, the Whittemores moved to the Arlington Hotel on Vermont Avenue one block to the north of Lafayette Square and rented out their New Hampshire Avenue home. Over the years, the Whittemore house had a number of tenants. The best known was Republican congressman from Massachusetts John W. Weeks, who leased the house from 1907 to 1911. Weeks was later elected a senator from Massachusetts and served as secretary of war under Harding and Coolidge. Sarah Whittemore died in 1907 at the age of seventy at her apartment in the Arlington Hotel. She left the house on New Hampshire Avenue to her son, Walter Wilcox, an explorer, travel author and photographer who lived there with his family until 1926.

The Woman's National Democratic Club purchased the Whittemore house in 1927. The *New York Sun* reported in May 1927 that the purchase of "one of the finest old houses in the heart of Washington's most exclusive residential sections" by the club was the "last word in putting the 'Ritz'

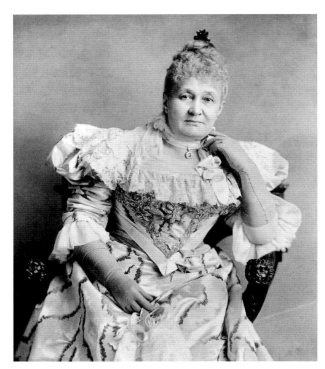

Left: Sarah Adams Whittemore. *Library of Congress.*

Below: Whittemore house at 1526 New Hampshire Avenue Northwest. The Leiter mansion can be seen in the background to the left. *Library of Congress.*

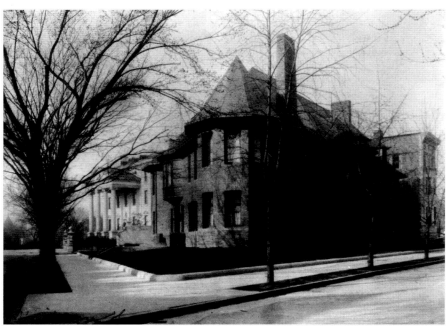

into politics." In 1967, a modern, poured-concrete Brutalist-style ballroom designed by architect Nicholas Satterlee was added on the Q Street side of the house.

GERMAN BREWER CHRISTIAN HEURICH

German-born brewer Christian Heurich immigrated to the United States from Germany in 1866. In 1872, he entered into a partnership with another brew master, Paul Ritter, and began searching for a city to set up their business. After deciding on Washington, they leased a brewery owned by George Schnell near Dupont Circle on Twentieth Street between M and N Streets. Heurich boarded with Ritter and his wife at their house next to the brewery.

At the age of thirty, Heurich had begun to think about marriage and told his sister Elisabeth, who was visiting from Baltimore at the time, that he had a girl in mind but thought he might be too busy to get married. The girl was Amelia Mueller Schnell, the recent widow of George Schnell, from whom Heurich had leased the brewery. Schnell had died in November 1872, leaving everything to his wife. Amelia was also the daughter of August Mueller, whose small farm was still in operation on Dupont Circle. With the encouragement of his sister, Heurich walked up to Mueller's farm and proposed to Amelia. After they were married, Heurich purchased the remaining outstanding interests in Schell's brewery and renamed it Heurich's Lager Beer Brewery.

Amelia had hoped to build a house of their own and, in 1879, bought two lots on the corner of New Hampshire Avenue and Sunderland Place, just one block south of Dupont Circle, but she died in 1884 before a house could be built. Three years later, Christian married Mathilde Daetz, the sister of the brewery's secretary. The new couple moved to a larger house at 1218 Nineteenth Street, just behind his brewery, and spent two years improving it under the direction of architect John Granville Meyers.

In 1890, Heurich incorporated the brewery and became an instant millionaire. The following year, he once again engaged architect John Granville Meyers to build a mansion at 1307 New Hampshire Avenue that would be representative of his new wealth. Two of the four lots that the new house covered were those that were bought by Amelia for the site of the house she was never to build.

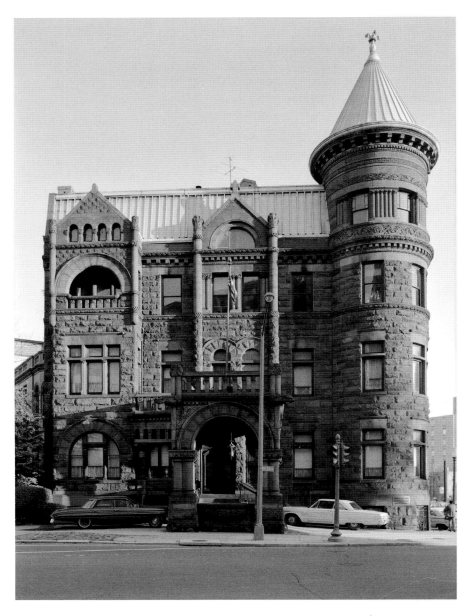

Christian Heurich mansion at 1307 New Hampshire Avenue Northwest. *Library of Congress.*

A history of fires at the brewery had made Heurich very concerned about fire, and he made certain his new house would not suffer the same fate. It would be of poured concrete and reinforced steel and would be the city's first fireproof home. Even though the building was fireproof, Heurich was so afraid of a fire that the mansion's many fireplaces were never used.

The Heurichs moved into the house in 1894, but the couple did not enjoy it for long. Mathilde died after only a few months of living in the house. Four years later, Christian, fifty-seven, married thirty-three-year-old Amelia Keyser, the niece of his first wife, Amelia. Together they had four children, a son and three daughters, though one daughter died in infancy.

Heurich kept the brewery in business through Prohibition by supplying ice to the U.S. Congress and the U.S. Supreme Court until he was able to resume brewing beer. In 1945, the 102-year-old Heurich died in his home at 1307 New Hampshire Avenue, and the following year, the Christian Heurich Brewing Company closed. The grand house still stands as a testament to the brewing industry in Washington and is now open to the public as the Heurich House Museum.

THE BOARDMANS

One of the most prominent families in Washington at the turn of the century was the Boardmans. Before moving to Washington in 1888 with his wife, Florence, and six children, William Jarvis Boardman had been a Cleveland lawyer and active in that city's business, civic and political affairs. The move provided an opportunity to introduce his three daughters to Washington society. His one son, William Henry, remained in Cleveland to carry on his father's law practice. In 1893, Boardman contracted the architectural firm of Hornblower and Marshall to build a home at 1801 P Street. Boardman was an early fan of the automobile, and the house featured a carriage drive-through on the west side of the house, off which was the main entry to the house. This feature would also be designed into the Wadsworth home across the street.

Once in Washington, William Boardman became active in charitable and philanthropic work. He helped his daughter Mabel in the development of the American Red Cross and served as chairman of the board of directors of the Emergency Hospital and chairman of the St. John's Episcopal Church Orphanage Board.

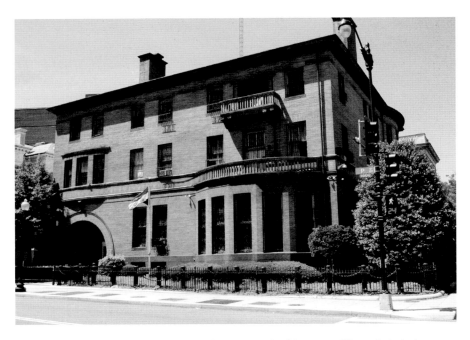

Boardman mansion at 1801 P Street Northwest, now the Chancery of Iraq. *Author's photo.*

William Boardman was an old friend of William Howard Taft, who often referred to Boardman as "Foxy Grandpa." Taft would often avail himself of the Boardmans' friendship as well the use of their home. But Taft was no stranger to Dupont Circle himself. He had rented the house at 5 Dupont Circle for two years while he was serving as solicitor general for the Department of Justice under President Benjamin Harrison. When President Theodore Roosevelt named him secretary of war in 1904, Taft rented a house among the Cave Dwellers at Sixteenth and K Streets Northwest. Yet he would still receive callers at the Boardman home instead of his own. The Tafts stayed on the third floor of the Boardman house before his inauguration in 1909. Even while president, Taft would often drop by to pass many an informal evening at the Boardman home.

William Boardman's eldest daughter, Mabel, was Taft's closest female friend and confidante outside his own family. In 1905, Mabel, along with close friend Alice Roosevelt, joined Secretary of War Taft's Imperial Cruise to the Philippines.

Florence was the first Boardman daughter to wed, marrying Chicago millionaire Frederick Keep in 1900. The wedding, with music provided by

the Marine Band, was held in the Boardman house and attended by, among others, Secretary of State John Hay and his wife, British ambassador Julian Pauncefote and most of the other European ambassadors. The Keeps built a formidable house in the up and coming neighborhood of Sheridan Circle. Florence became a widow when Frederick died in Paris in 1911 of a heart attack while visiting a massage parlor.

Boardman daughter Josephine became very prominent in Washington's younger smart set, attracting attention with her interest and knowledge of foreign affairs as well as with her fluency in French, German and Italian. She was particularly popular with the younger male diplomats, including Baron Ivan Rubido-Zichy of the Austrian Embassy, a love interest of Marguerite Cassini. The young baron carelessly once said to Josephine at the Chevy Chase Club that he would do anything for her, at which point she dared him to ride into the club's ballroom on horseback, which he did immediately.

Josephine shocked society when her engagement to a man thirty years her senior, Senator Winthrop Murray Crane of Massachusetts, was announced. The couple would initially not stray far from the Boardman home, occupying the same house that Senator William Clark had previously rented just across the Circle at 1915 Massachusetts Avenue and remaining there until moving to a house on Rhode Island Avenue near the then location of the French Embassy.

Mabel's work with the American Red Cross gave rise to her worldwide reputation. She worked tirelessly to shape Clara Barton's organization into an international one. Mabel was named to the board of incorporators of the American Red Cross in 1900 when friends submitted her name without her knowledge. The following year, she was elected to the board of governors and subsequently led the faction that ousted Clara Barton from the presidency of the organization in 1904. With the help of William Howard Taft and Dupont Circle neighbor, former Secretary of State John Watson Foster, Mabel drafted the organization's congressional charter in 1904. She spent $1 million on a new building for the organization at Seventeenth and D Streets Northwest as well as commissioned three windows from the Tiffany Studios for the Board of Governors Hall. When members of the finance committee objected to the size and expense of the building, she replied, "If we ever have a war, we'll need that space for additional quarters." Her foresight was vindicated. Throughout her life, Mabel never took a salary.

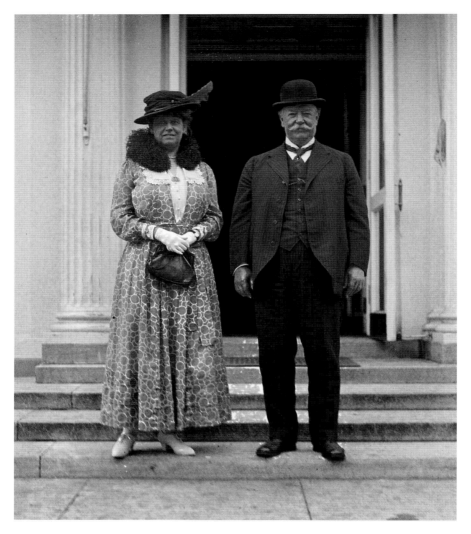

Mabel Boardman with family friend William Howard Taft. *Library of Congress.*

Mabel was awarded the Red Cross Distinguished Service Gold Medal as well as the Cosmopolitan Club's Distinguished Service Medal for "outstanding and unselfish service to her community." In her spare time, she was also a member of the Chevy Chase Club and a founder of the Sulgrave Club, whose headquarters were in the old Wadsworth mansion and just across the street from her own home.

Mabel was a formidable character and bore a striking resemblance to Britain's Dowager Queen Mary. When then the Prince of Wales, Edward VIII, was visiting Washington, he was introduced to Mabel and exclaimed, "Good Lord—there's Mother!" Mabel never married, undoubtedly because she could find no time for organizing and managing a husband as well. She died in 1946 at the age of eighty-five of a heart attack at the Boardman home with her sister Florence Keep at her bedside. The house now serves as the Chancery of Iraq.

MRS. GRANT RETURNS TO WASHINGTON

By 1895, Julia Grant, the widow of President Ulysses S. Grant, had grown tired of living in New York City. After leaving Washington in 1877 under a cloud of scandals that marked her husband's administration, Mrs. Grant had hoped that the dust had settled enough for a quiet return to Washington.

The return to Washington was a practical move for Julia Grant. Along with many of her lifelong friends, she had a considerable amount of family in town: a son, a daughter and two sisters. She bought the 1885 Hornblower and Marshall–designed home of Senator Edmunds at 2111 Massachusetts that stood across the street from the Patten sisters.

Julia's divorced daughter, Nellie, had returned to Washington the year before her mother and was living in Dupont Circle. Julia's son, Colonel Frederick Dent Grant, was already well established in Washington when Julia arrived. He had married Ida Marie Honoré, the daughter of Chicago real estate magnate Henry Hamilton Honoré. Ida's sister Bertha married Chicago millionaire and Levi Leiter's former business partner, Potter Palmer, in 1874. Frederick and Ida's daughter, Julia Dent Grant, followed the precedent set by her aunt Nellie and married a well-positioned foreigner, Prince Mikhail Mikhailovich Cantacuzène, Count Speransky, a cavalry officer of the Russian Imperial Army. That marriage ended in divorce as well.

During her last years in Washington, Julia Grant suffered from rheumatism and had become so feeble that it was impossible for her to accept any social engagements. She died in her Massachusetts Avenue home in 1902. After the death of Frederick Grant in 1912, Ida bought a recently completed house at 1711 New Hampshire Avenue and became one of the

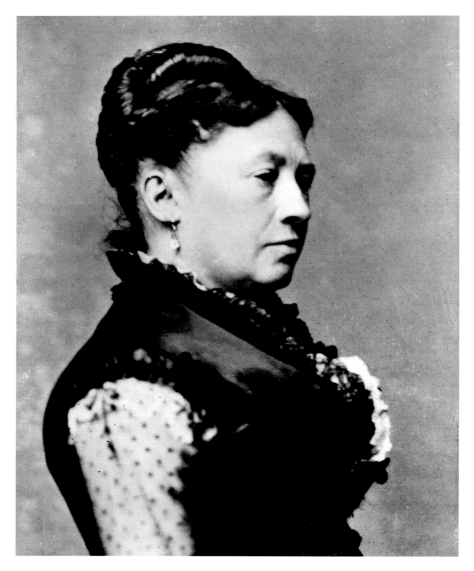

Above: Julia Grant, widow of President Ulysses S. Grant. *Library of Congress.*

Opposite: Frederick Dent Grant and Ida Grant. *Library of Congress.*

leading social figures in the city. She was one of the last of the society women to give up her horse and carriage for an automobile. Ida died in her New Hampshire Avenue home in 1930 at the age of seventy-six, attended by her daughter, the Princess Cantacuzène-Speransky.

BIRTH OF THE PHILLIPS COLLECTION

In 1895, Major Duncan Clinch Phillips, a Pittsburgh businessman and Civil War veteran, moved with his wife and two sons to Washington in search of a milder climate. He bought a lot at Twenty-first and Q Streets and hired the architectural firm of Hornblower and Marshall to design a house at 1600 Twenty-first Street that was completed in 1897.

The two Phillips sons, James and Duncan, were very close—so close, in fact, that when James, the older brother, was ready to leave home for Yale in 1902, he waited two years so that Duncan could graduate from secondary school and enroll at the same time with him. They graduated together in the class of 1908.

The brothers developed an early love of contemporary art, and in 1916, their efforts to identify and purchase modern paintings had become so

successful that James requested an annual stipend of $10,000 from their parents for the purchase of works of art for their growing collection.

Colonel Phillips died unexpectedly in 1917, and the following year, James died in the family home of the "Spanish flu," as the influenza outbreak of that year was called. In his grief, the thirty-two-year-old Duncan dedicated his life to building a suitable memorial to both his father and his brother by creating a museum in their honor originally called the Phillips Memorial Art Gallery.

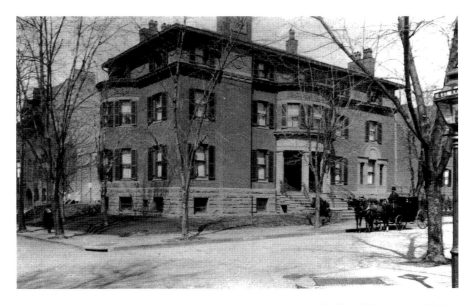

Above: Home of Major Duncan Clinch Phillips and now of the Phillips Collection at 1600 Twenty-first Street Northwest. *Phillips Collection.*

Opposite: Duncan Phillips Jr. (left); his father, Major Duncan Clinch Phillips (seated); and his brother, James, who died of influenza in October 1918. *Phillips Collection.*

In 1920, the architectural firm of McKim, Mead & White designed a second sky-lit story over the north wing of the Phillips house, which became the main gallery once the museum opened in 1921. The firm also provided plans for a new museum for the collection, but it was never built. Instead, the Phillipses built "Dunmarlin," a large house on Foxhall Road in Washington where they resided from the mid-1920s until the mid-1980s, leaving the existing building for the collection.

Duncan Phillips married artist Marjorie Acker in 1921, and the two worked closely over the years, establishing relationships with artists—both as patrons and collectors—curating exhibitions and rearranging and hanging exhibits in the galleries. Duncan Phillips served as the museum's director until his death in 1966. His son, Laughlin Phillips, served as the gallery's director from 1972 to 1992.

Once, when Duncan Phillips was standing with Albert Barnes of the Barnes Collection in Philadelphia in front of the Phillips Collection's signature work of art—Renoir's masterpiece *Luncheon of the Boating*

Party—Barnes asked, "That's the only Renoir you have, isn't it?" Duncan replied, "It's the only one I need."

Today, the Phillips Collection is still housed in the original family home facing Twenty-first Street that has since expanded north on the street and incorporated the last home of Curtis Hillyer as part of the museum as well.

Thomas Nelson Page

In 1893, author, club and society man Thomas Nelson Page gave up a successful law practice in Virginia and moved to Washington. That year he had also married Florence Lathrop Field, a Washington, D.C. native and widow of Henry Field, the grandson of Marshall Field and heir to the Chicago mercantilist's fortune. This was also Page's second marriage, his first wife having died in 1888.

Three years after moving to Washington, architect Stanford White designed a Georgian Federalist–style mansion on a prominent corner on New Hampshire Avenue and R Street at 1759 R Street Northwest. After settling into his new house, Page devoted himself almost entirely to his writing, and his home became the center of Washington literary life.

Page was one of the best-known writers of his day. In addition to fiction, he wrote prolifically about history, politics and social mores of the time. Yet his fictional works were often characterized by a distorted and nostalgic view of the old South in which the slaves were happy and simple and grateful for the care their masters provided for them. In his 1904 essay, "The Negro: The Southerner's Problem," he defended the white man's right to lynch for the crime of rape, claiming that black people were ultimately responsible for lynchings at that time because they did not attempt to punish alleged black rapists themselves.

Thomas Page had an opinion on almost everything and was not afraid to share it. He was a self-appointed monitor of good taste, class, society, morals, race, art and diplomacy. He had a disdain for the smart set, both that in New York and what he thought to be its humble imitator in Washington, and went so far as to say that he thought that the ostentatious homes of his neighbors in Dupont Circle were un-American. Page also alienated himself from the powerful naval social set due to remarks about its members cohorting too much with the decadent Newport crowd.

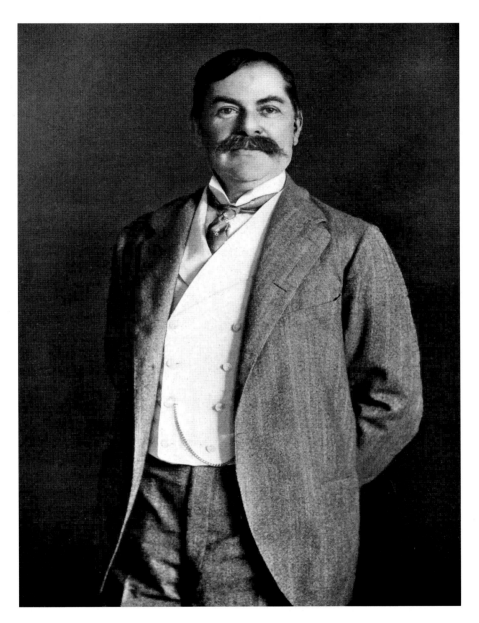

Thomas Nelson Page. *In* The World's Work.

The Pages had a particularly strong dislike of divorcés and claimed that divorced and doubly divorced people were leading New York and Newport society. Florence Page said that she had never received a divorcé in her home, nor had she ever called on one. She even carried her disdain of divorcés on to her daughters when they were young, as they were not allowed to associate with other girls whose parents had been divorced.

As the old saying goes, the chickens always come home to roost. In 1907, Page's own stepdaughter Minna Field, the eldest daughter of his wife from her previous marriage to Henry Field, filed for divorce from her husband, charging him with cruelty and seeking custody of their child. She then moved back in with the Pages. The Pages' efforts that same year to exclude Perry Belmont and his previously divorced wife from society were still fresh in the minds of Washington society.

Page's sometimes controversial opinions, which today would certainly keep anyone out of public life, had little effect on his career. President Woodrow Wilson appointed Page U.S. ambassador to Italy for six years between 1913 and 1919, after which time he returned to Washington to resume his writing career and died just three years later. His grand Georgian home now serves as the headquarters for the American Institute for Cancer Research.

Wanting to both be near her daughter-in-law, Florence, as well as to be in Washington during the winter season, Mrs. Albertine Field, together with George Vanderbilt, bought lots on New Hampshire Avenue for their homes, but neither ended up building their own houses in the city. Mrs. Field became a buccaneer herself, marrying Englishman Maldwin Drummond in 1908 and moving to England to live at his manor estate, Cadland, near Southampton. After renting a town house on Seventeenth Street, George Vanderbilt bought former Pennsylvania senator Matthew Stanley Quay's house on K Street, which he must have considered as a very quant cottage in comparison to his Biltmore estate in North Carolina.

George Westinghouse

In 1899, James Blaine's widow, Harriet, decided it was time to sell the old mansion at 2000 Massachusetts Avenue. By now, she was one of the wealthiest widows of Washington society and was living quietly among the Cave Dwellers in the old Seward House on Lafayette Square. She sold the house to millionaire air brake king George Westinghouse. During a few of

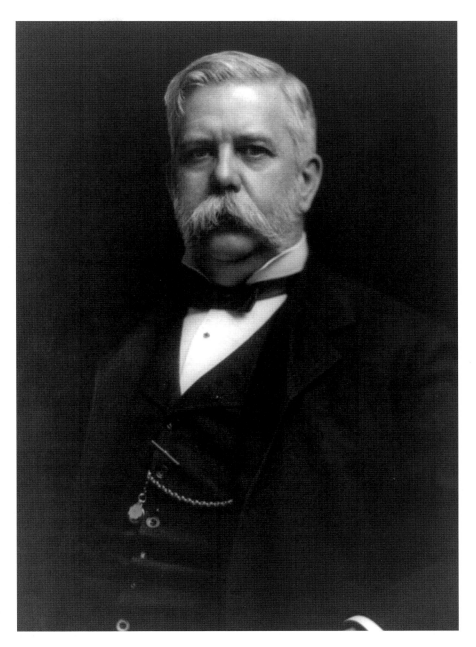

Railway air brake king, George Westinghouse. *Library of Congress.*

the previous social seasons, George Westinghouse and his wife, Marguerite, had taken suites at the Arlington Hotel.

The year they moved into the Blaine mansion, the Westinghouses gave their first reception in honor of the American Society of Mechanical Engineers. But the Blaine mansion was too small to accommodate the crowd. Mrs. Westinghouse added a gracefully designed temporary annex of forty by forty feet onto the west wing for the banquet hall that was removed after the party. It was touted by the press as the most brilliant reception of the season given in Washington.

The Westinghouses took a shining to the young members of the smart set. Once, George Westinghouse decided to throw a ball for them to be organized by Marguerite Cassini and Alice Roosevelt. According to Cassini, Westinghouse told the pair to make their own invitation list. The list was so long that Westinghouse once again had to build a temporary annex onto the ballroom. But the annex was not completed in time for the party, and to compensate, the Westinghouses ordered carloads of orchids to completely cover its unfinished walls. Unfortunately, the orchids wilted early in the evening, and Marguerite and Alice left well before their ball was over.

By 1909, the Westinghouses were hardly ever in the Massachusetts Avenue house as Mrs. Westinghouse preferred to spend time in England with their son. George and Marguerite both died within months of each other in 1914. The Blaine-Westinghouse mansion still stands today and is one of the last three grand mansions immediately on or near the circle today.

THE PALACES OF VANITY FAIR

That portion of the city that barely thirty years ago was laughed at has become one of the world's greatest centers for homes of wealth, luxury and refinement.
—Washington Times, *1902.*

The World's Columbian Exposition in Chicago in 1893 and its fairground, nicknamed the "White City," introduced the City Beautiful movement that flourished in the United States during the 1890s and the early years of the twentieth century. New York architects Richard Morris Hunt and Charles McKim of the firm of McKim, Mead & White, together with Chicago architects Louis Sullivan and Daniel Burnham, created the White City—an ideal city made up of classically designed monumental buildings. The descriptor white comes from the fact that the buildings were not only constructed of plaster of Paris and painted a chalky white but also lit by electrical lights at night, further adding to their grandeur and impact.

The City Beautiful movement introduced the concept of beautification and monumental grandeur to cities that had been ravished by industrialization, resulting in a lack of a sense of order, dignity and beauty. The fundamental idea promoted at the fair was that the cities no longer needed to be symbols of economic development and industrialization but could be planned with the goal of enhancing the aesthetic environment and, therefore, the quality of the lives of their inhabitants.

In Washington, D.C., the City Beautiful movement led to the creation of the 1902 McMillan Plan, named after its sponsor, Michigan senator

James McMillan. It was the first governmental plan to attempt to regulate aesthetics. The plan was the result of recommendations by the Senate Park Commission, which was composed of some of the major players in the planning of the Chicago White City: architects Daniel Burnham and Charles F. McKim, landscape architect Frederick Law Olmsted Jr. and sculptor Augustus Saint-Gaudens.

The essence of the McMillian Plan was to replace the slums surrounding the U.S. Capitol with monumental government buildings. At the heart of the design was the creation of the National Mall and improvements for the park system in and around the city. One of the grand statements of the plan was Burnham's 1907 Union Station. Unfortunately, the plan also promoted replacing older buildings with those that met the ideals and aesthetic of the movement, often without regard to their historical significance, including those of the old Cave Dwellers near the White House and around Lafayette Square. The McMillan Plan set the tone for monumental and residential architecture in the city and created a plan for public parks and green space in the capital that is still adhered to today.

The premier architectural style of the City Beautiful movement was Beaux Arts, a neoclassical style taught at the École des Beaux-Arts in Paris, where many American architects of the Gilded Age received their training before returning to cities like Chicago, New York and Washington to practice their craft for wealthy clients. The Beaux Arts style was adopted as the symbol of the smart set through which it could make an ostentatious statement about its wealth and power. As a result, Dupont Circle's older mansions, sometimes only a decade old or less, were systematically upgraded or replaced by new mansions in the newer Beaux Arts style.

Notable features of the Beaux Arts style were symmetrical façades of smooth, often light-colored stone or brick. Slightly overscaled yet restrained details included cornices, decorative swags or garlands, shields, pilasters, columns and corner quoins. The ground floors of these grand homes were often rusticated with exaggerated stone or brick joints that moved the eye up from street level to the main living floor, or the piano nobile—enforcing the impression that the home's inhabitants occupied a level higher than the outside observer standing on street level.

The next generation of millionaires arriving in Washington immediately after the turn of the century—still only to spend the season—were not of the class of the millionaires of the previous decade. These newcomers' fortunes were now the equivalent to billions in today's dollars. The next wave of mining kingpins was far richer than William Stewart had ever been. Politicians were

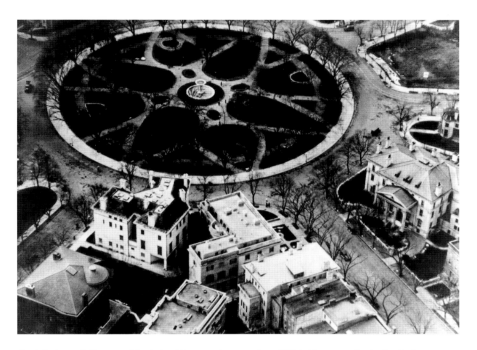

Aerial view of Dupont Circle looking southwest, circa 1924. Counter clockwise is the Boardman home on P Street (lower left), Elinor Patterson at 15 Dupont Circle and the Leiter mansion between New Hampshire Avenue and Nineteenth Street. In the upper right of the photo is the empty lot where Stewart's Castle once stood. *Library of Congress.*

wealthier and more powerful, and many could be considered plutocrats, representing entire industries rather than just their constituents back home.

At this time, the society pages of newspapers, both in Washington and nationally, read like a Dupont Circle social directory. In January 1911, the *Washington Post* society pages carried the following news item:

> *Dupont Circle was the hub of the social world last night. The ball at the home of Mrs. Leiter, in complement to Miss Helen Taft, preceded by a dinner given by Mr. and Mrs. Joseph Leiter; a dinner at the home of Mrs. Hitt, in honor of Mrs. French Vanderbilt; a dinner at the home of Mr. and Mrs. William J. Boardman, in complement to Miss Helen Taft…a dance for the younger people of the smart circles at the home of Rear Admiral and Mrs. Richardson Clover, and, earlier in the evening, a benefit for the Working Boys' Home at the residences of Mr. and Mrs. Bell…*

Even with this next explosion of wealth and building in Dupont Circle, the clock was ticking. With available space in the neighborhood filled, the next wave of settlers turned their attention to the area around the next public circle to the west, Sheridan Circle. South African gold-mining king Hennen Jennings and diamond mining engineer Gardner F. Williams both built their palatial new homes on Sheridan Circle by 1907. Sheridan Circle also began attracting residents away from Dupont Circle. Alice Pike Barney would build her famous Studio House there, and nine years later, Joseph Beale, who had only a few years before built his house at 2012 Massachusetts Avenue, built another home on Sheridan Circle.

Then came the Panic of 1907. It had a similar effect on development in Dupont Circle as did the Panic of 1893, and again construction on the grand homes almost stopped completely. This time, the panic was triggered by a failed attempt to corner the copper market that caused the bankruptcy of two major brokerage firms. The New York Stock Exchange fell almost 50 percent from its peak the previous year, taking with it much of the fortunes of those who had placed their money in invested trusts. As he had done in the financial crisis of the previous decade, financier J.P. Morgan again intervened and pledged large sums of his own money, convincing other New York bankers to do the same, in order to shore up and restore confidence in the banking system.

In addition to the banking scare, the first federal income tax was imposed in 1913 and introduced a progressive tax structure for high-income earners. With the imposition of income taxes and with fortunes that continued to suffer from the Panic of 1907, those who still had money became much more cautious with it.

With money in tighter supply, and with rising commercial rents elsewhere in the city, the owners of the large houses along Connecticut Avenue welcomed the opportunity to rent out part or all of their homes for office space and ground-floor stores. Connecticut Avenue from K Street to Florida Avenue became mostly commercial. Dupont Circle's Gilded Age was soon to come to an end.

JULES HENRI DE SIBOUR: DUPONT CIRCLE'S PREMIER BEAUX ARTS ARCHITECT

During the early 1900s, the most prolific Beaux Arts architect in the Dupont Circle neighborhood was Jules Henri de Sibour. The Beaux Arts–style homes that he did not design in Dupont Circle during this period proved the exception to the rule.

Jules Henri de Sibour was born in 1872 to an American mother—Mary Johnson, from Belfast, Maine—and a French father, Vicomte Gabriel de Sibour, who was a direct descendant of France's King Louis XVI. Jules grew up in both France and the United States, attending St. Paul's School in New Hampshire and then Yale University, graduating in 1896. Jules's pedigree made him one of Washington's elite socialites himself and was the perfect calling card for landing a large number of status-conscious clients.

After graduation from Yale, de Sibour took up architecture and began working for the architectural firm of Ernest Flagg and Bruce Price in New York City, who designed one of the best-known Beaux Arts–style buildings in the world, the Château Fontenac in Quebec City.

Bruce Price convinced de Sibour to go to Paris and receive formal training at the École des Beaux-Arts. He remained there for only eighteen months and, after returning to New York, made a name for himself as an architect. Bruce Price died in 1903, and de Sibour inherited the practice and continued to work under the name of Bruce Price & de Sibour.

De Sibour began designing homes and commercial properties in Washington in 1900 and maintained offices in both New York and Washington until 1911. In Washington, his work was not limited to only grand Beaux Arts homes in Dupont Circle—he was quick to follow the flow of new money west on Massachusetts Avenue to Sheridan Circle as well. He also designed dozens of office buildings, hotels, apartment buildings and other types of buildings throughout the city.

THE FOSTERS: THREE GENERATIONS OF SECRETARIES OF STATE

Like Washington's first governor, Henry Cooke, who used the *Ohio State Journal* to promote the Republican Party after the Civil War to gain favor with President Grant, Indiana-born, Civil War veteran, lawyer and editor

of the *Evansville Daily Journal* John Watson Foster also won the support of President Ulysses S. Grant.

President Grant launched Foster on a long diplomatic career with his first appointment as minister to Mexico in 1873 and again in 1880. President Garfield then appointed Foster minister to Russia, a post he held for only one year. After a brief return to private practice, Chester Arthur appointed Foster minister to Spain, where he served until 1885, whereupon he again returned to private practice and served as counsel representing foreign diplomatic legations in the United States.

In 1892, President Harrison appointed Foster secretary of state during the last eight months of his administration. Returning again to private practice, Foster represented sealing interests in Alaska. He was also an active citizen, serving as president of the Washington Society of the Archaeological Institute and attending the Church of the Covenant on N Street. In 1900, Foster made the move to Dupont Circle and contracted locally prominent architect Clarence Harding to build a four-story home at 1323 Eighteenth Street.

In 1890, Foster's daughter Eleanor married a legal advisor at the State Department, Robert Lansing, who replaced William Jennings Bryan as secretary of state in 1915, when Bryan resigned in protest of Wilson's approach to U.S. neutrality, although Lansing was opposed to Wilson's League of Nations. When John Foster died in 1917, the Lansings were living in the Foster home at 1323 Eighteenth Street, where Lansing later died in 1928.

Another of Foster's daughters, Edith, married Presbyterian minister Allen Dulles and their children included John Foster Dulles, who served as U.S. secretary of state under President Dwight D. Eisenhower, and Allen Welsh Dulles, the founder and longest-serving director of the CIA. Their daughter Eleanor Lansing Dulles went on to become an economist and diplomat.

Senator William A. Clark:
Montana Copper Croesus

In 1901, Montana senator William Andrews Clark, also known as the "Montana Copper Croesus," demolished Stewart's Castle, which he had purchased from William Stewart in 1899. Clark never occupied the castle himself and occasionally donated it for use for charity functions.

Clark had made his massive fortune in copper mining, electric power companies, railroads and newspapers and was known as one of the three

Senator William Andrews Clark. *Library of Congress.*

"Copper Kings" of Butte, Montana, along with Marcus Daly and F. Augustus Heinze. At the time of his arrival in Washington to fill a Senate seat in 1899, Clark was one of the two richest men in the United States, rivaled only by John D. Rockefeller at the time.

Unfortunately for Clark, as soon as he arrived in Washington, the news broke that he had bribed members of the Montana state legislature in return for their votes, and the U.S. Senate refused to seat him. But Clark's second Senate campaign was successful, and he served a single term from 1901 until 1907. In responding to criticism of his bribery of the Montana legislature, Clark is reported to have said, "I never bought a man who wasn't for sale."

Mark Twain detested William Clark and in a 1907 essay entitled "Senator Clark of Montana," he wrote:

> *He is as rotten a human being as can be found anywhere under the flag; he is a shame to the American nation, and no one has helped to send him to the Senate who did not know that his proper place was the penitentiary, with a ball and chain on his legs. To my mind he is the most disgusting creature that the republic has produced since Tweed's time.*

Clark was undoubtedly inspired by the location and size of the Stewarts' mansion and was planning on replacing it with something even larger as a statement of his vast wealth. But after a rocky start in Washington politics, he was not certain how long he would be staying in town and therefore probably did not want to invest in a large house and be tied down in the city. Instead, he leased a twenty-room home next door at 1915 Massachusetts Avenue whose eastward-facing windows looked over the huge hole in his empty lot.

Clark left Washington after his Senate term for the 121-room mansion he built on Fifth Avenue in New York City, which was completed in 1908 after ten years of legal disputes. Millionaire senator Winthrop Murray Crane of Massachusetts, who had been residing at the Willard Hotel, then moved into the Massachusetts Avenue house and lived there with his new bride, Josephine Boardman.

Clark held on to the Stewart Castle lot until 1921, when he sold it to an automobile dealership that built a showroom on much of the lot. In 1922, Riggs Bank constructed a building to the west of the showroom and later acquired the showroom, incorporating it into the bank.

Clark died in his New York City mansion at the age of eighty-six, one of the fifty richest Americans ever. Clark's New York City home stood for only twenty years and was demolished two years after his death in 1925.

Clark had originally willed his $3 million art collection to the Metropolitan Museum of Art in New York with the condition that a special room be provided to display the collection. Due to a lack of space, the Metropolitan Museum declined the gift, and it was given to the Corcoran Gallery of Art in Washington. But Clark's collection was no stranger to the Corcoran. Before his New York mansion was finished, and needing a place to temporarily house his collection, he loaned it to the Corcoran for display. He also donated $100,000 to the Corcoran to endow a prize fund for American artists, with the remainder to be spent on acquiring works by American artists.

Clark's youngest daughter, Huguette Marcelle Clark, one of two children from his second marriage, only recently died in 2011 at the age of 104. In her later years, she was a recluse, living in hospitals for more than twenty years while her mansions, though empty, were meticulously maintained. She left behind a fortune of more than $300 million, most of which was donated to charity. Huguette shared her father's special affinity for the Corcoran Gallery of Art and bequeathed the gallery one of Claude Monet's water lilies paintings. But because her will was contested by relatives, the Corcoran lost the painting and received a settlement of $10 million instead.

MARY TOWNSEND

Mary "Minnie" Scott Townsend was the daughter of William Scott, a Pennsylvania railroad and coal magnate who had once served as a Democratic member of Congress. Her husband, Richard Townsend, was president of the Erie and Pittsburgh Railroad. When Minnie's father died in 1891 and she inherited his massive fortune, she decided to return to Washington. The Townsends opened up her father's old house at 22 Jackson Place on Lafayette Square, where Minnie had lived while he was in Congress. But times had changed since that house was built and they had first occupied it. The small, intimate receptions and dinners of the old Cave Dwellers were no longer fashionable, and large dinner parties were now a must. The Townsends enlarged the house in order to accommodate a larger dining room. But the house still did not provide enough space to meet her social needs, and Minnie began the search for a larger property. Her eyes turned to Dupont Circle, and in 1898, the Townsends bought Curtis Hillyer's house on Massachusetts Avenue, just across the street from her dear friends the Patten sisters.

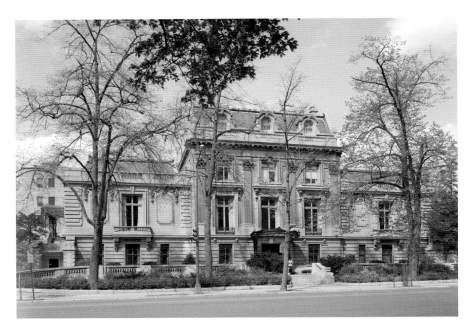

The Townsend mansion, former home of Curtis Hillyer, at 2121 Massachusetts Avenue Northwest. It is now home to the Cosmos Club. *Library of Congress.*

The Townsends had originally planned to move directly into the Hillyer house as it was because Minnie had a fear of living in a totally new house, believing that it would bring about her premature death. But the old-fashioned Hillyer house did not meet Minnie's social and entertaining requirements in its current state. Rather than tearing the old house down, she decided to remodel and enlarge it. For this, she used the architectural firm of Carrere & Hastings in New York, which had done the modifications to her residence on Lafayette Square.

Under the Townsends' direction, Curtis Hillyer's house went through a remarkable transformation. The high steps leading to the main entrance were removed, and the new entrance was placed on street level. The interior was entirely renovated, leaving nothing of the old house except the exterior walls. Two large wings were added on the east and west sides of the house to accommodate a spacious ballroom and library. The front and back were also added on to. When finished in 1900, the Second Empire–style Hillyer house became a grand statement of the Beaux Arts style.

In the end, no part of the original Hillyer house was visible, yet enough of the old house remained to put Minnie's mind at rest about her fear of

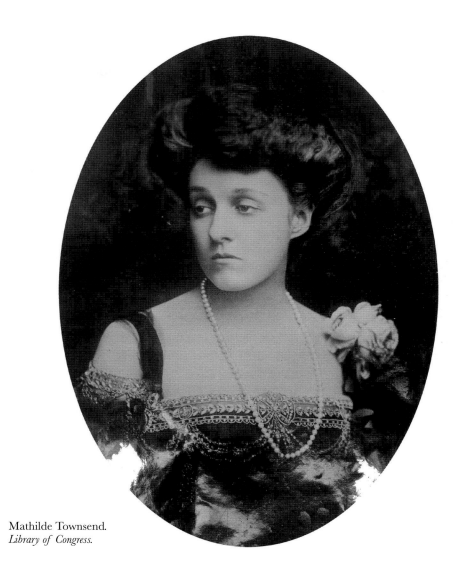

Mathilde Townsend.
Library of Congress.

dying as a result of living in a new house. Unfortunately, Minnie's successful conquering of her superstition did not apply to her husband. Richard was thrown from a horse in Rock Creek Park and died from a broken neck in 1902, shortly after the house was completed. Minnie would continue to live in the house until her death in 1931.

Minnie, to whom Mary Leiter's torch as the leader of the smart set was passed, attracted the most brilliant and cosmopolitan people in the

city with her magnetic personality. Like Mary Leiter, she entertained with elaborate ceremony, and her elegant sit-down dinners for one hundred guests at a time were not to be equaled. She is said to have spent as much as $240,000 a year (about $6 million in today's dollars) running the house and entertaining.

Minnie's friends across the street, the prudish Patten sisters, were probably not privy to all that went on in the Townsend house. Minnie played matchmaker to the married German ambassador Count Johann Heinrich von Bernstorff and often made her house available for his various trysts, which included the married Cissy Patterson.

The Townsends' only child, Mathilde, was a close friend of Alice Roosevelt and Marguerite Cassini and was one of Dupont Circle's social brat pack. Mathilde's first marriage in 1910 was to Rhode Island senator Peter Goelet Gerry, and that marriage ended in divorce in 1925. Gerry would later marry Edith Stuyvesant Dresser Vanderbilt, the widow of George Vanderbilt, who had died in Washington in 1914.

LARZ AND ISABEL ANDERSON

By the time he moved to Washington, diplomat Larz Anderson was not a stranger to the city. His parents owned a home at 1530 K Street that had been designed by famed architect and friend of his father's, Henry Hobson Richardson, and it was here that Larz would stay when visiting his parents during school breaks.

Larz's diplomatic career began in 1891 when fellow Harvard fraternity brother Robert Todd Lincoln, who was then serving as the U.S. minister to the Court of St. James's in London, secured Anderson a post as the second secretary of the American Legation in London. Three years later, Anderson was appointed first secretary of the American Embassy in Rome and served for a short time as the charge d'affaires. While in Rome, Larz met Isabel Weld Perkins, whom he married in Boston in 1897.

Isabel Perkins was the daughter of Commodore George Hamilton Perkins and heiress to her grandfather's fortune of $17 million. She, unlike other young women with such wealth, wisely turned down marriage proposals from titled foreigners. The couple spent a short season in Washington

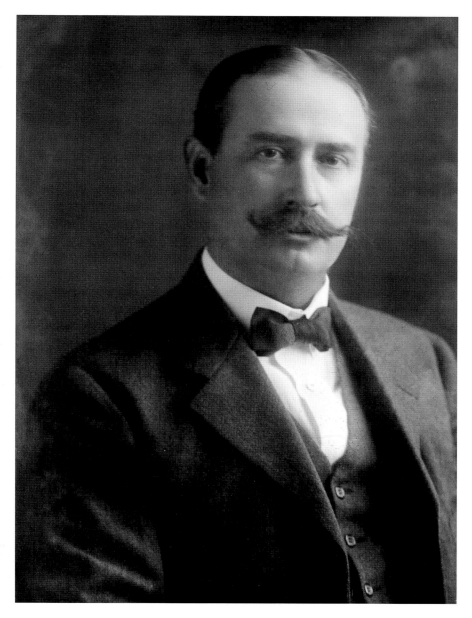

Larz Anderson. *Library of Congress.*

The Anderson house at 2118 Massachusetts Avenue Northwest, now the headquarters and museum of the Society of the Cincinnati. *Library of Congress.*

immediately after their marriage, but at that time, they were not much interested in local social life. After a few years of extensive travel, they decided to make Washington their winter home.

The Andersons initially had the option of moving in with Larz's mother, but a difference in lifestyles precluded that option. Larz bought several lots from the Patten sisters immediately to the east of their house on Massachusetts Avenue and hired the Boston firm of Arthur Little and Herbert Browne to design a fifty-room, Italian-style palace, modeled after the Ludovisi Palace in Rome, at 2118 Massachusetts Avenue.

By the time it was finally completed in 1905, the house and its elaborate interiors had cost $800,000 to build. The Andersons then filled it with fine furniture, tapestries, paintings and objects they had gathered in their world travels. The house was intended only to serve as the couple's winter residence during the Washington social season and was one of several homes they owned. When they were in town, their time was spent hosting diplomatic

and inaugural receptions, formal dinners and luncheons, concerts and dramatic performances in the house's two-story ballroom.

In Isabel's 1940 published collection of her husband's letters, she included one that described their dinners at the house:

> *Our dinners proved successful. The house was full of flowers,—azaleas, orchids, miles and tulips. We remained, I believe, the only house in Washington, except the Embassies, which turned out the servants in full-dress livery, shorts and stockings, buckled shoes, and braided coats. These dinners were swan songs to the old order.*

The Andersons enjoyed a lavish lifestyle and were not afraid of being ostentatious with their money. Mrs. Anderson once wore a $500,000 gown when she was presented at court to King Edward VII and Queen Alexandra. The spectacle made the queen visibly gasp.

During the Spanish-American War, Larz served as a captain and then as assistant adjutant general of the Second Army Corps. After the war, he and Isabel devoted themselves to outside interests, splitting their time between Washington and Boston. In 1911, President Taft appointed Larz Anderson minister to Belgium and, the following year, ambassador to Japan. Larz retired from the diplomatic corps in 1913.

Isabel Anderson was a respected author of plays, poetry, fiction and a number of travel books. During the First World War, she became involved in the American Red Cross and Belgium Relief work, serving as an organizer and colonel in command of the corps under Mabel Boardman. Mabel Boardman had developed the idea for the Washington Refreshment Corps that would feed hungry soldiers en masse who were arriving in Washington and then handed it over to Isabel to organize and manage. Isabel started with 36 volunteers and ended up with 150 in charge of the daily stocking of a kitchen trailer and sandwich truck in the Andersons' three-story carriage house. This experience provided enough training that in September 1917, Isabel left for Europe for eight months of service in the Red Cross canteen at Epernay and in hospitals on the Belgium and French fronts. She was awarded the French Croix de Guerre, the Royal Belgian Medal of Elizabeth with Red Cross, and the American Red Cross Canteen Medal.

By the 1920s, the Andersons were no longer staying much in Washington, spending their time in Europe, on world tours or at their other homes instead. In 1920, Isabel wrote her memoirs of the time she spent in Washington and working for the war effort, which was entitled *Presidents and Pies*.

When Larz died in 1937, Isabel's attention again turned to Washington as a place to inter his remains. She built St. Mary's Chapel in the Washington National Cathedral for his final resting place, and when she died in 1948, her ashes were joined there with her husband's. Larz had always intended that the house on Massachusetts Avenue should eventually become the headquarters of the Society of the Cincinnati, which his great-grandfather Colonel Richard Clough Anderson had founded and of which Anderson was a member. The society's members are descendants of certain commissioned officers who served during the Revolutionary War. After Larz's death, Isabel donated Anderson House to the society for its headquarters and a museum. It still serves as the national headquarters for the society today. The house, still with its original furnishing, is open to visitors. Musicales in the old Anderson tradition are still held in the ballroom.

HERBERT AND MARTHA WADSWORTH

When Herbert and Martha Wadsworth from New York decided to build a winter home in Washington, there were only two lots left on Dupont Circle large enough to accommodate a respectable-sized mansion. On one of those lots still sat the old Holy Cross Episcopal Church. In 1896, Charles Van Wyck's widow, Kate, sold the lot, along with the deconsecrated church, to the Wadsworths.

Although many other wealthy Americans at the time arrived in Washington cold, not knowing anyone, the Wadsworths already had established family connections to the city and had been traveling to the city frequently to visit friends and relatives. Herbert's cousin, James Wadsworth, had been in Congress since 1881, and Martha's late sister, Nelly, Madame De Smirnoff, had been a well-known Washington socialite. Her daughter, Nelke, remained in town.

The Wadsworths chose architect and longtime friend George Cary to design a house for the pie-shaped lot, although Martha often claimed she had designed it herself. A prominent Buffalo Beaux Arts architect, Cary is perhaps best remembered today for the New York State Pavilion at the Pan American Exposition of 1901.

Construction of the house began in 1900 and by the time it was completed, the cost exceeded $85,000. The Wadsworths' pie slice–shaped house located at 1801 Massachusetts Avenue was designed specifically for entertaining, boasting a dramatic two-story ballroom with a musicians

Home of Herbert and Martha Wadsworth at 1801 Massachusetts Avenue Northwest, now the Sulgrave Club. *Library of Congress.*

gallery. Another unique feature of the house was the drive-through carriage entry that, like that of the Boardmans across the street, went through the house from front to back, off which was also the main entrance to the house. Opposite the main entrance in the drive through was an automobile room, one of the first parking garages in the city.

Martha was always organizing some type of social event, either beauty lessons, a barn dance or jiu jitsu classes—Martha was one of the first women in America to achieve the rank of black belt in jiu jitsu. She once organized an ugliest baby photograph competition. Martha's husband, Herbert, won, and Marguerite Cassini came in second.

On Thursday evenings, Martha would host small dances with musicians playing waltzes and polkas. For these, she demanded a commitment from her invited guests at the beginning of the social season: either every Thursday or specific Thursdays designated by the guests in advance. Dinner was served at ten in the evening, followed by the dance. For these dances, the ballroom was often so dimly lit that guests could not see one another. When Lent season arrived, the weekly dances were replaced with a musicale.

Mrs. Wadsworth was also a fine pianist in her own right and one of the earliest promoters of the musical arts for amateurs in Washington. She offered singing classes held throughout the season in her ballroom. The classes consisted of forty women of the smart set, and they would give small concerts at the house on Saturday evenings. At this point, everyone began giving musicales in their homes with suppers served afterward. But everyone agreed that Phoebe Hearst still had the best musicales. The Wadsworths also backed the organization of Washington's first orchestra, the Washington Philharmonic Orchestra.

One night, Martha woke up to find Marguerite Cassini dumped on an upstairs sofa. At the age of seventeen, Marguerite had decided to end her life over a failed romance. That evening, she had her coachman drive from pharmacy to pharmacy, collecting small portions of poison that she claimed she wanted to use to put down her ailing dog. When she thought she had enough, she took it all in the back of the coach. Her last stop was undoubtedly Thompson's Drug Store on Dupont Circle. When she suddenly changed her mind and called out for help, the driver turned into the Wadsworths' carriageway. Marguerite was carried upstairs and laid out unconscious on a sofa. Martha immediately called the doctor, who told her the only way to save her was keep her awake until the poison wore off. Martha was up to the task. She had Marguerite carried into the ballroom, laid on the bare floor and set to work slapping her, rolling her and dragging her across the room, punching and finally getting her to walk. Marguerite preferred to die than suffer through Martha's treatment, begging to be allowed to, but Martha was determined that she would not. When morning came, Martha had won, and Marguerite lay on the floor still alive and sleeping soundly.

As the Wadsworths grew older, they spent less and less time in Washington. The house was used in 1918 by the local chapter of the Red Cross and then only sporadically by the Wadsworths. It then stood empty for twelve years. Through the efforts of Mabel Boardman, the house was purchased in 1932 for the headquarters of the new Sulgrave Club for women. Had Mabel and the club's organizing committee not acted when they did, the house would have become a Masonic Lodge.

Members of the Sulgrave Club represented the top tier of Washington's power women in the political, judicial, diplomatic, communications and business fields. Cissy Patterson became a charter member of the club, and Helen Taft became an honorary member its first year. Isabel Anderson and Alice Roosevelt Longworth also joined shortly thereafter.

THE WALSHES AND THE MCLEANS

In 1903, Thomas Francis Walsh, who had emigrated penniless from Ireland in 1869 at the age of nineteen, completed the most expensive private house at the time in Washington, at the cost of $835,000. After losing his life's savings in the Panic of 1893, Walsh then made a second fortune by discovering and opening the Camp Bird gold mine in Quary, Colorado. At its peak, the mine was producing $5,000 worth of gold per day. Walsh sold the mine in 1903 for $5 million and decided to plant roots in Washington.

When Tom Walsh arrived in Washington in 1898 with his wife, Carrie; son Vinson; and daughter Evalyn, he first purchased a house at 1825 Phelps Place in Washington's Sheridan-Kalorama neighborhood. Walsh did not know what exactly would be required to properly set up a home with all the necessary accoutrements required of his new status, so he bought the house completely furnished with all the books, ornaments, rugs, curtains, towels and other intimate appurtenances of the "cultured."

It was in this house that Walsh's daughter, Evalyn, was introduced to friends Alice Roosevelt and Marguerite Cassini. Evalyn was shocked at a party in the house to see Alice offer a cigarette to Marguerite Cassini, something very taboo in 1901. The house still stands and is now the Russian Cultural Center.

In 1901, Walsh hired New York architect Henry Anderson, who designed the massive four-story, sixty-room mansion at 2020 Massachusetts Avenue. The mansion featured a unique façade of combined Renaissance, Baroque and Louis XVI architectural elements, within an overall Art Nouveau context. The Walshes referred to the house simply by its street number, 2020 ("twenty-twenty").

The interior of the house was just as spectacular as its exterior. Walsh wanted a main staircase reminiscent of an ocean liner, so Anderson created an open-decked promenade of carved mahogany through three floors of the house. He placed a ballroom with a pipe organ on the top floor of the house and installed a rope-pulled elevator to reach it. But the elevator only held four people at a time, and the Walshes would often invite four hundred guests to their balls. It could take up to an hour and a half for all the guests to reach the ballroom. An apartment was created in the house for family friend King Leopold of Belgium, which was later used by his son, King Albert, when he visited Washington. There is a legend that a slab of gold is built somewhere in the foundation.

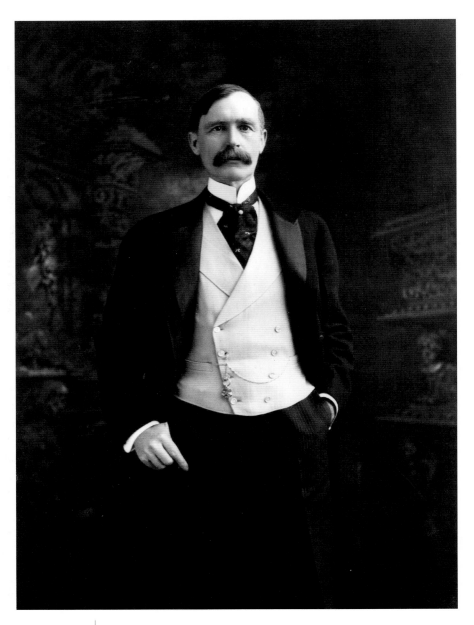

Thomas Walsh. *Library of Congress.*

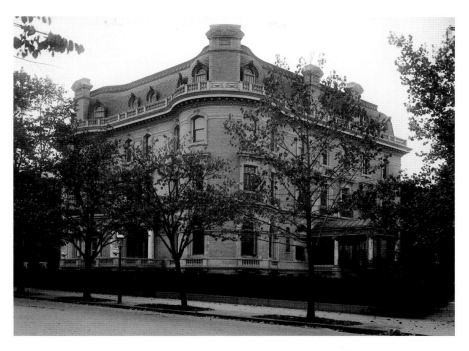

Thomas Walsh mansion at 2020 Massachusetts Avenue Northwest. *Library of Congress.*

One of the Walshes' dinner parties was said to have cost $200 a plate. The great room in which it was served had been converted into a flower garden, with flowers sent from Florida and fruit from California by special express. An orchestra played operatic selections from behind a lattice of 'American Beauty' roses. Hanging from the ceiling and suspended just over the dining room table was a great flower balloon, lit with electric lights. At the end of the dinner, the balloon swung open and a shower of songbirds greeted the guests with a rhapsody of melody.

In the summer of 1905, while staying in a rented house in Newport, the Walshes' son Vinson was killed when he lost control of an electric car he was driving. Evalyn was also in the car but survived with a crushed leg from which she would never completely recover. Ironically, Evalyn would name her own son Vinson after her brother; he, too, would die in childhood also as the result of an automobile accident.

After Thomas Walsh's death in 1910, Carrie Walsh continued to live and entertain at 2020. In 1919, she converted much of the house into a garment factory, where she and her "war workers" were busy converting

used and discarded clothes into clothing for needy European children after the war. The salons of the house were full of tables of garments and chests and boxes of materials. One room was dedicated to sewing machines; another contained knitting machines and turned out sweaters, stockings and mufflers. It was Carrie's intent that this work would serve as a model for other American cities.

In 1919, Carrie Walsh hosted a dinner given by Vice President and Mrs. Thomas Marshall for Belgian king Albert and Queen Elizabeth. The Marshalls were filling in for the ailing President Wilson, as the White House was no longer a suitable venue for state dinners. The Marshalls, who were close friends with Mrs. Walsh, asked to use her home. Mrs. Walsh was the only person not of official society at the dinner, but afterward, she was decorated by Queen Elizabeth, not as a courtesy for the dinner, but for her work for the benefit of those in the devastated regions of Belgium, France and Italy during the war.

In 1908, Evalyn Walsh married Edward "Ned" Beale McLean. Through his father, Ned was heir to both the *Washington Post* that John McLean had acquired from Beriah Wilkins in 1905 and the *Cincinnati Enquirer* publishing fortune. Evalyn's close friend and confidante Alice Roosevelt never took a liking to Ned and called him a "pathetic man with no chin and no character." While the McLeans spent some time at 2020, they spent most of their time at Friendship, a sprawling country mansion on Wisconsin Avenue in Washington designed by John Russell Pope for Ned's father. In addition to the Hitt mansion on New Hampshire Avenue, Pope also designed more than two dozen notable Washington buildings, including the Jefferson Memorial and the National Gallery of Art.

Ned and Evalyn had four children: Vinson Walsh McLean, Edward Beale McLean Jr., John Roll McLean II and Evalyn Washington McLean. Vinson, their first child, was popularly known as the "Million Dollar Baby."

In 1911, Ned McLean paid Pierre Cartier $180,000 (over $4 million in today's dollars) for the 45.52-carat blue Hope Diamond. Along with it, he bought another famous diamond, the 94.00-carat Star of the East. The Hope Diamond is supposedly cursed, and many of the events of Evalyn's life have been attributed to that curse. It was rumored that she would even let her dog wear the diamond. When she fell on hard times in the 1930s, the Hope Diamond was in and out of pawnshops.

Evalyn and Ned's ill-advised and highly publicized trip to Russia shortly after the Russian Revolution to try to get Ned's uncle George Bakhneteff reinstated as the Russian minister to the United State is memorialized in the famous 1934 Cole Porter song "Anything Goes" in the lines:

Ned and Evalyn McLean. *Library of Congress.*

When Mrs. Ned McLean (God bless her)
Can get Russian reds to "yes" her,
Then I suppose
Anything goes.

By 1927, the McLeans' marriage was on the rocks. Evalyn's addiction to morphine and Ned's alcoholism and infidelities led to their eventual separation, and Evalyn filed for divorce in 1929. Evalyn eventually decided against a divorce and had Ned declared insane in 1933. Ned died eight years later in a Baltimore hospital, leaving Evalyn with little money, as they had gone through a fortune of $100 million while in the prime of their lives. Carrie Walsh died in 1932 in the Massachusetts Avenue house that she had willed to Evalyn.

The Pattersons

Ten years after the Leiters had finished building their palatial house on New Hampshire Avenue, fellow Chicagoans Robert and Elinor "Nellie" Patterson would follow their lead and take the first steps in joining Washington society. Soon after the Pattersons arrived, they built a gleaming, white marble, Beaux Arts–style mansion on Dupont Circle.

Nellie was the daughter of Chicago newspaper tycoon Joseph Medill, the editor and publisher of the *Chicago Tribune*. Joseph Medill was also a cousin of Stanley McCormick, the schizophrenic son of "Reaper King" Cyrus McCormick, who would buy the old Noble mansion on Massachusetts Avenue a few years after the Pattersons moved to Washington.

In 1899, Nellie decided to test the social waters and rented a house on Sixteenth Street in which to spend her first winter season in Washington, and she became an immediate social success. She was joined in Washington by their daughter, Cissy, who was having a difficult time staying in boarding schools. Robert Patterson had little taste for Washington and its social life and quickly returned to Chicago after having helped Nellie select an appropriate rental house.

After a second successful season in Washington, Nellie decided to stop renting and build her own home. She bought a third of an acre lot immediately on Dupont Circle, just across from the street from the Leiters. Her socially competitive elder sister, Katharine "Kate," jibed her about moving to a "malaria swamp" at "Dupont Hollow," although not many years later, Kate and her husband would build their own house even farther out at 3000 Massachusetts Avenue.

In 1893, Nellie's father had contracted architect Stanford White to design Nellie and Robert's house in Chicago, and in 1901, Nellie again chose White to design her new house on Dupont Circle.

The 36,470-square-foot, four-story, thirty-room house with an elaborate white marble–faced exterior was finally complete at the end of 1903. The house also boasted the second enclosed garage to have been built in Washington, D.C.—the first was the Wadsworths'.

The north wing of Nellie's nearly completed home on Dupont Circle caught fire and suffered water damage when paint cans stored in the attic spontaneously combusted, causing thousands of dollars of damage, but the house was still finished in time for their planned move-in date of January 1, 1903. One year later, Nellie officially inaugurated the house with a dance to introduce their daughter, Cissy, to Washington society. This was not the first

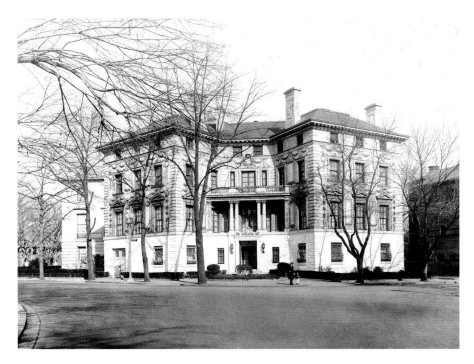

Patterson mansion at 15 Dupont Circle. *Library of Congress.*

time that Cissy, who was getting a little too advanced in age for such affairs, had been introduced to society, but Nellie needed an excuse for a party to show off her new house.

When Cissy's uncle Robert McCormick was named ambassador to Austria-Hungary in 1901 by President Roosevelt, Cissy accompanied him and her aunt Kate to Vienna, where Cissy met and fell in love with the penniless thirty-five-year-old Polish count Josef Gizycki. Nellie Patterson did everything in her power to keep Cissy from marrying the count, but to no avail. Robert Patterson even refused to pay Cissy's dowry, but that did not deter the count, as he knew he would be able to get money out of the Pattersons in other ways.

The count insisted on a Catholic wedding and found a Catholic priest at St. Matthews Church who was willing to marry the mixed-faith couple on unconsecrated ground at 15 Dupont Circle. After the wedding, Cissy returned with Count Gizycki to his home in what was then Russian Poland. Gizycki turned out to be a gambler and womanizer and was violent with

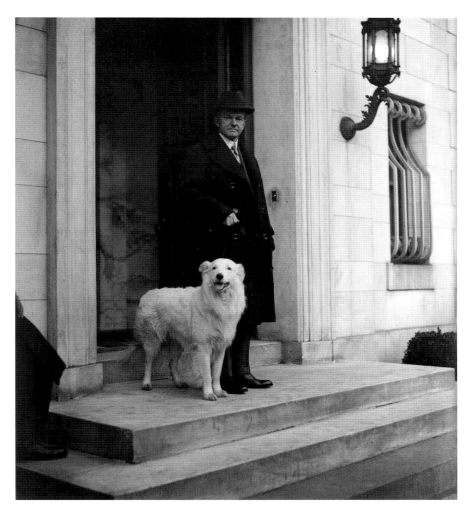

Above: President Coolidge on the steps of Patterson mansion when it served as the "Temporary White House." *Library of Congress.*

Opposite: Cissy Patterson. *Library of Congress.*

Cissy as well. When Cissy finally decided to call it quits, she fled with their daughter, Felicia, to London. The count had the girl kidnapped and hid her in an Austrian convent, demanding $1 million in ransom. Cissy filed for a divorce, which took thirteen years to obtain. President Taft and Czar Nicholas II both intervened in the eighteen-month effort to secure the release

of Felicia. Gizycki was imprisoned and reportedly never contacted Cissy or his daughter again.

In April 1910, Robert Patterson, whose health had been failing for years, died from an overdose of barbiturates. Nellie continued with her busy social schedule in Washington for another thirteen years but grew frustrated living in Dupont Circle, as she thought it was becoming too congested, and returned to Chicago. Her son, Joe, was ensconced in his job at the *Tribune* back in Chicago and had no interest in the Dupont Circle house, so in 1923, Nellie deeded it to Cissy.

In 1927, President and Mrs. Coolidge occupied the Patterson house for approximately six months while the White House was undergoing extensive repairs. During their occupancy, the house was often referred to as the "Temporary White House." While there, the Coolidges entertained Charles Lindbergh when he was in town to receive the Distinguished Flying Cross.

In 1920, Cissy had begun writing for her brother Joseph's new newspaper, the *New York Daily News*, as well as working for William Randolph Hearst. In 1930, her new husband of only four years, Elmer Schlesinger, died, at which point she legally changed her name back to Eleanor Medill Patterson. That same year, Hearst made her editor of both his *Washington Herald* and the evening *Washington Times* newspapers.

Architect Stanford White

Stanford White, the architect of the Patterson and Thomas Nelson Page houses, was a name partner in the architectural firm of McKim, Mead & White, a preeminent firm of the Beaux Arts architectural style that defined the look of the Gilded Age. White designed private homes for the rich and various public, institutional and religious buildings. In addition to Nellie Patterson's house in Chicago, White designed and decorated Fifth Avenue mansions for the Astors, the Vanderbilts and other high-society families.

In 1906, Stanford White met with an untimely death. Only three years after completing the Patterson house, he was shot dead at Madison Square Garden in New York City by Harry Kendall Thaw, the jealous husband of Evelyn Nesbit, a popular American chorus girl, with whom White had an affair.

The night of White's murder, Harry Thaw, Evelyn and Ned McLean's uncle, Truxton Beale, were enjoying dinner at Martin's Restaurant when Thaw got up and left the table abruptly. Beale then heard a pop. Thaw

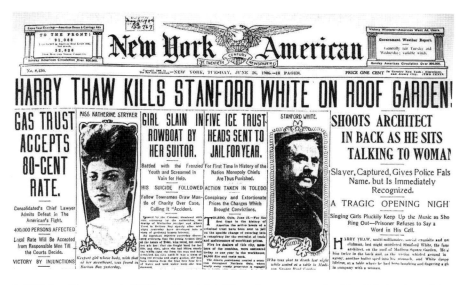

A 1906 headline story in William Randolph Hearst's newspaper the *New York American* of the murder of architect Stanford White by Harry Thaw.

returned to the table and said, "Here, Truxton, you take Evelyn home. I've just shot Stanford White." Truxton hustled Evelyn Nesbit down to the street, where they both jumped into a taxicab. Truxton caught a train for California. Thaw was found not guilty by reason of insanity. Truxton Beale did not return from the West Coast until the trial was over.

William Randolph Hearst played up the murder in his newspapers, with it becoming known as the "Trial of the Century." The story became the basis of the 1955 movie *The Girl in the Red Velvet Swing*, starring Ray Milland as Stanford White and Joan Collins as Evelyn Nesbit Thaw.

SOCIETY'S BRAT PACK

When Cissy Patterson first came to Washington to visit her mother during school holidays, she—along with President Roosevelt's daughter Alice and Marguerite "Maggie" Cassini, the ward of the Russian ambassador—was one of the leading young lights in Washington society. The trio was only the tip of a social iceberg of younger members of official society and the younger smart set. Also numbered among them were Martha Wadsworth's

niece Nelka Smirnoff, Mathilde Townsend, Katherine Elkins, the Patten sisters and Charles Bell's two daughters, Grace and Helen.

Alice was the eldest child of Theodore and Edith Roosevelt. When Roosevelt took office, "Princess Alice," as she was known, became an instant White House sensation. She smoked cigarettes in public and even on the roof of the White House after her father forbid her to smoke "under" his roof. She rode alone in cars with men and stayed out late partying. She kept a pet garter snake named Emily Spinach (after an aunt) in her pocket and was seen placing bets with a bookie. Once asked about his daughter's exploits, Teddy Roosevelt replied, "I can either run the country or I can attend to Alice, but I cannot possibly do both."

Upon leaving the White House after her father's second term, Alice is said to have buried a voodoo doll of the new first lady, Nellie Taft, somewhere in the front yard. Her public insults of Mrs. Taft caused her to be banned from the White House. She was also banned from the White House by the Wilsons due to her outspoken opposition to the League of Nations.

Marguerite Cassini came to Washington at the age of sixteen in 1898, ostensibly as the niece of the unmarried Russian minister, Count Arturo Paul Nicholas Cassini. The truth was that she was actually his daughter and the nurse that came with the pair was the minister's wife and Marguerite's mother. The reason for the ruse was that Marguerite's mother had no social status, and Tsar Nicholas II refused to recognize the marriage. Marguerite served as the minister's social hostess, which was usually the responsibility of the minister's wife. Finally, the tsar admitted that he knew that Marguerite was the minister's daughter and offered to correct the situation by granting her the title of countess, a title that she was already using in Washington. She then returned to Washington as her father's adopted daughter. The mother, unfortunately, continued to play the role of the nurse. Marguerite left Washington in 1905 to return to Russia with her father and did not return to Washington for thirty years.

Cissy's early friendship with Alice Roosevelt later developed into an ongoing, sometimes comical, other times bitter feud across Dupont Circle. They even sparred over men, including Alice's husband, Nicholas Longworth. "If any man ever caused trouble between Cissy and me," Alice Roosevelt Longworth mused long after, "it was…Nick. He adored her."

Washington rumor also tells of a dinner party at Alice's at which Cissy was said to have monopolized a young nobleman in a secluded upstairs room. He had been Alice's dinner partner, though it was not certain who the young man was. The following morning, Alice sent Cissy a note informing

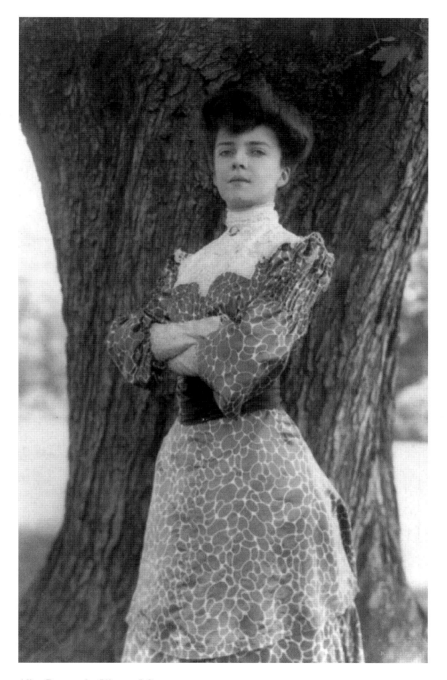

Alice Roosevelt. *Library of Congress.*

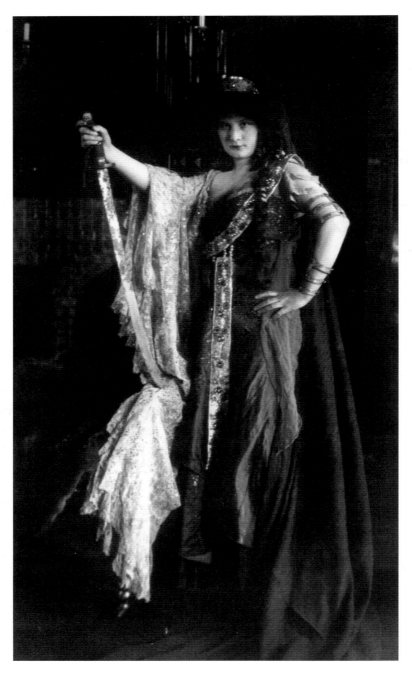

Countess Marguerite Cassini in a makeshift costume for one of Alice Pike Barney's parties. *Library of Congress.*

her that "upon sweeping up the library this morning, the maid found several hair-pins which I thought you might need and which I am returning." Cissy was reported to have replied: "Many thanks for the hair-pins. If you had looked at the chandelier you might have sent back my shoes or my chewing gum." While both Cissy and Alice claimed the rumor was not true, other incidents supported its veracity.

One evening at a dinner party hosted by the Longworths, Alice caught Cissy and Alice's husband, Nicholas, on the floor of an upstairs bathroom, with the light on and the door unlocked. Alice retaliated by having a lasting affair with Senator William Edgar Borah, with whom Cissy had also been having an affair, but Alice won out. The affair produced Alice's only child, Paulina. At another time, Alice suspected her husband, Nicholas, of hiding in Cissy's carriage.

Thomas T. Gaff

The first sense of the former grandeur of Dupont circle that many visitors get when exiting the city's metro system at the Q Street Dupont Circle exit is the site of the Thomas Gaff house at the corner of Twentieth and Q Streets.

In 1904, when Cincinnati distiller Thomas T. Gaff was appointed by Secretary of War William Howard Taft as a commissioner for the Panama Canal's construction, he—along with his wife and daughter, both named Zaidee—moved to Washington. The commission had been established by the U.S.-Panama treaty to assess damages for lands and property needed for the canal. The commission paid Gaff ten dollars a day plus expenses for his trips to Panama. Thomas Gaff retired from the Canal Commission in 1907 and disappeared completely from public life.

The Gaffs chose architect Jules Henri de Sibour to design their seventeenth-century château-style manor home at 1520 Twentieth Street on the corner of Twentieth and Q Streets Northwest. When construction of the house was completed in 1905, it featured such modern and novel conveniences as a hot-air system to dry clothes, a trapdoor to an icehouse so that deliveries could be made directly from the street and cork insulation for Gaff's wine cellar.

The Gaff home was the site of tea parties and other highly publicized society events, often to raise money for one of Zaidee's favorite charities, the British-American War Relief Fund. Zaidee was also prominent in the anti-suffrage movement, helping to raise money for the District Association

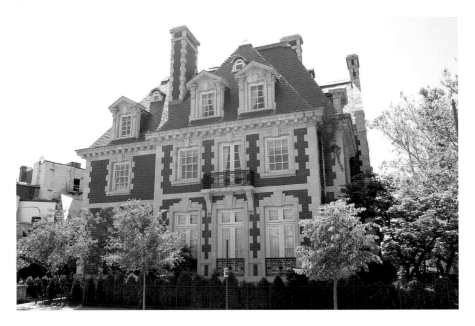

Thomas T. Gaff house at 1520 Twentieth Street Northwest. *Author's photo.*

Opposed to Woman Suffrage. Ironically, Alice Pike Barney's house on Rhode Island Avenue, where the Gaffs had first lived in Washington, later served as the headquarters of the National American Woman Suffrage Association.

The Gaffs continued to use the house off and on for twenty years. After Thomas Gaff died, Zaidee began leasing the house and moved to Bermuda, much preferring its warm climate over that of Washington during the social season. She leased the house to Rhode Island senator Peter Goelet Gerry for a year after his divorce from Mathilde Townsend, as well as Dwight Davis, President Calvin Coolidge's secretary of war, and to the government of Greece in 1929 for use as an embassy. In 1944, the Gaffs' daughter, Zaidee, sold the house to the government of Colombia. It has been used as the official residence of the Colombian ambassador to the United States ever since.

Stanley and Katharine McCormick

Three years after Elinor Patterson had finished building her mansion at 15 Dupont Circle, her second cousin Stanley McCormick and his wife,

Katharine, purchased the old Noble mansion at 1785 Massachusetts Avenue for their stays in Washington during the winter season.

Stanley was the youngest son of Cyrus McCormick, the inventor of the reaper and founder of the McCormick Harvesting Machine Company. Stanley graduated with highest honors from Princeton University, where he was a football star and champion tennis player. After graduation, Stanley worked as comptroller for the family's company and helped in a series of mergers to form International Harvester in 1902.

Stanley met Katharine Dexter, the daughter of a prominent Chicago attorney, while she was finishing her studies in biology at MIT. She was only the second woman to receive a degree from that institution. Katharine had planned on medical school. But in 1904, Stanley and Katharine married at her family's estate in Geneva, Switzerland.

The McCormicks spent the winter season of 1905 in Washington in a rented house on I Street. Stanley liked the city so much he decided to purchase a home in the city, finally settling on the Noble house just across the street from Senator Van Wyck's house. But the McCormicks would never occupy the Noble house themselves. About the time they had purchased the house, Stanley began suffering from violent, paranoid delusions, so the house was leased out by the McCormicks until it was razed in 1915.

By 1908, Stanley needed constant care and was transferred to Riven Rock, the McCormick family estate in Santa Barbara, California, where he lived under close supervision until his death in 1947. The Riven Rock estate had originally been built for Stanley's elder sister Mary Virginia, who was diagnosed with schizophrenia at age nineteen.

In 1909, Katharine had Stanley declared incompetent, and he was made a ward of the courts. Katharine and Stanley's siblings were appointed as a board of guardians to oversee his estate and medical treatment. From this point on, Katharine was basically forbidden to see her husband. Yet she refused to divorce him and remained a staunch advocate for the best possible care for him. Throughout her life, she tried to find a biological basis and cure for schizophrenia.

Separated from her husband, Katharine plunged herself into social causes, giving almost all her time and a large share of her wealth to the suffrage cause. She became secretary of the International Woman Suffrage Alliance and treasurer of the National Suffrage Association. Along with Margaret Sanger, who became the founder of America's birth control movement, Katharine fought for the development of the birth control pill to liberate women and, over the course of years, poured millions of dollars of her own money into its development.

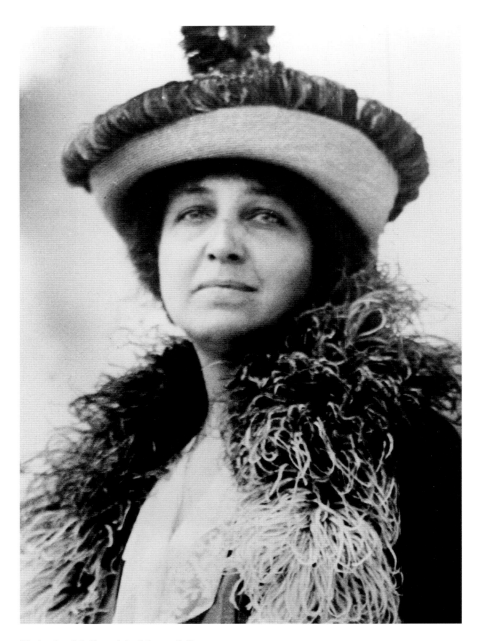

Katharine McCormick. *Library of Congress.*

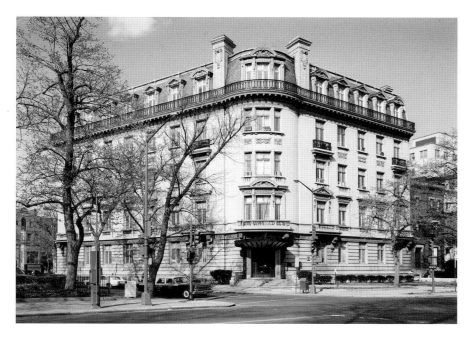

The McCormick Apartment Building at 1785 Massachusetts Avenue Northwest replaced the home of Beldon Noble. *Library of Congress*.

In 1915, Katharine decided she no longer had any use for the old Noble house. She had the building razed and, in its place, built the $500,000, five-story, steel-and-concrete Beaux Arts McCormick Apartment Building designed by architect Jules Henri de Sibour. With only six apartments and eleven thousand square feet of space divided among thirty-five rooms, it was meant to be one of the most luxurious buildings of its kind. When it opened in 1917, it housed about forty servants along with six families.

Katharine McCormick made the new building her home while she was in Washington. It was chidingly nicknamed "Mrs. McCormick's building." When it was completed in 1917, she was told she could never get high enough rents to make the building a profitable investment. But with the first World War came a sudden surge in the city's population, as well as many renters with a great deal of money, and she had no difficulty leasing any of the apartments.

In 1928, Katharine petitioned the courts for sole guardianship of her husband, claiming that his siblings had placed him under the care of

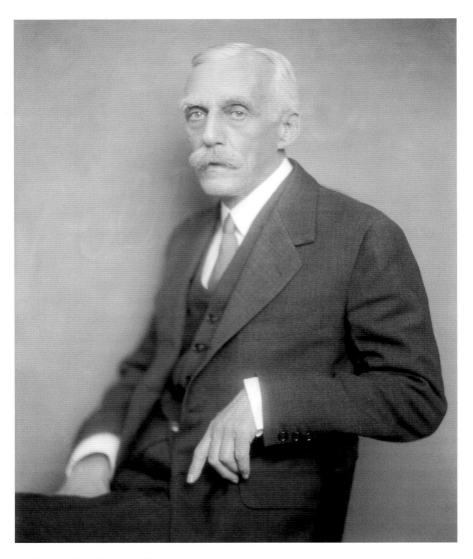

Andrew Mellon. *Library of Congress.*

psychiatrists whose methods she did not approve of and were dissipating his fortune. A lengthy court battle ensued over Stanley's care and control of his $50 million estate. The court case put the validity of the new field of psychiatry and the controversial Freudian-style psychoanalysis for mental illness on trial as well.

Ultimately, Katharine lost her bid to be appointed sole guardian of her husband. But the court ruled to increase the number of Stanley's guardians and to oust the psychoanalyst who had been receiving $120,000 a year to treat him. Stanley died in 1947.

The McCormick building remained an apartment building until 1940, when Katharine leased the building to the British government for offices and finally sold it to the American Council on Education in 1950. It was then sold to the Brookings Institution in 1970 and to the National Trust for Historic Preservation in 1976. In 2013, it was purchased by the American Enterprise Institute for $36.5 million.

Perhaps the most significant resident of 1785 Massachusetts Avenue was the millionaire industrialist Andrew Mellon, who lived there after becoming secretary of the Treasury in 1922, a position he held from 1921 to 1932. Mellon occupied the top-floor apartment until his death in 1937.

Mellon began ambitiously collecting art after he moved into the McCormick building. Between 1930 and 1931, he acquired twenty-one paintings from the Hermitage Museum in Saint Petersburg, Russia. These included rare works by Jan van Eyck, Botticelli and Titian, as well as two Raphaels, four Anthony van Dycks and five Rembrandts. In 1936, Mellon paid $21 million for forty-two works of painting and sculpture owned by Sir Joseph Duveen, an art dealer who was leasing the apartment just below Mellon's. At the time, this was the largest art transaction on record. He then donated his entire collection and the funds to construct a building to the United States. His donation became the National Gallery of Art.

TITANIC VICTIM CLARENCE MOORE

In 1890, Clarence Moore, a noted sportsman and horseman, moved from Virginia to Washington to work for one of the city's leading banking and brokerage firms. "Clarence Moore was the most daring horseman I have ever seen…he knew every phase of fox hunting, which was his greatest hobby," a friend told the *Washington Herald* in 1912. He served as the master of the hounds at the Chevy Chase Club for twenty-three years. He also owned a farm in Montgomery County, Maryland, where he raised cattle and horses and owned real estate near Leesburg, Virginia.

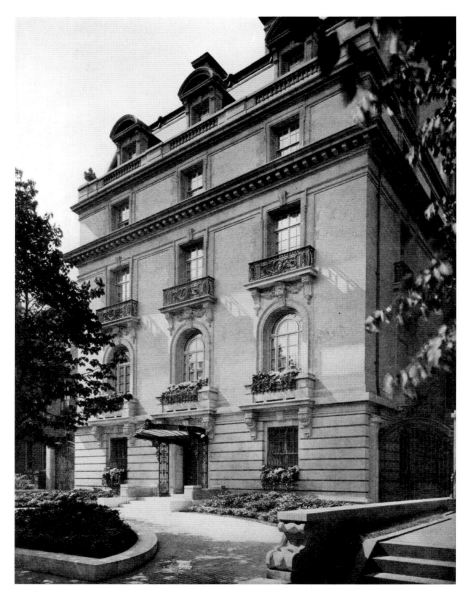

Home of RMS *Titanic* victim Clarence Moore at 1746 Massachusetts Avenue Northwest. *Library of Congress.*

Moore's first wife was Alice McLaughlin, the daughter of Frank McLaughlin, one-time owner of the *Philadelphia Times*. Alice died in 1897, and three years later, Moore married twenty-two-year-old Mabelle Swift of Chicago. Her father, Edwin Carlton Swift, made a fortune in the Chicago meatpacking business, which Mabelle inherited in 1901 when her father died.

Before her marriage to Moore, Mabelle was very active in the Parisian social scene. A rumor had started that she had gotten engaged to a Serbian prince. In an effort to quell the rumors, she immediately traveled to Washington and met and married Moore in 1900. Six years later, construction began on their new house at 1746 Massachusetts Avenue, designed by Jules Henri de Sibour, which was completed in 1909.

Clarence Moore left Washington on March 16, 1912, to vacation in London and to purchase foxhounds for the Loundon Hunt in Leesburg, Virginia, which continues to this day. His wife, as usual, stayed home; Moore often traveled abroad on his own. On April 10, 1912, Moore, along with his manservant, boarded the RMS *Titanic* at Southampton for the trip home. Also boarding the RMS *Titanic* were Washingtonians Major Archibald Butt, who was President Taft's personal aide; Frank D. Millet, a well-known artist; Major Archibald Gracie; and another Dupont Circle resident, Helen Candee.

At 11:40 p.m. on April 14, four days into the crossing and about 375 miles south of Newfoundland, the RMS *Titanic* struck an iceberg. According to the survivors who remained on the ship to the last, Clarence Moore was one of the most heroic men on board. When the ship struck the iceberg, Moore asked Captain Smith what he could do to help. "The thing to do is to see that all the women get off the ship in safety, and that the men do not crowd the boats," the captain replied. When the second lifeboat was being manned, one of the crew jumped in. "Can you row?" asked Moore. "Sure," said the man. "Are you certain you can?" The man replied that he could row as well as some of the others who were getting into boats. Evidently, Moore was not convinced and pulled the man out of the boat and put a woman in his place, then helped lower the boat. According to survivors, Moore's last words were to Colonel Archibald Butt. Moore stayed on the ship until its last minutes and then jumped into the ocean to his icy death. According to some reports, Moore and Butt jumped when the boilers of the *Titanic* burst.

Washington anxiously waited for news about survivors of the *Titanic*. Not since the Spanish-American War had such a national disaster held

Washington in as much painful suspense. It was not until the RMS *Carpathia* reached New York that Washington knew the fate of its residents who had boarded the ship for its maiden voyage. When news reached Washington that Clarence Moore, Major Butt and Frank Millet were not on the *Carpathia*, the city went into semi-mourning. Dinner parties at embassies, legations and private homes were canceled.

Major Gracie was the only male from Washington to survive. Gracie became so obsessed with determining the cause of the *Titanic*'s sinking that his health failed, and he died within a year of having survived one of the century's greatest disasters. Helen Candee was able to find a spot in one of the ship's lifeboats and, along with another first-class passenger, Margaret "Molly" Brown, helped man the oars.

Although she maintained the Washington home after Moore's death, Mabelle Moore spent a large part of her time traveling. When she was in Washington, Aksel Christian Prehan Wichfield, a Dane by birth, was a frequent guest of the Danish minister as well as at the Moore home. He accompanied Mabelle and the family during a trip abroad in 1914.

The marriage of Mabelle Moore, now the wealthiest widow in Washington, to Aksel Wichfield in the spring of 1915 gave society circles quite a surprise. There was no notice of an engagement, and the wedding license was issued only one hour before the ceremony. Mabelle was thirty-six, although the marriage license listed her age as twenty-six, and Aksel twenty-nine. The following year, Aksel was appointed as an attaché of the Danish Legation.

In 1927, Mabelle sold the Massachusetts Avenue house along with its furnishings to the Canadian government when its first diplomatic post was established in the United States. Mabelle and Aksel divorced in 1932, and Mabelle died of pneumonia the following year. The Moore house is now the Embassy of Uzbekistan.

Edson Bradley

In 1907, New York liquor baron and president of the Kentucky Distilleries and Warehouse Company, Edson Bradley, bought Gardiner Greene Hubbard's house on Dupont Circle. The Bradleys had been making Washington their winter home for several years already and had become quite active in the city's social life.

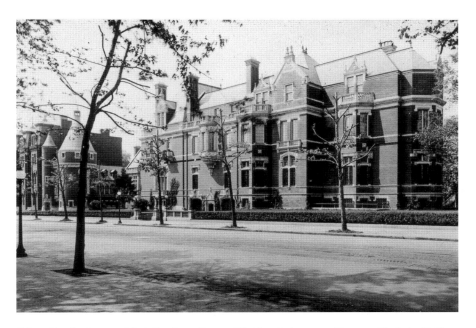

Edson Bradley's remodeled Gardiner Greene Hubbard's home on Dupont Circle in 1907. Samuel Carter's house is to the left, and beyond that is Phillips Row. *Historic Society of Washington D.C.*

Even after Hubbard's expansion of the original Galt house, it was still not large enough for the Bradleys. Bradley contracted New York architect Howard Greenley to rebuild the house. Entire rooms were purchased and imported intact from France and installed. When the improvements were complete after four years of work, the house covered more than half a city block and featured a Gothic chapel with seating for 150, a large ballroom, an art gallery, a five-hundred-seat theater with an electric action pipe organ and a reception hall on the second floor re-creating a Roman atrium. It was known as Aladdin's Palace due to its sheer size and grandiose nature. During the season, famous divas and world-famous musicians gave fortnightly musicales in the theater.

Mrs. Bradley became famous for what was dubbed the "American Beauty Ball," which has taken its place in the social history of Washington. She used so many 'American Beauty' roses to decorate the house for the dance that the market for the flowers was exhausted for days afterward.

In August 1922, the Bradleys' sixty-room summer home near Syracuse, New York, was destroyed by fire. The Bradleys were able to escape to

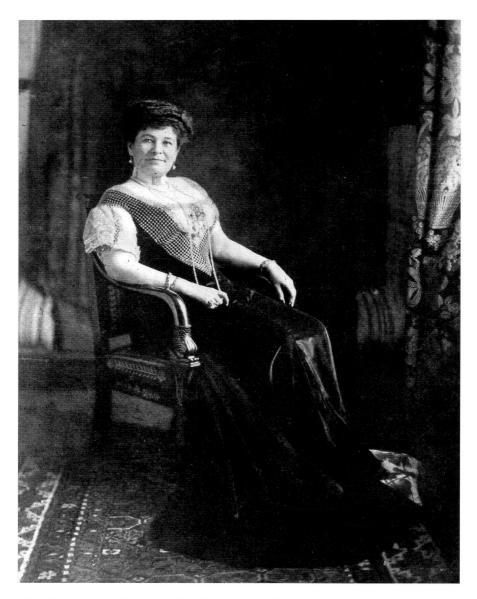

Mrs. Edson Bradley. *Historical Society of Washington, D.C.*

safety aboard their yacht. Nothing but the stone walls of the house were left standing. Finding themselves now without a proper summer home, the Bradleys decided to move from Washington to Newport, Rhode Island—not just themselves, but their entire house as well.

The Bradleys had their Dupont Circle house dismantled and shipped to the new location in Newport over the course of two years. A preexisting Elizabethan Revival mansion named Seaview Terrace was already on the new Newport site, and the Bradleys' Dupont Circle house was incorporated into its design. Work on the exterior continued for two years and required the use of many railroad cars and trucks and was one of the largest buildings ever to be moved in this manner. Rooms that had been imported intact from France and first installed in Washington, D.C., twenty years earlier were moved again and reassembled in Newport, and the new building was constructed around them. The project cost over $2 million, and when it was completed, it was the largest privately owned summer cottage of the Gilded Age.

The abandoned shell of the old Bradley house stood until 1931, when the Dupont Circle Building was constructed there, as well on as the site of the Carter house immediately to the south.

PERRY BELMONT

In 1906, wealthy New York lawyer Perry Belmont purchased the triangular lot between New Hampshire Avenue and Eighteenth and R Streets Northwest to build a house for his use during the winter season. At that time, it was one of the few remaining pieces of unimproved property left in the Dupont Circle area.

Perry Belmont first came to Washington in 1881 as a congressman from New York and served four terms. In 1898, Belmont was appointed United States minister to Spain. While in Europe, he was introduced to the designs of the École des Beaux-Arts–trained architect Ernest Sanson, whom he would hire to design his Washington residence.

Perry Belmont had successfully established himself in politics and diplomacy and was a member of Washington's official society. But his solid social standing was to change when he married a divorced woman.

In 1899, after seventeen years of marriage, Jessie Ann Robbins divorced her husband, Henry Sloane, the son of the founder of New York

Perry and Jessie Belmont. *Library of Congress.*

department store W.&J. Sloane, to marry Perry Belmont. The marriage occurred only five hours after the divorce was decreed. Under the terms of the divorce, Jessie was forced to give up her New York City mansion, along with all its contents, which Henry Sloane had only given her only the year before, as well as all other property she had received from Sloane. Sloane was granted custody of their two children, and Jessie forfeited all rights to see them until they turned twenty-one years of age. She was also prohibited from marrying again in the state of New York during the lifetime of Henry Sloane, although he retained the right to marry whomever and wherever he pleased, as if he were a widower.

When the Belmonts returned to Washington in 1906, they found themselves socially ostracized by the smart set. In order to reestablish themselves in official society after being away for eight years, the Belmonts hosted one of the most expensive entertainments known to Washington society at the time. In January of that year, the *Washington Post* announced that the Belmonts would host a musicale featuring the Italian tenor Enrique

Caruso, soprano Bessie Abbot and cellist Jean Gerardy. The Belmonts claimed that their music room was small and intimate so the number of invitations would have to be limited. Talk began at once about who would receive one of the coveted invitations. The invitations were sent out—to three hundred invitees of the official and limited residential society sets in Washington, mostly senators and congressmen and government and military officials. Noticeably absent from the guest list were members of Dupont Circle's smart set.

In 1907, Perry Belmont's name was proposed for membership in the exclusive Chevy Chase Club by his friend Senator Stephen Elkins. Whenever a name was submitted for membership, the board of governors of the club would vote on it. It only took two no votes, or "blackballs," to be denied membership. Dupont Circle resident William Boardman, who was also a neighbor of Perry Belmont in New York City, was one of the two of the club's governors who blackballed Belmont's application.

There were various theories as to why two of the governors would vote against such a prominent member of society. One theory was that Thomas Nelson Page might have had an influence on one of the voting governors. The Pages had a known dislike of New York society in general and the Belmonts in particular.

Another theory for Belmont's rejection from the Chevy Chase Club was that Mrs. Belmont's former husband, Henry Sloane, had a hand in the decision. Belmont placed the blame on Mrs. Roosevelt's private secretary and on the president's friendship with Thomas Nelson Page. Belmont had been an outspoken opponent of Roosevelt, and the Roosevelts had never been particularly friendly with the Belmonts. When Belmont's suspicion became public, they were no longer welcome at the White House.

Social setbacks did not deter Belmont's plans to build his winter home in Washington. In 1907, construction began on a grand Louis XVI–style Beaux Arts mansion on the lot he had purchased the year before. Located at 1618 New Hampshire Avenue, it sat directly across from Belmont's arch enemy Thomas Nelson Page's house, overshadowing his more traditional colonial home. Additionally, the architect placed the rear of Belmont's house facing Page's house so that Page's view out his front windows was of Belmont's servant and delivery entrance.

When completed, Perry Belmont's mansion became known as the "upside-down" house, as the kitchen was on the top floor of the house with three stories below. One of the largest crystal chandeliers in Washington was hung in the ballroom. It became a social center of Washington during the few months of the year when it was actually occupied by the Belmonts. The

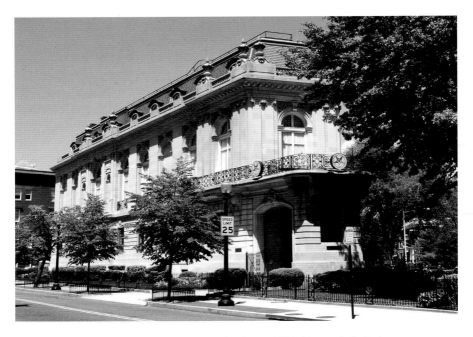

Perry Belmont house at 1618 New Hampshire Avenue Northwest. *Author's photo.*

Cave Dwellers dubbed the house the "Opening Wedge," as they viewed it as a way for the Belmonts to force themselves back into society. The house served as the residence for the Prince of Wales and his staff during his visit to Washington in 1919, when he much preferred to stay at the Belmont house over the old British Embassy building on Connecticut Avenue. The Belmonts preferred the family cottage Belcourt in Newport, Rhode Island, and Paris over Washington and ultimately did not spend many seasons in the New Hampshire Avenue house.

A Portrait of a Marriage

William "Billy" Hitt and Katherine Elkins were scions of two of the most powerful and wealthy Washington political families at the turn of the twentieth century. They grew up together, and Billy pursued Katherine for years. It was assumed by both families that they would eventually marry. They did—twice—but not without some significant complications.

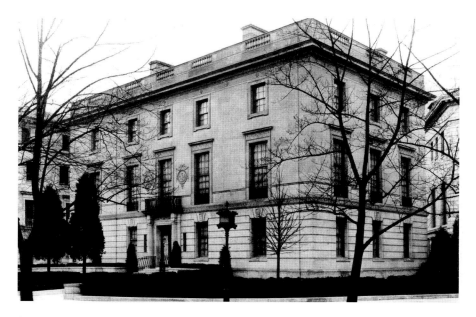

Sallie Hitt mansion at 1511 New Hampshire Avenue Northwest. *Historical Society of Washington, D.C.*

Billy was the younger of two sons of Illinois congressman Robert Roberts Hitt and Sallie Reynolds Hitt. The Hitts' eldest son, Robert, served as envoy extraordinary and minister plenipotentiary to Panama and Guatemala. Billy considered himself a financier and a sportsman, though it seems that he never held any professional positions.

Not long after his arrival in Washington in 1881, Robert Hitt bought a house lot in Dupont Circle at 1511 New Hampshire Avenue Northwest, but nothing was built on it until after his death in 1906. Until his death, the Hitts had lived at 1507 K Street Northwest near McPherson Square, where Mrs. Hitt had developed a reputation as one of the city's leading socialites. It was at their K Street home that the Hitts became friends with neighbor Senator Stephen Elkins of West Virginia and where Billy first met the Elkin's young daughter, Katherine.

Two years after Robert Hitt died, Sallie engaged the services of prominent architect John Russell Pope to design a new house on the land her husband had purchased on Dupont Circle. The house stood immediately to the left of the Patterson mansion and across the street from the Leiters. The Indiana limestone house was four stories in height and eighty-five feet across

the front, and it was completed in 1909. Oddly, after Sallie had such a large house built, she curtailed much of her entertaining. Sallie lived in the house as a Cave Dweller, sandwiched between the homes of Dupont Circle's smart set, until she died in the house in 1949 at the age of 105.

Few American heiresses have taken a firmer hold on the country's attention than Katherine Elkins. Katherine grew up in her parents' home at 1623 K Street Northwest, and her close childhood friends included Alice Roosevelt, Marguerite Cassini and Cissy Patterson. At one point, Alice was concerned that her fiancé, Nicholas Longworth, might run off with Katherine. Alice, Cissy and Katherine would all later become Dupont Circle neighbors.

Prince Luigi Amadeo, the Duke of Abruzzi and the son of Amadeo, once the king of Spain and the cousin of King Victor Emanuel of Italy, was introduced to Katherine at a dance at the home of Ambassador and Mrs. Larz Anderson in 1907. It was love at first sight, and for months the duke remained in the company of Miss Elkins wherever she went.

In the spring of 1908, rumors had started that the duke and Miss Elkins were engaged. Neither of the families denied the rumors, and stories surfaced that negotiations with the Italian royal family to approve the marriage were in the works and that Katherine's trousseau was being made in New York. But in the autumn of 1908, it was reported that Italy's Dowager Queen Margherita was opposed to the marriage. While the duke's cousin, the king of Italy, initially gave his approval, Margherita maintained full control over the royal family and had the final word. A promise of $1 million by Senator Elkins to help revive the duke's expended fortune appeared to have temporarily weakened the queen's opposition to the marriage but ultimately did not sway her opinion. Elkins kept his money, and in late 1908, he publicly denied all rumors that Miss Elkins and the duke were ever engaged.

In January 1909, the duke attempted to resign from the royal family and the Italian navy, renouncing his title and all royal privileges in hopes of removing any obstacles to his marriage to Miss Elkins. The king refused his resignation from the navy. King Edward of England himself tried to persuade the Dowager Queen Margherita that, judging from his acquaintance with Miss Elkins, she was worthy of any man of any blood, provided that the man relinquished all claims to a throne. But this did not persuade the queen either.

In the spring of 1909, Katherine and her mother traveled to Europe, where there appears to have been at least one tryst between Katherine and the duke, with the pair meeting in Baden-Baden, Germany, but the duke denied rumors of any such rendezvous. They also purportedly met up at

Katherine Elkins (center). *Library of Congress.*

Billy Hitt. *Library of Congress.*

a secluded resort in Austria. Finally in October 1910, Katherine returned from Europe, declaring that she "was coming home to be an American."

In October 1912, a rumor surfaced that Katherine Elkins had married Billy Hitt in Rome. This news was considered a slight to the duke by the Italian nobility. But after a frantic citywide search of hotels and pensiones for the couple, it was determined that no such marriage had occurred in Rome. The rumor was also immediately denied by the Elkins family.

But Katherine did marry Billy without any notice in October 1913 in a very brief and simple service at her parents' estate Halliehurst in West Virginia. He had been pursuing her for years, both at home and abroad, and it was assumed by the Elkins that Katherine would sooner or later give in, although to date there had not been the slightest hint that they were considering marriage. The duke heard of the news of the marriage through the newspapers. He never married, and when he died in 1933, the only two

pictures on the walls in the living room of his house were those of King Victor Emanuel and Katherine Elkins Hitt.

In 1922, Katherine Hitt traveled to Paris to file for divorce from Billy, claiming that they were not on terms of affection necessary for married life and that he refused conjugal relations. Friends of the couple observed that while they were very compatible as friends, they found each other incompatible as man and wife; what they had interpreted as love was really a good friendship and nothing more.

After the divorce was granted, the couple returned to the United States together on the same ship and, according to other passengers, were on the best of terms. In March 1923, they remarried in a civil ceremony in Washington that was as much of a surprise to society as their first marriage had been. The couple then moved to Billy's house in Middleburg, Virginia, with a houseful of servants and spent their time breeding horses and raising dogs.

Katherine Hitt died in 1936 in New York City. Funeral services were held at her mother-in-law's New Hampshire Avenue mansion. Upon her death, she was remembered more by the press for her romance with the Duke of Abruzzi than for her two marriages to Billy Hitt. Billy later married Eugenia Woodward, a fiery southern beauty and divorcée whose family owned a Birmingham, Alabama department store.

In 1951, Billy Hitt sold the house at 1511 New Hampshire Avenue to the Pan American Sanitary Bureau when it was converted to offices. It was then sold in 1965 to the American Council on Education and was finally demolished in 1970 to make way for the present office building. Billy died in 1960 at his Park Avenue home in New York City.

BERIAH AND EMILY WILKINS

In 1889, Beriah Wilkins, a Civil War veteran and three-time congressman from Ohio, along with former U.S. postmaster general Frank Hatton, purchased the *Washington Post* newspaper from Stilson Hutchins. Wilkins served as its editor until his death in 1905.

To promote the newspaper, Wilkins and Hatton asked the leader of the Marine Band, John Philip Sousa, to compose a march for the newspaper's essay contest awards ceremony. Sousa composed "The Washington Post March," which remains one of his best-known works. Wilkins bought out Hatton's share of the newspaper in 1894 and eventually handed over

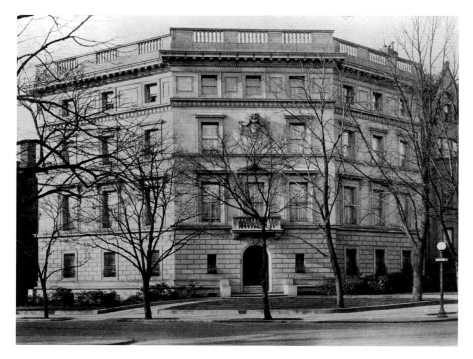

Emily Wilkins house at 1700 Massachusetts Avenue Northwest. *Library of Congress.*

management of the Post Publishing Company to his son John and placed his other son, Robert, in charge of one of the paper's departments.

In 1900, Wilkins built his first house on a large, one-half-acre lot at 1711 Massachusetts Avenue. It was designed by architect Appleton P. Clark Jr. in the French Colonial style, not the in-vogue Beaux Arts style. When it was completed, it was one of the largest homes in the city, boasting thirty-five rooms and ten baths. Beriah Wilkins died in 1905, and his sons continued to run the paper for two more years before selling it to John Roll McLean, owner of the *Cincinnati Enquirer*.

Three years after her husband's death, Emily saw her chance to join the Beaux Arts revolution. She bought a corner lot at 1700 Massachusetts Avenue that was occupied by Tibbett's grocery store. It was the last "unimproved" corner on Massachusetts Avenue from Thomas Circle as far west as Sheridan Circle and, at the time, considered the best remaining building site in this section of the city. To make sure her new house, although not as large as the first, would be in the latest style, she contracted architect Jules Henri de Sibour to design it.

Emily Wilkins sold her old house to Senator Henry Algernon Du Pont of Delaware, who had been occupying the Barney house at 1626 Rhode Island Avenue and waiting for a choice piece of property in the neighborhood to open up. It was one of the largest residential sales made in years. As the furniture in it was custom built for the house, it conveyed with the sale.

Unfortunately, Emily Wilkins died the same year her new house was completed, leaving the house to her son John. Her funeral was held at the Church of the Covenant, and one of her pallbearers was her architect, Jules Henry de Sibour.

John Wilkins and his wife, Julia, became very socially prominent and stayed in the Massachusetts Avenue house often during the winter seasons. John served as president of the Chevy Chase Club and as a member of the board of governors of the Metropolitan Club. John Wilkins died in the Massachusetts Avenue house in 1941.

After John Wilkins's death, the house changed hands many times. In 1947, it became the Australian Embassy, and in 1973, it was purchased by the Republic of Peru for its embassy, which it remains today.

THE DUPONT FOUNTAIN ARRIVES

While Dupont Circle had become a mecca of Washington wealth and society, the unpopular bronze statue of Admiral Du Pont still stood in the center of the circle. By 1916, the base of the statue had begun to sink, causing it to list. The Du Pont family had always despised the statue and did not regard it as a work of art suitable for the place it occupied. Mrs. Willard Saulsbury, a niece of the admiral, led efforts to remove the old statue and substitute a new one. Congress voted to allow the Du Pont family to replace statue, but at their own expense.

In 1917, the Victorian bronze statue of Admiral Du Pont was moved to Rockford Park in Wilmington, Delaware. Instead of another statue, the Du Pont family commissioned sculptor Daniel Chester French and architect Henry Bacon to design a classically inspired marble fountain that reflected the contemporary Beaux Arts and neoclassical architectural styles embodied by the City Beautiful movement and prevalent in Dupont Circle. French was already known in Washington for his public sculpture. In 1913, he had designed the Archibald Butt–Frank Millet Fountain to commemorate two of Washington's notable residents who went down with the RMS *Titanic*.

In 1917, the Commission on Fine Arts approved the design of the double-tiered, white marble fountain, which featured carvings of three classical

The dedication of the Dupont Circle fountain, 1921. *Library of Congress.*

nudes symbolizing the sea, the stars and the wind on the fountain's shaft. But Congress did not want to lose credit for its earlier attempt to honor the admiral—the base of the fountain bears the inscription "This Memorial Fountain Replaces a Statue Erected by the Congress of the United States in Recognition of His Distinguished Services."

The fountain was completed and installed in 1920 and dedicated in 1921. The following year, the Lincoln Memorial, another collaboration between French and Bacon, was also dedicated.

NICHOLAS LONGWORTH AND ALICE ROOSEVELT

In 1925, Speaker-elect of the House of Representatives Nicholas Longworth and his wife, Alice Lee Roosevelt Longworth, bought the house that still stands at 2009 Massachusetts Avenue. But Alice was not the first

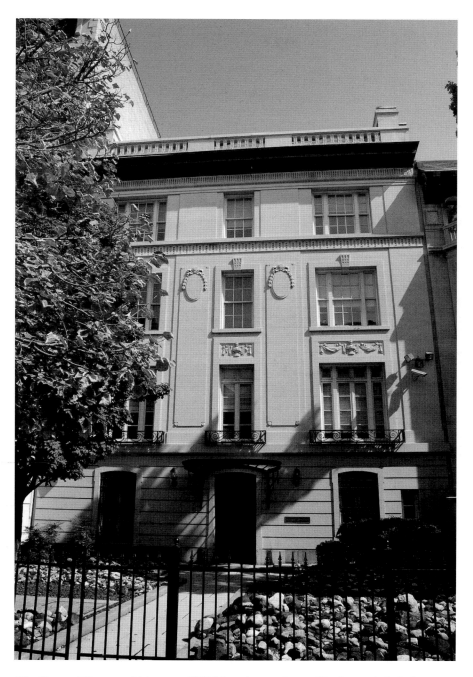

Alice Roosevelt Longworth's home at 2009 Massachusetts Avenue Northwest. *Author's photo.*

Roosevelt to live in the house. In 1910, the house was purchased by Robert Barnhill Roosevelt Jr., a New York real estate magnate and a cousin to Theodore Roosevelt.

Robert Roosevelt expanded the original 1881 house into an open lot on the east and removed the front bays and the earthen berm in front in order to place the entrance on street level. He then had the façade refaced in the Beaux Arts fashion with cut limestone and ornamented with laurels. The result was a new five-story, limestone house, consisting of twenty rooms and six baths. Roosevelt lived in the house off and on, renting it out for periods of time. When he died in 1929, he was living in a house in Washington's Sheridan-Kalorama neighborhood.

In 1906, Alice and Congressman Nicholas Longworth were married in a White House ceremony. Nicholas Longworth, for whom the Longworth Office Building is named, served as House majority leader from 1923 to 1925. The year the Longworths moved into the Massachusetts Avenue house, Nicholas became Speaker of the U.S. House of Representatives, a position he held until his death in 1931.

The Longworths moved into their new home at the beginning of the season in 1925. That same year, their daughter, Paulina, was born only two days after Alice's forty-first birthday and was called the "Valentine Baby." But Alice had had a long, ongoing affair with Senator William Borah. By Alice's own admission, the child was Borah's, and everybody called her "Aurora Borah Alice."

The Longworths' marriage had been rocky from the start, and Alice was rarely a political ally of her husband. During her father's 1912 bid for reelection against incumbent president William Howard Taft and Nicholas's run for reelection in the House, Alice appeared on stage with her father's vice presidential candidate Hiram Johnson in Longworth's home district of Cincinnati, Ohio. Consequently, Longworth lost his own reelection bid by about 105 votes—Alice jokingly took credit for at least 100 of them. However, Longworth was elected again in 1914. After Nicholas's death in 1931, Alice would remain in the Massachusetts Avenue house, from where she would reign over Washington social and political life for the next fifty years until her death in 1980.

THE SCIONS OF
DUPONT CIRCLE'S GILDED AGE

There are many other great houses in the Capital which by sad changes have been resolved into dust-stained mysteries. I have been in all of them: when they were alive, gay with music, laughter, champagne—when they were bright with jewels, fine fabrics, and lustrous eyes.
—From Evalyn Walsh McLean, in Father Struck It Rich.

Quite a few Dupont Circle residents lived well into the twentieth century. But times had changed and the days of maintaining a large seasonal house and entertaining lavishly had passed. A series of financial panics, the introduction of income tax, the First World War and the stock market crash of 1929 and the following Great Depression took their tolls and sealed the fate of the lavish lifestyles of the preceding decades in Dupont Circle.

The diplomatic corps that had initially begun renting the great homes when their owners decided to skip a social season were exempt from American property taxes, and with the financial resources of their own countries behind them, they were now the ones who could afford to buy and maintain many of the vacated palaces. Thankfully, a large number of these homes still survive today as embassies, allowing a limited glimpse back in time and the opportunity to imagine life in another age.

Evalyn Walsh McLean and Alice Roosevelt Longworth remained lifelong friends. In *Alice: Alice Roosevelt Longworth, from White House Princess to Washington Power Broker*, Stacy Cordery recounts an exchange between the two when Evalyn had fallen on hard times during the Great Depression. One day, Evalyn

arrived on Alice's doorstep in tears, bearing her new itemized budget. "Alice, what will I do?" she cried, "I simply can't get my budget below $250,000 a year. Flowers, $40,000; household, $100,000; travel, $35,000..." Past her initial shock and not wishing to upset her friend further, Alice simply replied, "You are quite right. You simply can't shave it one cent."

Evalyn inherited the mansion at 2020 Massachusetts Avenue in 1932 upon the death of her mother, Carrie Walsh. But Evalyn left the house vacant, preferring to live in the McLeans' home Friendship on Wisconsin Avenue. In her 1936 biography, *Father Struck It Rich*—the title coined from when her father exclaimed to her, "Daughter, I've struck it rich!"—Evalyn described a return to the great house:

> *As I rolled under the porte-cochere in my green Duesenberg a few passers-by gathered on the sidewalk. One of the great plates of glass in the outer wall of that carriage shelter had been broken, possibly by a thrown rock...As I mounted the stone steps, I shivered. A stream of air poured out of all the reaches of the house. It was so cold, so much colder than the outdoors winter that it was almost visible, and it flowed swiftly. The house was as a cavern, a subterranean place in my past, and its deepest chill was lodged into my heart. This place had been my home.*

Between 1936 and 1937, the U.S. government used the house for New Deal programs. Evalyn then tried to have the house rezoned for commercial use as either a hotel or apartment house, with shops on the first floor. The proposal met with stubborn opposition from neighbors, and the house was never rezoned.

In 1940, 2020 Massachusetts once again became the center of war work. Evalyn turned the house over for use as the headquarters of the District Chapter of the American Red Cross and the Washington Committee of the American League for Finnish War Orphans. The huge ballroom where the elite of Washington once danced was converted into a busy production office. The drawing room with its silk-lined walls became executive offices. The music room was filled with plain wooden tables stacked with surgical dressings. The dining room's walls were covered with shelves and filled to the ceiling with packages to be shipped overseas. The master bedroom became the public relations office, and the rest of the bedrooms were used as offices.

In 1942, Evalyn had to leave the Friendship estate where she had been living when the trustees of her husband's estate sold the property to the federal government for dormitory housing for defense workers. It is now

A visibly bored Evalyn Walsh McLean in 1936 wearing the Hope Diamond along with an armload of jewels. *Library of Congress.*

the site of the McLean Gardens condominiums. Evalyn died in 1947 at the age of sixty from pneumonia at her home in Georgetown. She insisted on wearing the Hope Diamond on her deathbed. After her death, her estate rented 2020 Massachusetts Avenue out until 1951, when it was sold to the Indonesian government for use as its embassy.

After her divorce from Senator Peter Goelet Gerry in 1925, Mathilde Townsend married Sumner Welles two years later. Welles would later become undersecretary of state during the Franklin Roosevelt administration. The couple lived in the house at 2121 Massachusetts Avenue along with Minnie Townsend. In his biography of his father, Benjamin Welles remembered the grand mansion after Minnie's death in 1931:

> *With her death, the great mansion on Massachusetts Avenue became more sepulchral than ever, its tapestried salons and marbled halls silent except for the ticking of ornamental clocks or the low, canonical tones of the English butler, Frederick, responding to telephone inquiries.*

Mathilde and Sumner Welles continued to occupy the house at 2121 Massachusetts Avenue until the Second World War when the American Women's Volunteer Service, following the example set by Isabel Anderson across the street during the First World War, took over the mansion's stables for canteen preparations. In 1943, the Townsend house was occupied by the headquarters detachment of the Canadian Women's Army Corps.

After the war, the Welleses spent most of their time at their forty-nine-room "country cottage" known as Oxon Hill Manor, situated on 245 acres in Prince George's County, Maryland, and designed by Jules Henri de Sibour. Mathilde died in 1949, and with no direct descendants of her own, her estate sold the house at 2121 Massachusetts Avenue to the Cosmos Club in 1950.

By the beginning of the Great Depression, Perry and Jessie Belmont were dividing their time between Paris and Newport and made only occasional visits to Washington. In 1933, the eighty-one-year-old Perry Belmont petitioned the District Zoning Commission to allow him to transform his mansion at 1618 New Hampshire Avenue into six deluxe apartments for a restricted clientele without altering the building's distinctive architectural design. He said that he would "rather see it rented to desirable tenants than see it stand there, a monument to the depression" and claimed that the project would provide temporary work for a few unemployed men. Nothing came of his proposal.

The Belmonts' grand house stood vacant until 1935 when it was purchased by the General Grand Chapter of the Order of the Eastern Star for $100,000. Belmont was an honored guest at the dedication of the building in 1937. That same year, Jessie Belmont died of a heart attack in Paris, where they were spending the year. With his wife's death, Perry Belmont returned from Paris to live in Newport, where he died in 1947 at the age of ninety-six.

In 1934, Helen Patten applied for a zoning change to convert their property at 2122 Massachusetts Avenue into an apartment building. Larz Anderson, whose property next door was considered to be the most valuable in the neighborhood at that time, opposed the rezoning. Neighbors claimed that Massachusetts Avenue west of Twenty-first Street was still one of the few remaining high-grade streets within the limits of the old city of Washington and that there was no particular demand for apartments at the time. Such a building would be a disgrace to the neighborhood.

Helen Patten continued to push her cause and, by 1936, was seeking to tear their house down to allow for the construction of an apartment building. But by now, neighbors were beginning to recognize that that stretch of

Massachusetts Avenue was already a string of boardinghouses from Thomas to Sheridan Circle and now thought that a "high class apartment building" would not be so detrimental to the neighborhood. The D.C. Zoning Commission approved Helen's request.

Yet the grand Patten house and lot did not sell, and the old spinster sisters Mary, Josephine and Helen continued hosting their high teas there. Mathilde Welles would sometimes make the trip across the street from the Townsend mansion to attend one of the teas and visit with her mother's old friends.

By the time they finally sold the house in 1944, the Patten sisters were quietly living in a more modest house on the other side of Dupont Circle at 1726 Massachusetts Avenue. Josephine died in 1945, and Nellie a year later. Edythe Corbin lived until 1959 when she died at the age of ninety. In 1950, construction began on the new $1 million, 312-unit apartment building that stands on the site of the old Patten house today. It took almost three months to completely tear the old house down.

Cissy Patterson remained at 15 Dupont Circle throughout her adult life, while also spending time at her country home, Dower House, in Prince Georges County, Maryland. By 1936, the circulation of William Randolph Hearst's papers the *Washington Herald* and the evening *Washington Times* under Cissy's editorship had doubled to 120,000. Cissy ultimately bought both papers from Hearst in 1939 and merged them into the new *Times-Herald*. As one of the first to hire female reporters, she helped launch the careers of journalists Adela Rogers St. Johns and Martha Blair. In 1936, she was invited to join the American Society of Newspaper Editors.

Unfortunately, Cissy's family life was strained. She was forever feuding with her daughter, the Countess Felicia Gizycki, who publicly disowned her in 1945. She frequently exchanged barbed comments in the press with her former son-in-law, Drew Pearson. In 1948 at the age of sixty-six, alone and alienated from her friends and daughter, Cissy Patterson had turned to drugs and alcohol and died of a heart attack at Dower House.

Cissy left the *Times-Herald* to seven of her editors, who then sold the paper to Cissy's cousin Colonel Robert McCormick. He held on to the paper for only five years before he sold it to the rival paper the *Washington Post*, which promptly shut it down. The house at 15 Dupont Circle was left to the American Red Cross, and in 1951, it was purchased by the Washington Club as its new headquarters. The mansion is now slated to become micro apartments.

The longest-living heiress of Dupont Circle society was Alice Roosevelt Longworth, who was sometimes referred to as the "Duchess of Dupont

Cissy Patterson. *Library of Congress.*

Circle." Perhaps more than any other person associated with Dupont Circle, Alice's long life embodied much of the history and tradition of the neighborhood.

When Nicholas Longworth died in 1931, the Longworth family fortune was nearly exhausted, and Alice needed to find a way to earn money. In 1933, Alice published her autobiography, *Crowded Hours*, full of reminiscences of

her father, family and people in public life. With her half brother Ted, she co-edited *The Desk-Drawer Anthology: Poems for the American People* in 1938. She even posed for cold cream and cigarette advertisements. Still in need of money in 1938, Alice put the Massachusetts Avenue house on the market, thinking that lecture engagements would keep her away from Washington for extended periods of time. She still planned to keep Washington as her home base and to move to smaller accommodations. The house never sold, and Alice would remain there until her death in 1980.

As one of Washington most notorious insiders, "Mrs. L" (as she wished to be called) was very outspoken with her views on family, politics and politicians. The political elite sought Alice's advice and opinions at her famous dinner and tea parties. An invitation to one of her dinner parties was the most coveted invitation in town. She was given the epithet "the Second Washington Monument."

Alice's daughter, Paulina, died in 1957 from an overdose of sleeping pills that was possibly a suicide. Alice fought for custody of her granddaughter, Joanna Sturm, whom she raised as her own daughter. Unlike her troubled relationship with Paulina, Alice and Joanna were very close.

Alice was perhaps best known for her famous quips and quotes, which included "I've always believed in the adage that the secret of eternal youth is arrested development" and "My specialty is detached malevolence." She stated that her philosophy in life was simply to "fill what's empty, empty what's full, and scratch where it itches." When Senator Joseph McCarthy jokingly remarked at a party, "I am going to call you Alice," she responded, "The trash man and the policeman on my block call me Alice, but you may not." She informed President Johnson that she wore wide-brimmed hats so he couldn't kiss her. When Johnson proudly showed off an abdominal surgery scar, Alice commented dryly, "Thank God it wasn't his prostate." And when a well-known Washington senator was discovered to have been having an affair with a young woman less than half his age, Mrs. Longworth quipped, "You can't make a soufflé rise twice." After a second mastectomy in 1970, she called herself "Washington's only topless octogenarian." Perhaps her most famous quote found its way to a needlepoint pillow on her settee: "If you haven't got anything good to say about anybody, come sit next to me."

In the 1960s and 1970s, when Dupont Circle had become home to hippies, the house at 2009 Massachusetts Avenue stood in fading splendor, and Alice continued to live there, leading a life of shabby gentility. One night during the Vietnam protests in the circle, she stuck her head out a

Alice strikes a pose in the foyer of her Massachusetts Avenue house. *Library of Congress.*

window during a clash between demonstrators and the police and "got a clear little whiff of tear gas," which she said "cleared my sinuses."

Alice never paid much attention to the upkeep of the house and wanted to ensure that guests came to see her and not the house. The house was covered with vines, and the front yard was overgrown with brush and poison ivy (knowing Alice, the poison ivy was probably intentional). Little light

emanated from the windows at night, and it looked like no one lived there. The house was cluttered with tattered animal skins and stuffed heads from her father's hunting expeditions and filled with a lifetime of mementos and photographs. Everything was covered with newspapers and books, and cats were crawling all over the house. The kitchen still had the servants' room bells from more opulent times, now hanging off the walls by their wires. She did not let help spend the night in the house. "I like a day that begins at 11 a.m. after reading all night. They [servants] come at 11:00, and I say go away and then they come back at half past one." Alice slept on the third floor, which had a refrigerator stocked with late-night snacks to accompany her reading.

In her last years, Alice began showing signs of senility and fewer and fewer friends came to see her. Her granddaughter, Joanna, would call Alice's friends and urge them to go to visit. In 1979, the year before she died, Alice opened up the musty mansion for a fundraiser for a yoga center thrown by a distant cousin, Nicholas Roosevelt. Alice stayed upstairs on the third floor with her pet parakeet reading Carl Jung. When informed about the event downstairs, she giggled, "They're doing exercises? Poor simpletons."

Alice Roosevelt Longworth died a week after her ninety-sixth birthday on February 20, 1980. Though Alice was Theodore Roosevelt's firstborn child, she was the last of his children to die, surviving all five of her half siblings from her father's second marriage. At her own request, her granddaughter buried her without fanfare in Rock Creek Cemetery. With Alice's passing, Dupont Circle's own Gilded Age finally came to an end, and perhaps the way Alice may have wished for it: its then shabby gentility disappearing, like herself, without any fanfare.

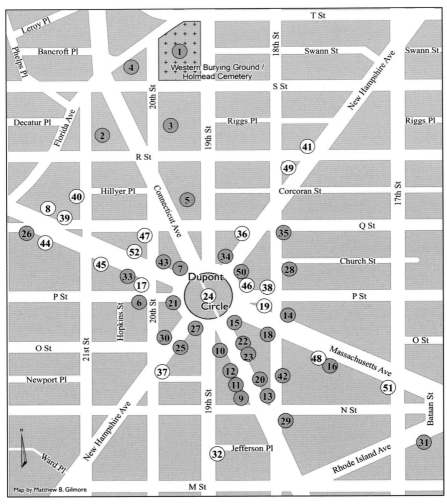

Map by Matthew G. Gilmore.

MAP OF PEOPLE AND LOCATIONS

1. Western Burial Ground (Holmead's Cemetery), Florida Avenue and Twentieth Street Northwest.

2. Guy Graham, 1700 block of Connecticut Avenue Northwest.

3. Ridgeway Tavern, Twentieth Street between R and S Streets Northwest.

4. Douglass Gardens, Connecticut Avenue, S Street and Florida Avenue Northwest.

5. William O'Neale's farm, 1600 block of Connecticut Avenue Northwest.

6. Hopkins Brickyard.

7. Stewart's Castle, Dupont Circle.

8. Curtis Hillyer/Mary Townsend, 2121 Massachusetts Avenue Northwest.

9. British Legation, 1300 Connecticut Avenue Northwest.

10. William Galt/Gardiner Greene Hubbard/Edson Bradley, 1328 Connecticut Avenue Northwest.

11. Phillips Row, 1302–1314 Connecticut Avenue Northwest.

12. Samuel Carter, 1316 Connecticut Avenue Northwest.

13. William Helmsley Emory, 1301 Connecticut Avenue Northwest.

14. Beldon Noble/Stanley McCormick, 1785 Massachusetts Avenue Northwest.

15. Miller-Hopkins houses, 1347 Connecticut Avenue and 1826 Massachusetts Avenue Northwest.

16. Force School, Massachusetts Avenue between Seventeenth and Eighteenth Streets Northwest.

17. James Blaine/George Westinghouse, 2000 Massachusetts Avenue Northwest.

18. Charles Van Wyck, 1800 Massachusetts Avenue Northwest.

19. Holy Cross Church/Henry Wadsworth, 1801 Massachusetts Avenue Northwest.

20. David Yulee, 1305 Connecticut Avenue Northwest.

21. Azor Nickerson, 7 Dupont Circle.

22. Alexander Graham Bell, 1331 Connecticut Avenue Northwest.

23. Charles Bell, 1325 Connecticut Avenue Northwest.

24. Dupont Circle Park with Du Pont Statue and Fountain.

25. Marguerite Lammont Du Pont, 1321 New Hampshire Avenue Northwest.

26. Anastasia Patten, 2122 Massachusetts Avenue Northwest.

27. A.M. Gibson/Reverend John Abel Aspinwall, 17 Dupont Circle.

28. St. Thomas' Parish Church, Eighteenth and Church Streets Northwest.

29. Church of the Covenant, Connecticut Avenue and N Street.

30. John Field/George Hearst, 1400 New Hampshire Avenue Northwest.

31. Alice Pike Barney, 1626 Rhode Island Avenue Northwest.

32. Theodore Roosevelt, 1215 Nineteenth Street Northwest.

33. Grace Litchfield, 2010 Massachusetts Avenue Northwest.

34. Levi Leiter, 1500 New Hampshire Avenue Northwest.

35. Thomas Franklin "T.F." Schneider, 1539 Eighteenth Street Northwest.

36. Sarah Whittemore, 1526 New Hampshire Avenue Northwest.

37. Christian Heurich, 1307 New Hampshire Avenue Northwest.

38. William Boardman, 1801 P Street Northwest.

39. Julia Grant, 2111 Massachusetts Avenue Northwest.

40. Duncan Phillips, 1600 Twenty-first Street Northwest.

41. Thomas Nelson Page, 1759 R Street Northwest.

42. John Watson Foster, 1323 Eighteenth Street Northwest.

43. William Clark/Winthrop Murray Crane, 1915 Massachusetts Avenue Northwest.

44. Larz Anderson, 2118 Massachusetts Avenue Northwest.

45. Thomas Walsh, 2020 Massachusetts Avenue Northwest.

46. Elinor Patterson, 15 Dupont Circle.

47. Thomas Gaff, 1520 Twentieth Street Northwest.

48. Clarence Moore, 1746 Massachusetts Avenue Northwest.

49. Perry Belmont, 1618 New Hampshire Avenue Northwest.

50. Sallie Hitt, 1511 New Hampshire Avenue Northwest.

51. Emily Wilkins, 1700 Massachusetts Avenue Northwest.

52. Nicholas and Alice Roosevelt Longworth, 2009 Massachusetts Avenue Northwest.

SELECTED BIBLIOGRAPHY

Anderson, Isabel. *Larz Anderson Letters and Journals of a Diplomat*. 1st ed. New York: Fleming H. Revell Co, 1940.

———. *Presidents and Pies: Life in Washington 1897–1919*. Boston, New York: Houghton Mifflin, 1920.

Arnebeck, Bob. *Through a Fiery Trial: Building Washington, 1790–1800*. Lantham, NY; London: Madison Books, 1994.

Baker, Paul R. Stanny: *The Gilded Life of Stanford White*. New York: Free Press, 1989.

Baltimore Sun. "Defends Society Homes: Rev. Dr. Hamilton Thinks Thomas Nelson Page Mistaken." August 20, 1900.

Bingham, June. *Before the Colors Fade: Alice Roosevelt Longworth*. New York: American Heritage Publishing Co., Inc., 1969.

Cassini, Marguerite. *Never a Dull Moment: The Memoirs of Countess Marguerite Cassini*. New York: Harper & Brothers, 1956.

Cordery, Stacy A. *Alice: Alice Roosevelt Longworth, from White House Princess to Washington Power Broker*. New York: Penguin, 2008.

De Voto, Bernard, ed. *Mark Twain in Eruption: Hitherto Unpublished Pages about Men and Events*. 1st ed. New York: Harper & Row, 1940.

Dunetz, Marta Miller, and Sulgrave Club (Washington D.C.). *Sulgrave Club: Celebrating 75 Years, 1932–2007: Diamond Jubilee*. Washington, D.C.: Sulgrave Club, 2008.

Eaton, Peggy. *The Autobiography of Peggy Eaton*. New York: C. Scribner's Sons, 1932.

Evening Star. "Course of Slash Run Stream Traversed Important Section Years Ago Great Change Effected." June 3, 1906.

———. "Old Washington. Gadsby's Row." January 24, 1914.

———. "Sold for a Trifle: Early Owners of Land Around Dupont Circle." N.d.

———. "Will of William O'Neale" May 5, 1901.

Green, Constance McLaughlin. *Washington: Village and Capital, 1800–1878.* Princeton, NJ: Princeton University Press, 1962.

Hansen, Stephen A. *Kalorama Triangle: The History of a Capital Neighborhood.* Charleston, SC: The History Press, 2011.

Hutchins, Stilson, and Joseph West Moore. *The National Capital, Past and Present: The Story of Its Settlement, Progress, and Development.* Washington, D.C.: The Post publishing company, 1885.

Juarez, Angelo D. *The Tarnished Saber: Major Azor Howett Nickerson, USA, His Life and Times.* Chatham, MA: Nickerson Family Association, 2001.

Lanius, Judith H., and Sharon C. Park. "Martha Wadsworth's Mansion: The Gilded Age Comes to Dupont Circle." *Washington History* 7, no. 1 (April 1, 1995): 24–45.

Lee, Robert Edward, and Martha Custis Williams Carter. *"To Markie": The Letters of Robert E. Lee to Martha Custis Williams from the Originals in the Huntington Library.* Cambridge, MA: Harvard University Press, 1933.

Longworth, Alice Roosevelt. *Crowded Hours.* New York: Charles Scribner's Sons, 1933.

Marszalek, John F. *Petticoat Affair: Manners, Mutiny, and Sex in Andrew Jackson's White House.* New York: Free Press, 1997.

McLean, Evalyn Walsh. *Father Struck It Rich.* Boston: Little, Brown, and Company, 1936.

Miller, Francis Trevelyan, and Robert Sampson Lanier. *The Photographic History of the Civil War: Armies and Leaders.* Vol. 8. New York: Review of Reviews Company, 1911.

New York Times. "An American Princess; Public Wedding of Miss Julia Grant and Prince Cantacuzene." September 26, 1899.

———. "Captain of Naval Militia; Jacob W. Miller Appointed to the Position by Gov. Black." June 16, 1897.

———. "Clifton R. Breckinridge: Once Arkansas Representative—Was Son of Confederate General." December 4, 1932.

———. "A Congressman Married; the Wedding of Miss Patten and Mr. Glover." December 22, 1887.

———. "Miss Nancy Leiter Weds; Married to Major Campbell—Earl of Suffolk the Best Man." November 30, 1904.

———. "Sir Esmond Ovey, 83, a Former Diplomat." April 31, 1963.

————. "Was a Stranger to Form; Senator Van Wyck Ruthlessly Violated Senatorial Customs." October 27, 1895.

————. "Washington Society at Belmont Musicale; Jean Gerardy, Caruso, and Miss Bessie Abott Heard." January 26, 1906.

Omaha Daily Bee. "In the Domain of Women." March 16, 1902.

Page, Thomas Nelson. *The Negro: The Southerner's Problem.* New York: C. Scribner's Sons, 1904.

Page, Walter Hines, and Arthur W. Page. *The World's Work.* Vol. 6. New York: Doubleday, 1903.

Roth, Leland M. *McKim, Mead & White, Architects.* New York: Harper & Row, 1983.

Sacramento Daily Union. "Ex-Senator Van Wyck Dead." October 25, 1895.

Sartoris, Algernon, Jr. "Some Impressions of Washington Society." *Harpers Weekly* 49 (1905).

Smith, Amanda. *Newspaper Titan: The Infamous Life and Monumental Times of Cissy Patterson.* New York: Alfred A. Knopf, 2011.

Thaw, Harry K. *The Traitor.* Rockville, MD: Wildside Press LLC, 2010.

Trollope, Anthony. *North America 1863.* Carlisle, MA: Applewood Books, 2008.

Twain, Mark. *The Gilded Age: A Tale of Today.* New York: Harper & Brothers, 1915.

United States Commission of Fine Arts. *Massachusetts Avenue Architecture.* Washington, D.C.: U.S. Government Printing Office, 1973.

Washington Post. "The Bartholdi Fountain: An Engagement That Was Not Kept Because of the Assassination." July 30, 1881.

————. "The California Syndicate: Heavy Transfer of Real Estate to Ex-Senator Sharon." June 25, 1884.

————. "Chance for Good Investments." April 26, 1879.

————. "Death of William M. Galt: The Illness of the Well-Known Flour Dealer Ends Fatally." January 4, 1889.

————. "Depart to Meet Rescued at Dock: Relatives and Friends Leave Capital for New York." April 18, 1912.

————. "A High Tower in Ruins: The Handsome Church of the Covenant Partially Wrecked." August 23, 1888.

————. "Ice Stove Foe to Heat: Dr. Bell Invents Machine to Radiate Cooling Air." July 24, 1911.

————. "It Rises from Its Ruins: The New Church of the Covenant." February 25, 1889.

————. "Land Investors Well Rewarded for Confidence." December 6, 1927.

————. "Miss Emory Is Engaged to Wed British Diplomat." April 10, 1909.

————. "Mrs. Beriah Wilkins Dead: Was the Widow of Former Representative from Ohio." January 3, 1911.

———. "Nellie Grant Sartoris." October 13, 1885.

———. "The Nickerson Property Suit: Miss Carter Declares That She Obtained Possession Fairly." November 28, 1883.

———. "Our Wealthy Widows: Prominent in Washington Society. Mrs. Logan Is a Leader." December 9, 1894.

———. "Rich Widow Marries: Mrs. Marshall Field, Jr., an Englishman's Bride." September 4, 1908.

———. "Social and Personal: New Palaces of Vanity Fair to Rise in Washington." June 16, 1901.

———. "Stores on Dupont Circle: Business Encroachment on Connecticut Avenue Progresses Rapidly." May 18, 1913.

———. "T.F. Schneider Service Today at Residence: Builder of 2,000 Homes to Be Buried This Afternoon in Rock Creek." June 11, 1938.

———. "Threats of a Widow: Lead to Mrs. Gage's Detention in St. Elizabeth's." March 12, 1912.

———. "White House Brides: Wilson and Widow Shared Moonlight with Secret Service." July 19, 1966.

———. "World's Most Wealthy Capital Soon May Be Washington's Claim." January 31, 1911.

Welles, Benjamin. *Sumner Welles: FDR's Global Strategist*. 1st ed. New York: St. Martin's Press, 1997.

Willard, Frances Elizabeth, and Mary Ashton Rice Livermore. *A Woman of the Century: Fourteen Hundred-Seventy Biographical Sketches Accompanied by Portraits of Leading American Women in All Walks of Life*. Buffalo, NY: Moulton, 1893.

INDEX

ABOUT THE AUTHOR

Stephen A. Hansen is a longtime resident of Washington, D.C. He is an architectural historian, a historic preservation specialist and an author. He is principal at DC Historic Designs, LLC, in Washington, D.C. Previously, he worked for the National Park Service and as an archaeologist in and around the Washington area. He serves as a trustee of the Committee of 100 on the Federal City and sits on its historic preservation committee, as well as authors the monthly column "What Once Was in Washington, D.C." for the *InTowner* newspaper. He is a graduate of Oberlin College, George Washington University and Goucher College. He is also the author of *Kalorama Triangle: The History of a Capital Neighborhood*, published by The History Press in 2011.